OXFORD IN ASIA STUDIES IN CERAMICS
General Editor: L.L. LEGEZA

THE CERAMICS OF SOUTH-EAST ASIA

THE CERAMICS OF SOUTH-EAST ASIA

THEIR DATING
AND IDENTIFICATION

ROXANNA M. BROWN

KUALA LUMPUR
OXFORD UNIVERSITY PRESS
LONDON NEW YORK MELBOURNE
1977

Oxford University Press

OXFORD LONDON GLASGOW NEW YORK
TORONTO MELBOURNE WELLINGTON CAPE TOWN
IBADAN NAIROBI DAR ES SALAAM LUSAKA ADDIS ABABA
KUALA LUMPUR SINGAPORE JAKARTA HONG KONG TOKYO
DELHI BOMBAY CALCUTTA MADRAS KARACHI,

Printed in Singapore by Dainippon Tien Wah (Pte) Ltd.
Published by Oxford University Press, Lot 3, Jalan 13/3,
Petaling Jaya, Selangor, Malaysia

For Belva Orlena, Wesley,
Lorraine, and Fred

FOREWORD

THIS foreword has no other purpose than to wish Ms Brown's book *bon voyage*. I think it will find no great difficulty in making headway against whatever mild waves of criticism may be wafted against it. In particular, it offers much new information about the pottery wares of Vietnam, and about the ceramic art of Cambodia (scarcely known outside a narrow circle of collectors, and hardly represented in any major public collection anywhere in the world), and of the productions of the northern Thai and Laotian kilns; and in general it paints a large and well-filled picture of the South-East Asian pottery *oeuvre* seen from an historical point of view.

Roxanna Brown came to me some years ago with a plea to be given the opportunity to do some work, of some sort, on some aspect of Asian art history. My previous M.A. student, Ms Constance Sheares, had done some bed-rock research, almost a salvage operation one might say, on the fast-disappearing obsolescent textiles of South-East Asia, and I was able to suggest to Ms Brown that she might do the same with the pottery. Pots and cloths. Two of the most elemental inventions of civilised mankind, and nowhere richer in their beauty, variety of form and decoration, and technical accomplishment, than in these parts of the world.

I quickly recognised in Ms Brown an exceptional personality. A research student must, above all, have boundless enthusiasm for the specific task in hand; but also personal ambition, determination, tenacity of purpose, intellectual curiosity, the ability to sacrifice oneself, and a natural flair. One direct glance from Ms Brown's luminous, indeed incandescent, blue eyes assured me that she possessed these qualities in full. I think her thesis, and this present book, say as much. And I think, too, that oriental studies will benefit by her presence in this field. I should add, too, that her physical intrepidity, travelling long distances in little frequented parts of the South-East Asian peninsulas and archipelagos, has allowed her to extend the scope of her studies far beyond the normal requirements for an M.A. thesis.

I very well remember my own professor asking me with evident concern, at our preliminary interview at the Courtauld Institute of Art in London, now over twenty years ago, whether I was or was not a monomaniac; implying that only an obsessed lunatic would involve himself in an occupation so likely to lead nowhere, careerwise, as the study of Chinese art and/or archaeology (but this was in 1943), or would be likely to make anything out of it if he did.

It was a deliberate exaggeration. But Professor Yetts made his point. Historical scholarship, the creative reconstruction of the past, is sufficiently rewarding in itself to obviate any disadvantage such academic pursuits may have; but it demands a total involvement in its processes, and for this a

little bit of monomania in one's makeup is a very great help. It enables
the historian to keep his eye fixed on his goal, while at the same time
picking his way through the great mass of historical fact he must necessarily
encounter, and largely discard, on his way to reach that goal.

I am glad Ms Brown's thesis has reached definitive form as the first
publication in the Oxford Studies in Ceramics series, and wish it, once
again, *bon voyage*.

University of Malaya, WILLIAM WILLETTS F.R.S.A.
Kuala Lumpur,
December 1976

CONTENTS

MAPS

ABBREVIATIONS

BEFEO	*Bulletin de L'École Française D'Extrême-Orient*
BMRAH	*Bulletin des Musées Royaux D'Art et D'Histoire*
BSEI	*Bulletin de la Société des Études Indochinoises*
HJAS	*Harvard Journal of Asiatic Studies*
ILN	*Illustrated London News*
JSS	*Journal of the Siam Society*
RAA	*Revue des Arts Asiatiques*
TOCS	*Transactions of the Oriental Ceramic Society*
TSACS	*Transactions of the Southeast Asian Ceramic Society (Singapore)*

ILLUSTRATIONS

ACKNOWLEDGEMENTS

THIS work is a revised and expanded version of the author's thesis entitled *The Dating and Identification of Southeast Asian Ceramics* submitted for a Master's degree, after three years of research, to the University of Singapore in November 1973. Although 'ceramics' is a general term that includes both glazed and unglazed clay artifacts of all types, the emphasis both in the thesis and in this book is on the history of glazed pottery. Moreover, stress has been laid on the typical rather than the unusual as befits a preliminary survey. There are endless particular examples and points of discussion that could be fuel for many future more specialized studies.

Due to the scarcity of published material on the subject of South-East Asian ceramics, I am deeply indebted to the many persons who enthusiastically assisted me in my field research. Among them are Abu Ridho and Ridwan Ambari at the Museum Pusat, Jakarta, and Velma and Peter Gillert, Jakarta; Mde. J.P. Schotsmans at the Musées Royaux D'Art et D'Histoire, Brussels; Nghiem Tham and Tran van Tot at the National Museum, Saigon, and the former curator, Vuong hong Sen; Ha duc Can; Somporn Yupho, Nikom Suthiragsa and Nikom Musigokama at the National Museum, Bangkok; Princess Pantip Chumbhot of Suan Pakhad Palace, Bangkok; Mali Koksanthiya and his son Narong at the Fine Arts Department, Old Sukhothai; Kraisri Nimmanahaeminda, Sommai Premchit and Bhayap Boonmark, Chiengmai; Ly Vuong at the National Museum, Phnom Penh; Terry Baylosis, Mr. and Mrs. Ramon Echevarria, and Dr. Robert B. Fox in the Philippines; Vance Childress; John Ayers, who was my external examiner; Dr. John A. Pope; and especially Bernard Groslier.

I wish to thank the Lee Foundation, Singapore, for financial assistance; members of the Southeast Asian Ceramic Society, Singapore, for unceasing assistance and encouragement, in particular Frank and Pamela Hickley; Mr. and Mrs. Donald Sinclair; and William Harrington, Ligra Varon, Dolly Pillay, Peter Parker, Silvia Pedraza, Christine Cue, Rod Buchan, and Dr. Eunice Thio.

The photographs appearing in this book have been taken by the author with the permission of those persons or institutions credited in the captions; the illustrations, too, are the author's except those of the Khmer pieces, which were drawn by Vance Childress, and some of the Thai, which are the work of Narong Koksanthiya.

The subject matter is one that was suggested by William Willetts, last curator of the former Art Museum of the University of Singapore, who patiently advised and guided me through the research and to whom I owe much gratitude. In relation to the amount of popular interest in South-

East Asian ceramic wares, little systematic research has been conducted, and it is thought that besides contributing to the general appreciation of the wares, an attempted summary of the available evidence for dating the objects would be useful to archaeologists. If the wares could ever be precisely dated, then they could serve, in turn, to give a definite date to the hundreds of old trading centres and ancient burial and habitation sites where their presence has been noted in South-East Asia.

London, ROXANNA M. BROWN
July 1975

INTRODUCTION

THE earliest known Western investigation of old South-East Asian glazed ceramics took place in the late nineteenth century when Sir Ernest Satow, then the British representative in Bangkok, collected a small celadon bowl, which he gave to the British Museum in 1887, and several Sawankhalok celadon sherds from the ruins of the ancient city of Sri Sachanalai in North-Central Thailand in December 1885 (Brinkley, pp. 64–5). The possibility of the existence of indigenous Thai pottery had been suggested by the Frenchman Albert Jacquemart (1873, p. 170) who, because of the Arabic word for celadon, 'martabani', suspected that early celadons may have been manufactured near the port of Martaban, a former possession of Thailand. But although Satow's finds did verify the existence of Thai celadons, these are only rarely found in Arab lands.

It is more probable the nomenclature arose from the fact that the port was an important transhipment centre for Chinese products to the West, especially in the sixteenth and seventeenth centuries, some years after the Sawankhalok kilns must have ceased production.

Others soon followed Satow to Sri Sachanalai, and the actual kilns outside the city walls seem to have first been visited by Lucien Fournereau who journeyed there in 1891, but whose account of them was not published until 1908. Further descriptions of the site were written by T.H. Lyle (1901 and 1903), who recounted the local belief that the kilns were 1,400 years old; E. Lunet de Lajonquière (1906 and 1912), who guessed that they dated from the thirteenth century; G.E. Gerini (1904); and Reginald Le May (1925), whose later article (1933) was the first attempt at a classification of Sukhothai and Sawankhalok products.

The presence of additional kilns at nearby Old Sukhothai was first reported in 1909 by a Crown Prince of Thailand who later became King Rama VI, but the story of his visit to the old kingdom (1954 edition, p. 100) has never been translated. He described the wares as less fine but similar to those at Sri Sachanalai. Mention of the kilns in English did not occur until 1930–1 (Raphael).[1]

Meanwhile evidence of Khmer kilns had been discovered by Etienne Aymonier (1901, p. 414) on Phnom Kulen, 40 kilometres north-east of Angkor, when he travelled there in 1883. A later description of the site, with its piles of green-glazed sherds and wasters, was included in Victor Goloubew's *Le Phnom Kulen* (1924), but no excavation of the debris has yet taken place. Another possible Khmer site has recently been reported near Ban Kruat in lower North-East Thailand (Vallibhotama, 1974), and test trenches were begun there in late March 1975. Elsewhere in South-East Asia, kiln sites have been identified in northern Thailand, near Vientiane, and possibly near Qui Nhon in South Vietnam.

The study of Thai and Vietnamese ceramics was given a boost in the late 1920s and 1930s when H. Otley Beyer began unearthing Thai, Vietnamese and Chinese ceramics in the Philippines at the same time as excavations, which will be described in Chapter 1, were taking place in Vietnam, and hundreds of buried pieces were being discovered on Sulawesi (formerly the Celebes) in Indonesia. It was during this time, too, that E.W. Van Orsoy de Flines was amassing his superb collection of export wares found in Indonesia. This collection is now on display in the Museum Pusat, Jakarta.

Beyer published very little, but his early conclusions, after a survey of Rizal Province near Manila, were summarized in 1930 in a two-part article by Walter Robb who claimed that Beyer's dating rested on stratified habitation sites. But because no actual excavation reports have been published, at least one writer on Oriental ceramics, John Addis (1968), has questioned his findings. At any rate, Robb's article indicates that Beyer gave a thirteenth to fourteenth century date to Sukhothai pieces (which are illustrated, though labelled Sawankhalok), a fifteenth to sixteenth century date for Sawankhalok, and generally a fifteenth century date for Vietnamese blue and white (which are mistakenly illustrated as Sawankhalok).

The history of ceramic finds in Sulawesi is of special interest because so many pieces may still be found there today, and since an important Japanese book by Chuta Ito and Yositaro Kamakura (1937 and 1941) dealing with some of the earliest of these has not been published in English, it will be discussed briefly here.[2] The early discoveries were fortuitous: villagers uncovered ceramics along with bits of gold and silver jewellery in their fields. Further digging was solely in search of more of the precious metals until a Japanese artist visiting Macassar in May 1936 reported seeing old pottery in some of the local shops. The location of their source was then sought and it was decided that they originated in Kampong Pareko, 40 kilometres south of Macassar along the Macassar-Takalar railway line. At the request of the authors of the book, Kanji Sawada, a resident of Macassar, engaged a group of villagers to excavate the site for ceramics. The collecting lasted for three months, from August to October, but no archaeological instructions were given or observations made; Sawada only visited the site occasionally for the purpose of collecting the pieces excavated. The 600 ceramic pieces gathered were sent to Japan and a description of them forms the subject of the book. The authors divided them into three categories: Sino-Siamese, Sino-Annamese, and Chinese.

The Sino-Siamese included only Sawankhalok, no Sukhothai. They were 140 in number, comprising just over 20 per cent of the total finds. Most were underglaze black wares, primarily covered boxes, followed by celadons, and then brown-glazed wares. Photographs of 116 of them appear in the book. The number of Sino-Annamese, or Vietnamese, is more difficult to judge. Of 104 of those illustrated, only about 50 are actually Vietnamese. The illustrations are mainly of blue and white, some with overglaze enamels, along with three copper green pieces, and two underglaze black bowls. Most of the others pictured as Sino-Annamese are Chinese, and a small number Sawankhalok. In general the assemblage of wares is very similar to that recorded later at Calatagan in the Philippines; and the majority belong to the fifteenth and sixteenth centuries.

Research was soon interrupted by the Second World War, and renewed local interest in ceramics did not develop in the Philippines until the 1958 Calatagan excavations of Dr. Robert Fox, conducted at a site already partially investigated by Olov Janse in 1940 (*HJAS*, 1944-5), and the Locsin (1967) Santa Ana excavations, which stimulated the assembling of several fine major collections in the islands, innumerable minor ones, and, unfortunately, the widespread looting of old burial grounds.[3] In Cambodia excavations begun by Bernard Groslier in 1953 have led to the first construction of at least a general outline for dating Khmer wares that will be described in Chapter 2, and in North-East Thailand the excavation of a former Khmer kiln site has recently commenced. A controlled excavation was also attempted in Sulawesi by the Indonesian Fine Arts Department, but apart from finding Sawankhalok celadon and Vietnamese blue and white sherds in close association, the results were negligible; the site was found to have been previously disturbed (Tjandrasamita, 1970).

Notable studies specifically on South-East Asian ceramics have been contributed by Okuda Seiichi (1954) and Lefebvre d'Argencé (1958) on Vietnamese ceramics, and Charles Nelson Spinks (1965 and 1971) on Thai. More recently interest in the wares was considerably heightened by the publication of a catalogue of an exhibition of Thai, Khmer, and Vietnamese ceramics staged by the Southeast Asian Ceramic Society in Singapore. Compiled by William Willetts (1971), it was the first work to formulate a classification of Vietnamese export wares, to give an outline dating of Khmer pottery, and to draw stylistic correlations between Sukhothai and fourteenth-century Vietnamese wares. A year later another exhibition, including many ceramics made in South-East Asia, was organized in Vancouver by the Society for Asian Art there (Gunn, 1972). Later a catalogue of the Vietnamese wares in the Museum Pusat, Jakarta, appeared (Lammers and Ridho, 1974). Also important is a survey, including an extensive bibliography, of all research on ceramics, both South-East Asian and Chinese, in South-East Asia, compiled by Dr. Chêng Tê-k'un (1972).

The present study stems directly from the Willetts' catalogue. By grouping South-East Asian wares together, it is hoped that any crosscurrents between the ceramics of these neighbouring countries might be placed in perspective.

[1]For a more detailed description of the history of research on Thai ceramics, see Brown, *The Legacy of Phra Ruang* (1974).
[2]For more details on the history of ceramic finds on Sulawesi, see Brown, *TSACS* (1974).
[3]For accounts of this commercial digging, see Locsin (1967), pp. 127-88, and Brown, *TSACS* (1973).

PHILIPPINES

LEYTE

BOHOL

CEBU

Manila

Calatagan
Puerto Galera
MINDORO

TIMOR

(CELEBES) Sulawesi

SUNDA IS.

MADURA

J A V A

KALIMANTAN

Makasar

S U M A T R A

SINGAPORE

MALAYA

Qui Nhon

V I E T N A M

L A O S

C A M B O D I A

Bat-
trang
Haiphong
Hanoi
Thanh-
Hoa

Red R.

Vientiane

Mekong

Phnom Penh
Saigon

Angkor

Surin

THAILAND

Bangkok

Sukhothai

Chieng
Mai

Sri Sachanalai

Moulmein

Rangoon

Irrawaddy

Gulf of Martaban

Nakorn Sri Thammarat

1. South-East Asia

[1]

VIETNAMESE CERAMICS

FROM the time of the Han to the period of the T'ang Dynasty in China there existed on the far south-eastern borders of the country a conquered territory called by the Chinese *Nam Viet* (or *Nan Yüeh*). This territory consisted of the present Chinese provinces of Kwangtung (including the city of Canton) and Kwangsi, as well as northern Vietnam as far south as Thanh-hoa (Schafer, 1967, p. 104). It was divided into two major administrative parts: Lingnan, in the north-east, and Annam, in the south-west. After its conquest in 111 B.C., Annam was directly ruled by the Chinese until A.D. 979 and again for a brief period between 1407 and 1427.

Until 1803, the year following the establishment of the national capital at Hué in central Vietnam, when the emperor Gia-long requested that his country henceforth be known as Vietnam, the official Chinese designation for the country remained Annam (Deveria, 1880, p. 1), literally meaning 'Pacified South'. Thus Vietnamese ceramics have been called 'Annamese', a practice that seems to have been initiated by the Japanese and then used in English after the publication of *Annam Toji Zukan* or *Annamese Ceramics,* the first extensive work on the wares, by Okuda Seiichi (1954).[1] The registers of the Dutch East India Company, which traded the wares in the seventeenth century, refer to them as Tongkinese (Volker, 1954), due to a mispronunciation of the name of the capital at Hanoi which was then called Dong Kinh.

For nationalistic reasons, the Vietnamese themselves preferred to call their country Dai Nam, meaning 'Great South'; Dai Viet, after their race; or by its ancient name, Giao Chih. Thus the preferred nomenclature here is Vietnamese rather than Annamese, though the terms are interchangeable.

That Vietnamese wares formed a distinct class of Oriental ceramics in their own right was first recognized during the widespread excavations that took place mainly in Thanh-hoa Province in Vietnam during the 1920s and 1930s. The excavations yielded thousands of objects, chiefly pottery and some bronze, mostly from burial grounds of the first to the third centuries, and the tenth to the thirteenth centuries, periods roughly contemporary with the Later Han and Sung dynasties of China. The finds came as a consequence of the French Government's construction of roads, irrigation canals, buildings and other public works. The antiques soon reached the curio shops of Hanoi, Peking, and Shanghai, where the pottery became known as 'Thanh-hoa ware'. An exhibition of some of the artifacts was held at the Musée Guimet in Paris as early as 1931 (Goloubew, 1931–2),

and it was just a year later that the inscribed Vietnamese bottle that will be discussed shortly was discovered by R.L. Hobson (1933–4) in the Topkapu Sarayi Museum of Istanbul.

The first of these ceramic objects began to filter sporadically into the Louis-Finot Museum (now Musée Historique) at Hanoi by 1915 (d' Argencé, 1958, p. 1). Then in 1924 the customs officer at Thanh-hoa, Louis Pajot, was asked by Leonard Aurousseau of the École Française d'Extrême-Orient to investigate and if possible to excavate the sources of those and other finds. The energetic Pajot remained an avid technical supervisor for the École's excavations there for several years.

Pajot, a former circus performer turned seaman, had gained his appointment at Thanh-hoa after a voyage brought him to the French colony. His qualifications, unfortunately, were not those of an archaeologist, and he left no record of his excavations. More adept at systematic investigation was Olov Janse who, sponsored by the French museums and aided by the École Française, carried out excavations between 1934 and 1939, concentrating on the Dong-so'n (pre-Chinese) and Han period sites. His three-volume work, *Archaeological Research in Indo-China* (1947, 1951, and 1958; hereafter abbreviated to *Arch. Research*) was a landmark, and his various other articles (see Bibliography) were enlightening contributions to the study of Vietnamese ceramics.

By 1925 the looting of ancient graves had become so rampant that the Government of Indo-China issued an order in April of that year prohibiting unauthorized digging. Apparently this ruling was hardly a deterrent. For example, before his departure in 1938, Clement Huet, a Belgian business-man with an import-export company in Vietnam and also an amateur archaeologist, was able to amass a personal collection of over 5,000 artifacts. Besides contributing to both the Musée Louis-Finot at Hanoi and the Musée Khai-Dinh in Hué, he was also able to supply pieces for his brother Leon's shop which opened in 1930 on Rue du Rosière, Genval, Belgium. Another major collector of the time was Albert Pouyanne, most of whose acquisitions went to the Musée Guimet.

Leon Huet's shop and its contents were fortunately noticed by Madame Houyoux, a curator at the Musées Royaux D'Art et D'Histoire in Brussels (also known as the Musée Cinquantenaire), who in 1952 negotiated the purchase of nearly 3,000 pieces from the Clement Huet private collection. The pieces, however, lack any documentation other than paper labels that identify them as either 'Han', 'Sung', or 'Ming', etc. But it is known from information provided by Huet's adopted son, and which is on record at the museum, that all the pieces came from Vietnam, and that some were excavated by Huet himself and others bought from villagers. Also Huet, as a friend of Pajot, undoubtedly frequently consulted him as well as other orientalists in the area, such as Aurousseau, George Coedès and René Grousset, on matters such as the dating of the finds.[2]

Besides the earlier period burial wares, there are a number of later underglaze blue decorated pieces in the Huet collection. Many of these also entered the collection of the Hanoi museum during the 1920s and 1930s, but whether or not any came from graves is unknown. John Pope (1956, note p. 104) has said that those in the Huet collection were uncovered in 'cachettes' at Phu-ting Gia, Thanh-hoa Province, and Lam-Dien, Ha-dong Province. The provenance of those in Hanoi, among which are

kiln wasters (d'Argencé, 1958), does not seem to have been known or recorded.

Even with the extensive digging that characterized northern Vietnam before the Second World War, no old kiln sites that once produced the glazed ceramics were definitely identified then, nor have any been reported since. Janse (I, 1947, pp. 60–2) did uncover some 20 kilns in the Tam-tho region of Thanh-hoa which produced the unglazed reddish earthenware well-represented in the Han tombs of the area (Colour Pl. A, 1), but he did not find the kilns which produced the Han period cream or slightly greenish glazed white-bodied wares that were predominant in graves further north (1, Pl. 1).

Janse's kiln finds, however, do demonstrate that pottery was being locally produced and also provide a glimpse of the kiln construction of the period, for although kilns were excavated in 1955 at the Neolithic site of Pan-p'o-ts'un in Shensi, no Han period kilns have yet been discovered in China. Unlike the Annamese kilns, those at Pan-p'o-ts'un were dome-shaped with the firing chamber below the floor level of the baking compartment into which the heat entered through flues in the floor (Chêng, 1959, p. 79). Roughly cylindrical in shape with a step that separated the firing from the baking chamber, the Tam-tho kilns were built either of earth hardened by fire or partly with brick. They varied in length from 5 to 9 m up an inclined plane, and in width from 1·4 to 1·8 m, averaging 1·8 m in height. To judge from excavated kilns in Thailand, the Tam-tho kilns may have set the style for South-East Asia, although most of those in Thailand are built of brick (see Fig. 22).

Pope (1956, note p. 104) reports that Janse heard of the existence of Ming period kilns in the delta region east of Hanoi but was unable to investigate them. Janse does not mention this himself, but suggests searching for kilns in the area between Uong-binh and Van-chai in Tonkin where he says kaolin deposits are known to exist (III, 1958, p. 101). Perhaps what Pope refers to is the report of a kiln find by Fr. D.J. Finn who, after a visit to Tonkin in 1933–4, wrote a letter to H. Otley Beyer in the Philippines saying that he had visited an ancient kiln centre near Bai D'Along, a short distance from Haiphong, which had produced chiefly celadon wares. But Fr. Finn died in 1936 without leaving a more explicit description, and as far as we know, the site has never been re-located (Beyer, 1960, p. 10).

In the Huet collection at the Musées Royaux there are four kiln wasters labelled 'From near Hanoi' which stylistically appear to date from the thirteenth or early fourteenth centuries. Each is a vertical stack of three to twelve green-glazed bowls. One, whose uppermost bowl, unlike the others, has a brown-glazed exterior and cream-glazed interior, is marked fourteenth century. The bowls of one stack are separated by disc-supports; those of the others are set directly one upon the other, the foot of one resting on an unglazed ring cut through the glaze on the interior bottom of the bowl beneath. These wasters, along with those in the Hanoi museum (d'Argencé, 1958, p. 1), provide strong evidence for the existence of a local ceramic industry.

William Willetts (1971) has already outlined the Vietnamese traditions that trace the introduction of pottery making to immigrant Chinese in the first centuries before our era. One site that may prove to have been a major centre is the town of Bat-trang, 10 kilometres north of Hanoi. The

potters of Bat-trang say that their industry, which still continues, dates from at least the mid-sixteenth century. Another locality that certainly requires attention is the district of Nam Sach in Hai Du'o'ng Province east of Hanoi, the place named in the inscription on the blue and white bottle of Plate E which is dated A.D. 1450.

The lack of identified kiln sites other than Tam-tho in northern Vietnam is a disturbing problem for the ceramic historian, and one which prevents a conclusive summary of Vietnamese wares. But despite that and the general absence of archaeological data from Vietnam since the 1930s, the following preliminary outline and classification of the wares can be pieced together from what information is available.

1. *Later Han period* (c. 1st–3rd centuries)	White-bodied wares with cream-white to slightly greenish glazes essentially in Chinese-inspired shapes
2. *Intermediary period* (c. 4th–9th centuries)	Miscellaneous white to greyish-bodied wares with cream, brown, and watery green glazes
3. *Sung period* (c. 10th–early 13th centuries)	Unglazed blackish-grey wares, primarily covered urns, plus white to greyish-bodied wares of the following glaze types: iron brown inlay, crackled cream, white monochrome, brown monochrome, copper green, celadon, and underglaze black
4. *Export Era* *Early* (c. 13th–14th centuries)	White to greyish-bodied wares, primarily in the shapes of beakers, bowls, jarlets, dishes, and some covered boxes and ewers, of the following glaze types: celadon, copper green, brown, underglaze black, and monochrome white
5. *Middle* (c. 15th–16th centuries)	White to greyish-bodied wares decorated in underglaze blue, sometimes with overglaze red, green, or yellow enamels, in a profusion of shapes
6. *Late* (c. 17th–18th centuries)	Wares with a dirty whitish body and a crackled greying glaze, decorated in a medium blue underglaze wash; including bottles, jarlets, bowls, and dishes

7. *Domestic Cult wares*
(c. 15th–17th centuries)

Wares decorated in underglaze blue, often with unglazed whitish-bodied appliqué decorations of long dragons and rosette buttons, attributed to Bat-trang

Dark-bodied unglazed wares, primarily censers, elaborately modelled, attributed to Tho-ha

White-glazed wares, with a dirty white or buff body, and green and/or red enamels; sometimes called 'three-colour' wares

Thinly glazed wares, primarily censers, with amber and rust-brown slip coverings, and elaborate carved or moulded appliqué decoration

THE HAN PERIOD

The 2,000-year glazed ceramic history of Vietnam began about the first century of our era, under undoubtedly Chinese auspices, with the glazed wares excavated by Janse (see Bibliography) from the tombs of Lach-tru'o'ng and Bim-so'n north of the Thanh-hoa provincial capital, for which he was unable to locate the kiln source. But already these wares can be distinguished from the Chinese, for they are the earliest glazed white-bodied wares so far known in the Far East. They date from approximately the first to the third centuries A.D.

The shapes are in the Han Chinese tradition[3] and were doubtless produced under the direction of the Chinese overlords if not by imported Chinese potters. The most striking difference between the wares of the two countries lies in the colour of the body and glaze. The body of the contemporary or earlier Han China proper wares is usually reddish-brown to buff, never the off-white of the Vietnamese wares. Also, while the dominant contemporary Chinese glaze colour was opaque green in various shades, the glaze of the Vietnamese wares is a slightly translucent cream-white, sometimes with pale greenish tinges. Part of the reason for this early difference of Vietnamese wares is the high quality clay deposits of northern Vietnam. It is the same finely levigated whitish clay body, in fact, that characterizes practically the entire ceramic production of northern Vietnam.

The Han period wares are well-baked and probably turned on a potter's wheel which seems to have already been used in China (Laufer, 1909, p. 8). The glaze has withstood the wear of time and burial with little or no chipping, and none of the decomposition that mars Chinese green glazes which are almost universally decomposed into a gold or silver iridescence. Generally strong and simple, the shapes include oval cups, incense-burners, vases, bowls, basins, jars and tripod forms (Fig. 1). Decoration consists of incised bands and sometimes appliqué handles or zoomorphic appendages.

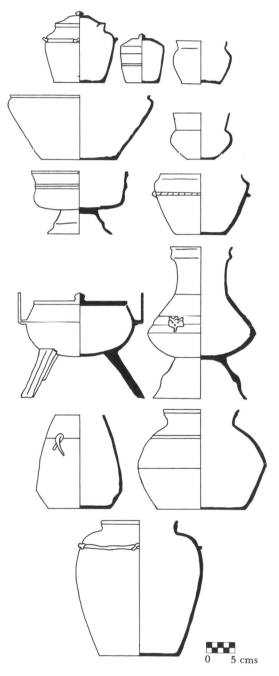

0 5 cms

Fig. 1 Vietnamese Han-Period Glazed Wares

One common characteristic of these wares is the thick, translucent, crackled dark green glaze accretions that Janse calls 'blisters' (I, 1947, p. 28) with the implication that they are flaws. But although they are often seen on interior bottoms or flattened mouth rims where a liquid glaze might easily gather, they sometimes occur, too, in places where some extra glaze may have been applied deliberately. The jar of Plate 1, #1, for instance, has the glaze run on the shoulder.

The numerous and elaborate brick Chinese tombs in the territory of Annam dated to the first centuries A.D. may indicate a former commercial centre of some importance. It is significant that G.E. Gerini (1909, p. 304) in his treatise on the Greek *Geographiké Hyphegesis* (an ancient geography compiled about the first half of the second century) has calculated that the port of Pagrasa mentioned by Ptolemy must have been located at the mouth of the river Song Ma, the site of the Thanh-hoa provincial capital near which many of the Han period artifacts were excavated. Evidence in Chinese records (Hirth, 1885, p. 42) also points to this region as having been the location of the southernmost Chinese port during these years.

THE INTERMEDIARY WARES

During the years between the third century and the end of the tenth or early eleventh century, when Annam's position as a commercial centre appears from Arab records (see, for example, Ferrand, 1913–14) to have been usurped by Canton to the north and Champa to the south, very few ceramics appear to have been produced. Only a dozen or so examples have been assigned to the period. Janse unearthed only two tombs which he attributed to the T'ang period (seventh to tenth centuries).[4] They yielded an assortment of simple cups with a whitish body and cream to brown and greenish glazes of possible local origin similar to Plate 1, #4, illustrated here, a jar similar to Plate 1, #2, and an olive-glazed bowl (#5, Pl. 1). Another example of the period is a small olive-glazed jar in the Saigon National Museum (#3, Pl. 1).

THE SUNG PERIOD

About the beginning of the first of the great Vietnamese dynasties, the Ly (1009–1225), which was roughly contemporary with the Chinese Sung, Vietnamese ceramic history begins to become clearer. Considered by Vietnamese historians as an age of artistic renaissance, the Ly Dynasty was marked by great national awareness and continued independence following a successful rebellion against the Chinese in the tenth century. There were successive military victories against Champa, its Hinduized neighbour to the south, which began the gradual annexation of that kingdom. At this time agricultural techniques were also improved, taxes instituted, and Buddhism reached its apogée (Lê, 1955, p. 145).

During this period, too, maritime trade seems to have been established. According to Vietnamese sources used by the historian Lê Thánh Khôi, Vietnam did not seriously engage in maritime commerce until the reign of Emperor Ly Anh-tong (1137–1175). Previously trade was carried on primarily with China, via overland routes (see also Schafer, 1967, p. 31).

But in 1149 boats arrived from Java, Lo-lac[5] and Xiem-la (probably Siam). They entered Hai-dong (Quang-yen), and offers of presents and requests for trade were made. Ly Anh-tong acquiesced, opening trading points on the Van-don Islands near what is now Haiphong harbour. Within a short time vessels from Fukien and southern China were also taking advantage of the new port. But there is no evidence yet that ceramic wares were exported at this time. None of the wares excavated from the tumuli of northern Vietnam and dated by Janse and others to Sung times (960–1279), primarily on the basis of coin and other associated finds, have counterparts verifiably excavated abroad. None of the Vietnam graves of this period, it might be added, contained Chinese blue and white, although there were Chinese celadons—a fact that reinforces an early fourteenth century dating at the latest—for it was during the fourteenth century that Chinese blue and white wares are acknowledged to have first entered the export market.

Whether the Sung period graves of Vietnam are again those of ethnic Chinese, as those of the Han period are believed to have been, or, as is more likely, those of ethnic Vietnamese, has not been decided. Unlike the earlier graves, there were no brick structures and the dead appeared to have been laid in wooden coffins (Janse, 'Rapport Preliminaire', x, 1936, p. 46); contemporaneous tombs in China still used brick (Laufer, 1909, p. 312). Although the wares are by no means scarce in collections today, only two graves of this period, both in Thanh-hoa Province, have been documented by Janse[6] whose interests lie more with the Han period burials.

In contrast to the house models (Colour Pl. A, 1) of unglazed wares and the glazed ceremonial-type vessels that were included in the Han graves, the Sung wares include a greater variety of shapes, such as dishes and bowls, that may have been used in daily domestic life, along with covered food and beverage containers that may have been solely funerary. The shapes, many of them uniquely Vietnamese, include covered urns (Figs. 2–3), covered jars, basins, wine pots, beakers, dishes, and bowls. Glaze classes include brown inlay, crackled cream, copper green, brown, white, celadon, and underglaze black decorated wares.

All of these are stonewares, and in contrast to the more highly fired kaolin wares of China, they acquire from long burial a certain scent that has been aptly described by a former curator of the Saigon National Museum, Vu'o'ng hong Sen, as 'the smell of the first spring rain'. A characteristic of many of the later wares as well, it is evident in a roomful of the pieces, and can be intensified on a single piece by wetting the unglazed foot.

THE SUNG PERIOD CHRONOLOGY

Neither Huet's labelled wares in the Musées Royaux nor Janse's two Sung-period excavations[7] provide any clues for a more precise dating than merely 'Sung'. Pajot, in letters to the École Française kept in the Saigon Museum, writes of associated Sung coins; and Janse based his dating partly on the discovery of two inscribed tomb bricks or tablets during the construction of the nearby Ham-rong bridge in Thanh-hoa where many wares similar to those uncovered in his burial excavations were

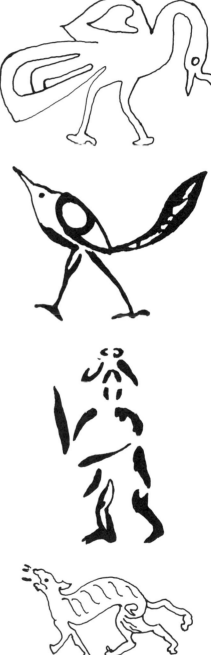

Fig. 2 Vietnamese Brown Inlay
Decorative Motifs

being unearthed by the local people. One of the inscriptions included a date equivalent to 6 November 1177. A tentative and general chronology, however, can be constructed from a stylistic examination of the wares. By presuming that the latest of the Thanh-hoa must be those that most resemble the earliest exported wares of the following period, the general trend in time leans toward an evolution from locally unique vessels to increasingly Chinese-influenced shapes and glazes. This tendency later culminates in the fifteenth-century blue and white, after which further Chinese stylistic intrusions are negligible.

The earliest of the Vietnamese Sung-period glazed ceramics are probably the inlay brown wares (Colour Pl. A, 2; 6–8, Pl. 2),[8] a group perhaps inspired by the tone contrasts of Chinese Tz'u Chou-types, which were already popular in China by the beginning of the Northern Sung (Gray, 1953, p. 24). The shapes are restricted to covered urns, some with hollow stand-type bases; tall cylindrical urns; wide, sturdy basins; and squat jars with flaring mouth rims. Decorations are carved in outline with wide scrapes and the space within inlaid with brown. The remainder of the vessel is then covered with an often runny, transparent or slightly greenish glaze. On some rare examples the designs are inlaid with white on a brown background (e.g. Goloubew, 1931–2, Pl. XXXVII). Occasionally a white slip coating is detectable under the glaze. Bases are always unglazed and usually flat, and the body whitish or pale grey.

The decorative patterns are mostly vegetal, with vines and simple flower blossoms, probably lotus, predominating, but there are also cloud forms, human figures, long-tailed birds, fish, and other animals such as tigers, monkeys and elephants (Fig. 2). One covered urn in the Musées Royaux has, in addition, the Chinese characters for 'wine vessel' brushed in brown slip on the unglazed interior of the cover.

It is with this group of wares that the spurred disc-shaped kiln support first makes an appearance in Vietnam. The scars left by the small feet of the fireclay stand (see Fig. 20) are often apparent on the inside bottoms of both basins and urns, indicating that those vessels played the role of saggar, or pottery container, in the kiln with smaller pieces stacked within. The use of the support continued to be popular with the Vietnamese potters until the introduction of blue and white, among which the scars are rare.

Because the inlay brown wares do not include dishes, bowls, or beakers, shapes that mark the evolution toward the exported wares, this group was probably discontinued well before ceramics were exported from the country. Moreover, the wares show no direct affinities to Chinese products. Although the idea of two-colour decoration probably came from *T'zu chou*-type Chinese wares, these never display the inlay technique, and the inlay brown shapes are not duplicated among Chinese pieces. While similar floral motifs are seen on early Sung Chinese ceramics,[9] human and animal figures comparable to those on the inlay brown have no such prototypes.[10] Thus it seems likely that the entire inlay brown group and its diagnostic shapes, when they appear in other glaze groups, belong to the early Sung or early Vietnamese Ly Dynasty. The majority probably date from the beginning of the eleventh to some time in the twelfth century.

Sharing the shape of the covered urn, the most common among the extant brown inlay examples, are the crackled cream, copper green, white,

Ht. 54 cms

Fig. 3 Vietnamese Brown Inlay Urn

and the brown-glazed wares. But these groups also include dishes, bowls, and sometimes beakers, shapes that presage the exported ceramics. One unglazed dark-bodied group that comprises only covered urns and small covered jars (Colour Pl. A, 4) probably belongs entirely to the early Ly Dynasty period. The vessels are carved or moulded with strong geometric decoration, and some have a brown-slipped interior. The crackled cream-glazed wares include the covered urn (#9, Pl. 2), though always with a flat base, plus related shapes such as bulbous ewers with tiny spouts and lotus petal collars, and simple, small cylindrical covered jars. Probable later shapes (late twelfth and thirteenth centuries) include squat globular jars, wine pots (#10, Pl. 3), and a very few bowls, usually with tall, carved foot rings (see Janse, III, Pl. 80).

The brown-glazed wares, which are relatively rare among the Thanh-hoa finds and normally monochrome, probably begin in the twelfth century. They include a small number of covered urns, small jars, beakers and bowls. The bowls often have a brown-slipped or 'chocolate' base, a common characteristic of the later exported wares. Yet the only brown-glazed wares excavated abroad have been bowls with a brown exterior and cream-glazed interior (#28-9, Pl. 9); these invariably have an unglazed stacking ring on the interior bottom. The only similarly glazed, non-monochrome example among the Thanh-hoa finds seen by this author is a wide-mouth bowl in the study collection of the Percival David Foundation, London (Fig. 4c). It has five spur marks on the interior and, like most of the bowls and beakers from Thanh-hoa, it has a demarcated interior bottom; around the perimeter of the well near the junction of the walls is a slight circular depression. The monochrome bowls found in Vietnam (like that illustrated on Pl. C, 3) seem to have been fired upside-down set on their mouth rims which are straight, shaved flat, and unglazed. The only other Vietnamese wares that could have been fired in this manner are the later large blue and white plates with a flattened mouth that has an unglazed raised outer edge.

The copper green and white monochrome wares seem to have endured throughout the Sung period and into the fourteenth century. They comprise shapes related to the inlay brown wares (Colour Pl. A, 3), and the two glazes were also used on some of the exported wares, though the copper green is much more prevalent than the white. Both, however, seem to have been most popular in the thirteenth and fourteenth centuries. Types of bowls and beakers from Thanh-hoa (#13-17, Pl. 4) often display brown-slipped bases similar to later pieces discovered abroad. Another shared characteristic that ties the latest of the Thanh-hoa finds to the first of the exported wares is a rounded mouth. This can be seen on the probable thirteenth century wine pot illustrated on Colour Plate B, 1 and on the small jar, Colour Plate B, 3 (compare with the jarlet of Pl. 8, #26). A prototype of the later, quite common, exported covered boxes can be seen on Plate B, 2. An uncommon and unusual shape that sometimes has traces of a thin copper green glaze is the cosmetic tray or box, Plate 3, #12. Only one example has been found accompanied by a cover (Janse, *Arch. Research,* III, Pl. 82-3). This type occurs only among the Thanh-hoa finds.

Wares that must have been developed only shortly before ceramics began to be exported are the underglaze black decorated and the celadon

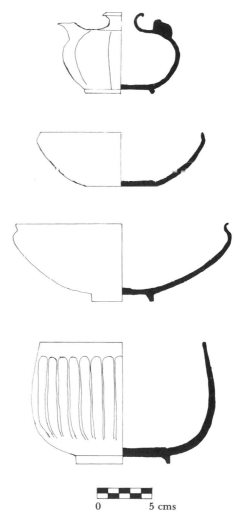

Fig. 4 Vietnamese Thirteenth-Century Shapes

groups. The underglaze black include a variety of bowls, some of them large and covered, and small jars. The glaze on these is often milky white, obstructing the clarity of the underglaze decoration on such examples as Plate 6, #21, a problem that was perhaps solved on others (e.g. #20, Pl. 6) by drawing over the glaze, a technique, according to Sir Harry Garner (1954, p. 3), that was evidently used on some early Chinese blue and white. Carved foot rings, rather than flat bases, begin to become common as they do also on other Thanh-hoa finds, such as copper green, white, and brown-glazed vessels that are presumed to date to the years immediately preceding the first exports. But while most of the other late Thanh-hoa finds have spur marks on their interior bottoms, some of the underglaze black bowls have, instead, unglazed rings cut on their interiors for stacking purposes.

Underglaze black decorations include sun-bursts that are later seen on Sukhothai and Sawankhalok wares of Thailand (e.g. #1, Colour Pl. 0), stylistic flower motifs (#20, Pl. 6), simple bands on an otherwise white monochrome vessel, or groups of thick amorphous brush strokes (#21, Pl. 6). One conical bowl in the Musées Royaux, Brussels, has a long sinuous dragon on its exterior.

Examples of Vietnamese celadon are rare, and the most common shape in the Thanh-hoa collections is an undecorated, heavily potted bowl with a carved foot ring and usually spur marks on the interior, a chocolate base, and foliate mouth lip (#18, Pl. 5). The body is most often greyish, and the glaze, commonly applied over a white slip, is murky, thick, and olive green. Another shape is the beaker, sometimes with a thick, unctuous, medium green glaze (#19, Pl. 5). Two unusual pieces in the Saigon Museum are a large wine pot (Colour Pl. C, 1) with a lustrous, opaque, greyish-green glaze, and a bowl with incised decoration and a translucent, soft-coloured lime-green glaze (Colour Pl. C, 2).

A puzzling aspect of the Vietnamese celadon wares is their seemingly short duration. Only a very few examples have been found abroad and these (see #30, Pl. 9) can be stylistically dated to the late thirteenth or fourteenth centuries. Perhaps the Vietnamese potters decided that the glaze was too difficult to handle or that blue and white was preferred by their customers or—a more interesting possibility—perhaps the potters who specialized in this ware moved to the kingdom of Sukhothai to initiate the making of celadon there. If such were the case, it would not be mere historical coincidence that about the time celadon production disappears from Vietnam, it begins in Thailand at the Sawankhalok kilns.

EARLY EXPORTED WARES

Exactly when Vietnam first entered the export pottery trade is uncertain, but stylistic evidence suggests the late thirteenth or early fourteenth centuries when commercially-minded Chinese refugees from the encroaching Mongol invaders may have settled in the country and helped to ply the local wares abroad. The early trade, however, was decidedly meagre, but showed signs of expansion in the late fourteenth century, perhaps as a result of the first Ming Emperor T'ai-tsu's (1368–1398) attempted ban on Chinese overseas voyages (Wolters, 1970, p. 49), and reached its height in the fifteenth and sixteenth centuries. Even so, it never

made any great inroads among the Chinese-export pottery consumers. Only an estimated 2 to 4 per cent of the fifteenth- and sixteenth-century foreign ceramics excavated in the Philippines are Vietnamese, while Thai wares sometimes comprise 20 to 40 per cent of the total during the same time period.[11]

The transition from the Thanh-hoa to the early export wares, which seem no longer to have been buried with the dead in Vietnam although they were still used as funeral objects by the natives of the Philippines and parts of Indonesia, is fairly smooth. Continued shapes include bowls with everted rims; conical bowls, usually with copper green glaze and embossed decoration; and beakers that have smooth or incised walls rather than the ribbed ones of the earlier examples (compare #19 and 24, Pls. 5 & 7). Both the use of the disc-shaped kiln support, which usually left triangular (though sometimes round) spur marks and, except on underglaze black wares, the unglazed stacking rings on bowls, were retained. Rounded mouth rims, which appeared on some of the late Thanh-hoa vessels, also typify many of the early exported jarlets. In addition, flat bases, which later disappear, are not yet rare. Inexplicably, however, practically all the earlier underglaze black shapes are totally abandoned, along with foliate rims on bowls.

The exported wares can be conveniently divided into three groups. Those in the first, or early, group are believed to belong to the late thirteenth or fourteenth century; they comprise probably the majority of the monochromes and the underglaze black wares which Beyer (1947, p. 251) says are more often found associated with earlier Chinese wares than are the blue and white. Those belonging to the second group are almost exclusively blue and white and are uncovered in Indonesia and the Philippines in association with Chinese wares believed to be fifteenth- and sixteenth-century, and with Thai Sawankhalok wares. None of the third group, which seems to consist exclusively of blue and white wares, has been located in any reported excavations.

The most abundant late thirteenth- or fourteenth-century wares are those decorated in underglaze black, followed by the green-glazed. The brown-glazed wares include only bowls with an everted rim and brown exterior, with a cream-glazed interior (#28–9, Pl. 9), one of which is the uppermost on a fused waster-stack of green-glazed bowls in the Huet collection at the Musées Royaux. Attached to the stack is a hand-written note identifying it as fourteenth-century. White monochromes were also exported, but they differ both in shape and glaze from earlier examples. The glaze is usually matt rather than lustrous as on the earlier wares, and the most common shape is a previously unknown flat-bottomed jarlet.

New shapes of the fourteenth century include small cup-like bowls, dishes of various sizes, oval-shaped covered boxes, flat-based jarlets, and occasional small gourd-shaped ewers and bottles (see Fig. 5). Many pieces have carved foot rings, sometimes straight and tall, sometimes very wide and shallow (see Colour Pl. D, 1b), but most often short and with an inside bevel. The body of the wares is still distinctively Vietnamese: finely levigated, slightly porous and generally whitish or, less often, pale grey. The underglaze black designs are relatively limited (Fig. 6), the most ubiquitous being a feathery flower blossom, probably a peony, usually encircled and sometimes with three stems. Other designs include lotus

Ht. 11 cms

Fig. 5 Vietnamese Fourteenth-Century
Underglaze Black Ewer

panels and bands of a summary classic scroll. On some examples of these wares, especially where the glaze is thin, the underglaze black acquires olive tones.

The chocolate base, first introduced among the late Thanh-hoa wares, becomes common in the fourteenth century, although there seem to be no criteria by which to predict its presence or absence; it consists of a brown slip that can be applied either to flat-based vessels or those with carved foot rings. On fifteenth- and sixteenth-century wares where the spirals of the brush stroke are often clear, as Adrian Joseph has noted (1973, p. 138), they most often unwind from the centre in an anti-clockwise direction—the opposite from the glaze marks on the bases of Chinese wares. On fourteenth-century wares the slip is generally too dark to tell the direction of the strokes. The direction, Joseph explains, indicates that the Vietnamese potter's wheel turned in an opposite direction from that of the Chinese. D'Argencé (1958) has conjectured that the slip may have designated wares reserved for temple use, but it is as common on exported wares as on those recovered in Vietnam, and pieces of similar quality may or may not have the slip. Perhaps it was added only at the potters' whim or as a kind of counting device.

THE INTRODUCTION OF BLUE AND WHITE

The turning point in the development of Vietnamese ceramics in the fifteenth century must undoubtedly be the result of the Ming invasion of the country in 1407 and its occupation by the Chinese until 1428. Once again the country was exposed to the full impact of Chinese civilization and probably, also, to the immigration of Chinese potters. The debt that Vietnamese blue and white wares of the fifteenth and sixteenth centuries owe to fourteenth-century Chinese blue and white is evident at a glance (see Pope, 1952 and 1956). Moreover, the seven voyages of Chêng Ho between 1405 and 1433 (Mills, 1970), in addition to the es-·tablishment of a Chinese Bureau of Trading Junks in Tonkin soon after the invasion (Chang, 1969, p. 29), indicate a renewed Chinese interest in trading in the South Seas. Consequently the wares traded from Vietnam after the beginning of the fifteenth century are much more abundant abroad than those of the earlier period. They comprise, probably exclusively by the mid-fifteenth century, blue and white with and without overglaze enamels. With the introduction of cobalt for underglaze blue decoration, the underglaze black and monochrome wares began to disappear.

Whether or not the Vietnamese potters used cobalt for underglaze decoration before the Chinese occupation is unknown, but at first its inclusion in their repertoire is subtle. Initially it begins to replace the underglaze black in decorations and on shapes that remain unchanged from those assigned above to the fourteenth century; these transition pieces probably belong to the first quarter of the fifteenth century (#31–2, Pl. 10). Sometimes the blue even occurs on the same piece along with the underglaze black,[12] thus providing evidence that some underglaze black wares were still being made alongside the first underglaze blue.

The remaining blue and white wares, however, mark an almost total break with the past. There is a profusion of Chinese-inspired shapes and a whole array of new decorative motifs and arrangements. The spur marks

Fig. 6 Fourteenth-Century Underglaze Black Decorative Motifs

and unglazed stacking rings of earlier wares practically disappear; the very wide, shallow foot rings typical of many fourteenth-century wares are no longer seen; and nearly all the former shapes are changed or discarded. It is with these blue and white wares that the potters of Vietnam reached the pinnacle of their craft.

The best of the blue and white wares were probably all produced about the mid-fifteenth century, the date of the inscribed bottle at the Topkapu Sarayi Museum in Istanbul (Colour Pl. E) to which most of the finest pieces are analogous. However, even at the beginning of the sixteenth century the wares were still held in high repute. Tomé Pires, indeed, says of Tonkin in his *Suma Oriental* (1944, I, p. 115), written between 1512 and 1515 at Malacca, that 'they have porcelain and pottery—some of great value—and these go from there to China to be sold'.

Although they developed their own distinctive variants of shapes and designs, the potters of Vietnam, once exposed to the fourteenth-century Chinese blue and white styles, did not strongly assert themselves again. Shapes and decorative motifs that must have been absorbed by the middle of the fifteenth century remain essentially unchanged probably until the seventeenth century. Yet the Vietnamese wares are rarely slavish copies of the Chinese. While patterns such as the lotus scroll, the trailing vine with peony, and the fish in ell-grass were borrowed from Chinese ceramic decoration (see Pope, 1952), they are never exact duplicates (see Figs. 7–8). The placement of the decoration also differs. The peony with leaves that is popular on the centre medallion of large Vietnamese plates (e.g. #51, Pl. 14) usually occupies a horizontal register on Chinese vases. Likewise the classic scroll on the mouth rims of Vietnamese plates is seen elsewhere on comparable Chinese wares on which a diaper border most commonly embellishes the mouth rim.

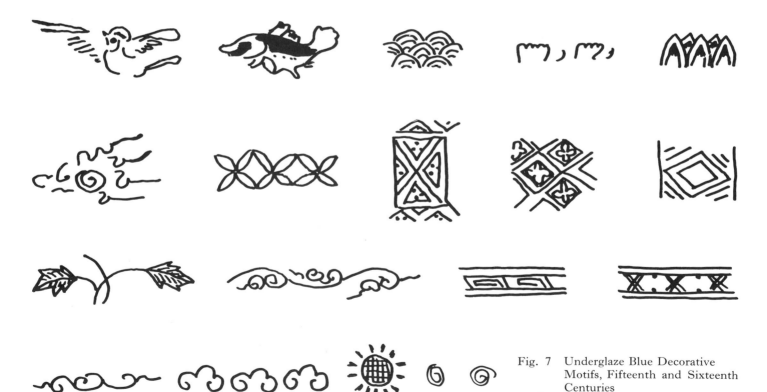

Fig. 7 Underglaze Blue Decorative Motifs, Fifteenth and Sixteenth Centuries

The Vietnamese shapes, in seemingly endless variations (see Colour Pls. D and E, and #31–54, Pls. 10-15), include bottles, jars, dishes, plates, bowls, covered boxes, kendi, jarlets, zoomorphic water droppers, and miniatures. The addition of overglaze red and green and sometimes yellow enamels appears to have been optional on any of them and to have been practised throughout most of the fifteenth and sixteenth centuries; one exceptional piece illustrated on Colour Plate D, 5 has only enamels. The body remains unchanged from that of earlier wares, although it is sometimes fired to porcellaneous hardness. Bases are occasionally covered with a thin transparent glaze, and with a chocolate slip on perhaps a third of the pieces. Foot rings are often bevelled on the interior, although they can be either tall, thin, and straight (Colour Pl. D, 4); short and squared; or short and rounded. Flat bases are rare. The unglazed raised outer edges on the mouth rims of the large plates suggest that these were either stacked upside-down on ridges in saggars or piled face-to-face and base-to-base in a similar manner to the Sankampaeng wares to be discussed in Chapter 5 (see Fig. 19). The remainder of the wares were probably fired upright on their foot rings, the bottom of which are unglazed.

Unfortunately, because of the internal homogeneity of the wares and the scarcity of archaeological data, it is extremely difficult at present to place them in a convincing chronological order. But it is likely that they begin towards the end of the first quarter of the fifteenth century and probably extend to at least the end of the sixteenth. H. Otley Beyer claims to have excavated them alongside fifteenth-century Chinese wares; the underglaze black, he says, are found in earlier contexts. At the Calatagan excavation in the Philippines (Fox, 1959) the blue and white were discovered with Chinese wares that dated to the fifteenth and sixteenth centuries.[13]

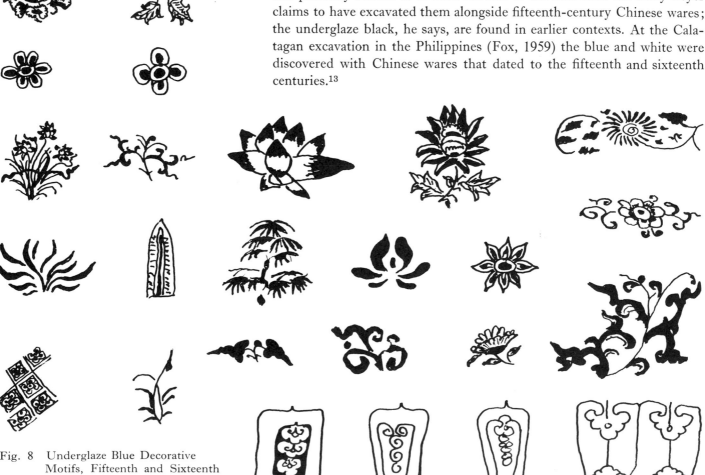

Fig. 8 Underglaze Blue Decorative Motifs, Fifteenth and Sixteenth Centuries

One attempt at dating the wares more precisely has involved X-ray fluorescence spectrometry tests at the Oxford Research Laboratory for Archaeology in which the manganese content of the cobalt pigment was determined. Earlier examinations of Chinese blue and white have shown that pieces made before the Hsüan-tê reign (1426–1435) used only imported cobalt, which had a low manganese content, and pieces beginning with that reign either had native ore (which has a high manganese content) or native mixed with imported (Garner, 1956). The results for the Vietnamese examples (Joseph, 1973, p. 137) showed that those decorated with fine linear brush strokes in a pale or bright clear blue used Middle Eastern type ore, while those with wash-type brushwork and a darker or blackish-blue employed the type native to China.[14] Thus if one assumes the Vietnamese used the same cobalt sources as the Chinese, then those examples with dark or blackish-blue wash (e.g. #38, Pl. 11) must be dated no earlier than the second quarter of the fifteenth century. Those pieces that use Middle Eastern cobalt could be either earlier, before the inclusion of local or Chinese ore, or later, when the imported variety, which was superior, was probably conserved for the finer pieces such as #40, Pl. 12. As far as this author can recall, all the early transitional underglaze blue studied during the writing of this work were, in fact, decorated with the type of blue which Joseph describes as being the result of using Middle Eastern ore, a characteristic that could be evidence for dating these pieces before the second quarter of the fifteenth century. Joseph also says that some Vietnamese pieces examined employed both types of ore separately on the same vessel.[15]

A far more important landmark in the study and dating of Vietnamese blue and white is a bottle in the Topkapu Sarayi Museum, Istanbul, (Colour Pl. E), the existence of which was first reported by R.L. Hobson (1933–4). It carries on its shoulders Chinese characters giving a date corresponding to A.D. 1450.[16] Although he did not publish the characters with his remarks on the vessel, he gave the translation as 'Painted for pleasure by Chuang a workman of Nan T'se-chou in the 8th year of Ta Ho'. Ta Ho, a variant of T'ai Ho, was a Vietnamese reign period extending from 1443 to 1454. The characters, which provide some interesting information, are as follows: 大和八年南策州匠人裴氏戲筆.

On re-examination the name character, the tenth in the inscription, has been found to be P'ei rather than Chuang.[17] The character that follows it is a classifier that in Chinese means merely 'person', with no sex distinction. When translated into Vietnamese, however, the classifier is 'Thi', which can only be applied to a woman.[18] This means that at least one skilled woman was involved in the potting industry in Vietnam. Furthermore, the characters for the place name (the fifth, sixth, and seventh), which become 'Nam Sach Phu' in Vietnamese, appear on fifteenth-century maps of Tonkin—in Hai Du'o'ng province, mid-way between Hanoi and Haiphong.[19] The district ('phu' is district) also appears on modern maps with the name unchanged; here the remains of ancient kilns could perhaps be located.

A dish, with decorative elements similar to the Topkapu bottle, in the Ardebil Shrine (Pope, 1956, Pl. 57) and nearly identical to #51, Pl. 14 illustrated here, must have entered that collection some time between 1350 and 1610, the years between which it was amassed. Dr. Pope reckons

it also to be mid-fifteenth century on the basis of a shared decorative style characterized by fine line drawing, outline and wash technique, and veined leaves. If it were not for the dated inscription on the Topkapu Sarayi bottle, these two pieces, based on knowledge of fourteenth century Chinese wares, might also be mistaken for fourteenth century. The mathematical placement of their decoration, in horizontal bands on the bottle and in concentric circles on the plate, as well as the motifs used, would justify this.

Elsewhere Vietnamese blue and white wares or sherds have been collected from the site of the former capital of Majapahit on Java, a site said to have been occupied between 1292 and 1500. Some samples of them are on display at the Museum Pusat in Jakarta. Numerous sherds, especially of covered boxes, have been found among the ruins of the Thai kingdom of Sukhothai,[20] and a small bottle with a tall tubular neck, reportedly from there, can be seen at the British Museum (Jenyns, 1935, Pl. 38A). In the collection of the Tokugawa Museum, Nagoya, there is a large cup or bowl with a tall carved foot and overglaze enamels that is said to have been in Japan since the end of the sixteenth century (Koyama and Figgess, 1961, Pl. 150). Sherds have also been gathered at Fostat, the former site of the city of Cairo in Egypt; one of these is included in the collection of the Percival David Foundation. Finds of the wares at excavations at Kampong Pareko, Sulawesi, and at Calatagan in the Philippines have already been mentioned.

THE SEVENTEENTH AND EIGHTEENTH CENTURIES

During the seventeenth century the Dutch became, at least among the European nations, the most important purveyors of Oriental pottery and porcelain in the Far East. Besides their headquarters at Batavia (Jakarta), the Dutch East India Company had offices in Japan, Cochin-China (southern Vietnam), Cambodia, Siam (Thailand), the Malay Peninsula and Burma. They also established an office in Tonkin in 1640, but no mention of Vietnamese ceramics enters the Company records, as assembled by T. Volker (1954), until 1663 when 'a junk from Tongking [sic] arrives [at Batavia] with 10,000 coarse porcelain bowls' (Volker, p. 206). The entry indicates two things: such a large initial shipment implies the pre-existence of a substantial ceramic centre in Tonkin, and since no mention is made of it as a Company venture, the Vietnamese must have been capable of shipping pottery on native craft.

The first reference in the Company records concerning the trade of Vietnamese wares appears in August 1672 when a Company vessel sailed from Batavia to Arakan (the western coast of Burma facing the Bay of Bengal) with a shipment of Tonkinese cups. Subsequent references to large amounts of 'coarse porcelain' from Tonkin occur in 1669, 1670, and 1672. Prior to these exports, Tonkin is listed as an importer of Chinese porcelain in the Company registers. In 1665, for instance, it was noted that Company trade with Tonkin had been poor for the year, one of the reasons being that six Chinese junks, a junk from Manila, and a navet from Macao had carried porcelain there.

The reason for the inauguration of Dutch trade in Tonkinese pottery, Volker explains (p. 193), was the scarcity of fine Chinese wares during

the troubled transition from the Ming to Ch'ing dynasties and the destruction wrought by the rebel Wu San-kuei at Ching-tê-chên, the southern Chinese potting centre, between 1673 and 1681. In a footnote (p. 184) Volker describes the Tonkinese wares as varying between porcellaneous stoneware and a rather fine porcelain with underglaze decoration in blue and suitable for daily use. As examples of this supposed seventeenth-century ware, he illustrates two pieces found in Sulawesi and now in the National Museum for Ethnology, Leiden; both are recognizable fifteenth to sixteenth century types, similar to wares described above as belonging to those centuries.

On the basis of a group of ceramics in the Saigon National Museum identified there as Bat-trang ware and attributed to the seventeenth and eighteenth centuries (Colour Pl. F) and in view of the evidence outlined above for the identification of wares belonging to the two previous centuries, Volker's hypothesis that these types of Vietnamese blue and white are later than the fifteenth and sixteenth centuries must be corrected. For there is a distinct group of ceramics in Indonesia, seen in shops and private collections by the author, that can be correlated with the Saigon Museum group.[21] It comprises dishes, bowls, bottles, vases and jarlets decorated in a medium blue wash under a crackled greying glaze (Colour Pl. F and 55–7, Pl. 16). They may have either a flat unglazed base or, more commonly, a thick, rounded foot ring and a glazed base. The most common decorative motif is a peony and vine spray. The group is less numerous in Indonesia than the earlier wares and none have been excavated in association with them. According to what ceramic sellers in Macassar have told the author, for example, the few pieces there have come from old private collections rather than from burial sites; none have come from documented excavations. In this respect it is significant that the Muslim religion, which discourages the practice of the burial of goods, was introduced to Sulawesi in 1605 (Vlekke, 1965, p. 106). Few, if any, ceramics belonging to the years following the conversion have been uncovered among the often extensive burial caches on the island.

DOMESTIC CULT WARES

In 1903 L'École Française d'Extrême-Orient acquired a group of 15 ceramic altar vases and censers. One pair of the vases, measuring almost a metre in height, carries an inscription giving a date equivalent to A.D. 1575 and also the names of donors, a prince and his wife who was a sister of the ruling emperor. The vases are sparsely decorated in a pale hue underglaze blue of the supposed imported variety with cloud patterns. Among the clouds, curled around the body of the vases, is a long, sinuous, appliqué dragon. The dragon, along with other appliqué decorations on the vessel, is carved or moulded, whitish in colour, and unglazed. Another censer in the group is dated 1665.

Mr. G. Dumoutier (1903, pp. 265–6), who purchased the relics from temples in the villages of Cao-xa and Hoa-ma, believed that the wares were fabricated at Bat-trang, which had been for several centuries a ceramic centre for pottery, glazed and unglazed, made with a particularly fine quality clay. Because of the rarity of similar pieces, Dumoutier guessed that the production was specialized and confined to the Vietnamese Mac

Dynasty (c. 1527–1677). Generally large, heavily potted, ornate, and with moulded or carved appliqué decorations, some of the wares collected by Dumoutier were decorated in a pale hue, runny underglaze blue, and others with brownish and amber slip coverings and a transparent slightly greenish glaze (e.g. Colour Pl. G, 3). Unlike the exported ceramics of the sixteenth and seventeenth centuries, which appear devoid of inspiration, these domestic cult examples reveal the continued mastery of the Vietnamese potter.

A few similar altar vases are included in the Huet collection in Brussels (Huet, January–February, 1942, Figs. 12-14), and an especially beautiful underglaze blue decorated censer, said to have been brought to Japan in the late sixteenth or early seventeenth century, is in the Tokugawa Museum, Nagoya (Koyama and Figgess, 1951, Pl. 156). Comparable objects may well have been among the censers sent as gifts to the Manchus of China when Vietnam submitted to their tributary system in 1662 (Deveria, 1880, p. 6).

Another group of domestic cult wares was that produced at Tho-ha, 4 kilometres north-west of Bac-ninh, north of Hanoi. The potters there, who in modern times make only domestic pottery and ceramic coffins, trace the establishment of their kilns to 1465 when, they say, their ancestors moved from Dau-khe, Hai-du'o'ng Province, a village that can no longer be identified (Huet, January–February, 1942). In the sixteenth and

2. Northern Vietnam

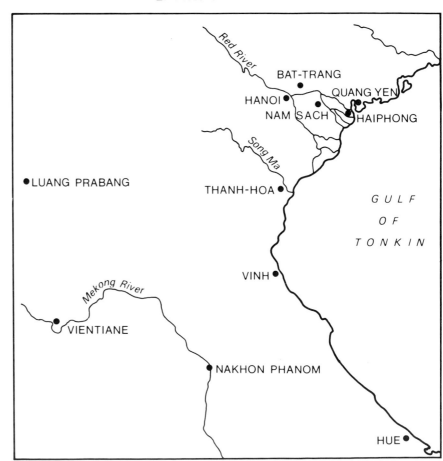

seventeenth centuries the Tho-ha kilns were noted for their dark-bodied unglazed cult wares, primarily ornate, somewhat gaudy, censers (#58, Pl. 17).

A further group of domestic wares is the three-colour (Patkó and Rév, Pls. 38–9), attributed by the Musée Historique, Hanoi, to the fifteenth and sixteenth centuries. They are white-glazed with green and usually red enamels (Colour Pl. G, 2), and like the cult wares collected by Dumoutier, they are ornately covered with carved or moulded appliqué rosettes or other small motifs. The group also includes less ornate lime pots (Colour Pl. G, 1) of a type distinctive to Vietnam (Huet, 1941).

THE MODERN PERIOD

Vietnamese wares beyond the eighteenth century are so far undefined, though the Bat-trang kilns, at least, have operated continuously at least from the sixteenth century. The *Guide Madrolle* (1925) reports a still sizeable ceramic industry there in the 1920s, and the North Vietnamese trade representative at Singapore has assured the writer that production has not yet ceased. During the nineteenth century, however, the court at Hué, where a new capital was established in 1802, had special sets of ceramic ware made to order in China (#59–60, Pl. 17).[22] Popularly called 'Bleu de Hué', they consist of delicate tea sets, and small dishes with landscapes often accompanied by short poems in Vietnamese 'chu nom' characters said to have been composed by Nguyen Du (1765–1820), a famous Vietnamese poet who was also the author of the national verse-novel of Vietnam, the *Kim Van Kieu.*

More recently, at the beginning of the present century, a group of Chinese potters from Fukien moved to Indo-China. A few families settled in Cambodia, at Kompong Cham, and others in southern Vietnam at Lai Thieu, 11 kilometres north of Saigon. Those who had opened kilns in Cambodia closed them in about 1945 and moved to southern Vietnam as well. The earliest wares of both groups of kilns consisted of utilitarian dishes and rice bowls, most of them characterized by a fish in underglaze blue on the interior bottom akin to those modern Fukien wares that can be bought in the Chinese emporiums of Singapore and Hong Kong today. The fish is still a popular design of the Lai Thieu wares, but is now often accented with the addition of red and green enamels. Besides table ware, other present-day productions include large enamelled elephants, garden pots, and vases, along with undulating nagas for the roof crests of Buddhist temples.

1. As has been noted by William Willetts (1971, p. 11), only about a third of Okuda's illustrations are, in fact, Vietnamese; the remainder appear to be southern Chinese.

2. Small items of information on the excavations, on Pajot, and on Huet have been gathered from a footnote in Janse (I, 1947, p. xxxiii), a footnote in Pope (1956, p. 104), a file in the archives of the Musées Royaux D'Art et D'Histoire made available to the writer through the kindness of Madame J.P. Schotsmans, some of Pajot's letters to the École Française which are on file at the Saigon National Museum, and a short introduction by Jean Capart to the first of three articles written by Huet for the *BMRAH* (Huet, 1941).

3. See, for instance, Laufer (1909), Gray (1953), and *The Charles B. Hoyt Collection* (1952).

4. See Janse, *Illustrated London News* (28 December 1935), Fig. 4; *Arch. Research,* III (1958), Pls. 76 and 78; and 'Rapport Preliminaire' (1936), Pl. XVc.

5. A place unidentified by Khôi, but perhaps a kingdom on the Malay Peninsula called 'Lo-cac' which Marco Polo visited at the end of the thirteenth century (Yule, II, 1929, pp. 276–80).

6. One is documented in *Arch. Research,* III, 1958, pp. 101–2; the other in 'Rapport Preliminaire', X, 1 (1939), p. 46.

7. One included a white-glazed conical bowl with a foot; a copper green bowl with embossed decoration similar to #15, Pl. 4 illustrated here; two cream-glazed bowls with everted mouth rims and tall, carved foot rings; one brown-glazed jarlet; one cream-glazed jarlet with moulded lotus petals in a collar at the mouth; three cream-glazed wine pots similar to #10, right, illustrated here; and a cosmetic tray similar to #12, Pl. 3. See *Arch. Research,* III, Pls. 80–2, and pp. 101–2. The other tomb was at Nong-cong, Thanh-hoa Province ('Rapport Preliminaire', X, 1, p. 46, Fig. 5). At both sites the objects were set in a row, and mostly upside-down–a practice also observed in the Philippines (Fox, 1959).

8. For further illustrations of the ware, see B. Groslier (1966, Pl. 86–8) who gives, without argument, the dates as tenth to eleventh centuries; Goloubew (1931–2, Pl. XXXVII, 16–19); also Hejzlar (1973, Pl. 72–5), and Patkó and Rév (1967, Pls. 32–4), both of whom use examples from the Musée Historique, Hanoi.

9. One striking example is a Tz'u Chou-type bottle dated to the Liao Dynasty (916–1124) which is decorated with a flower and stubby-leaf vine almost identical to that on Fig. 3. See Koyama (1962–3), Pl. 8b.

10. One human figure, Goloubew (1931–2, Pl. XXXVII) has suggested, is a native of Vietnam carrying a bow (see, here, Fig. 2); and the long-tailed bird (Fig. 2), probably the most common animal depicted, may represent the ocellated pheasant (*Rheinartia ocellata*), a bird native to Vietnam that the Vietnamese believe (White and Garrett, p. 471) is the original model for the Chinese mythical phoenix, a symbol of the South.

11. At Calatagan (Fox, 1959), for instance, only nine out of 510 ceramics dis-interred were identified by Beyer as Vietnamese; the percentage at Kampong Pareko (see Introduction) seems to have been similarly small.

12. One example is a dish in the University of Singapore Art Museum Collection bought by William Willetts in the Philippines, which has a central decoration of a feathery flower in underglaze blue encircled by an underglaze black ring. Another example is included in the Lammers' Collection at the Museum of Asian Art, University of Malaya.

13. Although Fox dated Calatagan to the fifteenth century in his preliminary report (1959), he later expressed the opinion (Locsin, 1967, p. 105) that the site included wares belonging to at least the first half of the sixteenth century, an opinion held by other Orientalists as well (e.g. Watt, 1971).

14. Adrian Joseph has informed the writer that when he submitted the Viet-namese wares for the spectrometry examination he also asked that they be tested by thermoluminescence, but it was discovered that they did not respond to that method of dating.

15. Some of these colour differences, however, may have been caused by the kiln atmosphere. On several large plates in the Jakarta Museum, for example, the colour described by Joseph as being the result of native ore decorates the interior while the imported variety is seen on the relatively unimportant exterior. Yet on other pieces both types can be seen on the interior.

16. Chinese and Chinese-based Vietnamese *chu nom* characters were used exclusively to transcribe the Vietnamese language at least until the seventeenth century when Alexandre de Rhodes introduced the Western alphabet, and continued to be used for scholarly and artistic works even until the beginning of the twentieth century.

17. The inscription was kindly translated for the writer by Professor D.C. Lau of the School of Oriental and African Studies, University of London, from photographs of the characters supplied by the Topkapu Sarayi Museum.

18. The Chinese characters were translated into Vietnamese with the aid of dictionary by John Harding, director of the B.B.C. Vietnamese language programmes, London.

19. See Bu'u Can *et al.* (1962), pp. 32, 194 and 211. For this reference the writer owes thanks to Dr. Ralph Smith, University of London.

20. The sherds were seen by the author among bushels of collected sherds in storage at the Old Sukhothai museum.

21. Although the writer has been unable to re-examine the Philippine collections since isolating this group, she can find no illustrations nor can she recall seeing any examples there. The Dutch had no trading posts in the Philippines, but the wares should have been able to reach the islands by native craft.

22. See Vu'ô'ng hong Sên (1944) for a further description of the wares. Corroborating evidence for their having been made in China was supplied by a friend of the writer's who reported seeing some examples on exhibit in a museum at Canton which were described as ware made in China for the Vietnamese court at Hué.

[2]

THE GO-SANH KILNS

LIKE the Thai words 'Tao-Hai' (literally, 'jar fields'), which have led to the discovery of at least one probable former kiln site in northern Thailand after an examination of the environs of a village of that name, 'Go-Sanh', which can be translated as 'pottery mounds', as the name of a village in central Vietnam has led to the discovery of a probable kiln site there. The village is located some 10 kilometres north-west along the road to Pleiku from Qui Nhon, a coastal city in Binh Dinh Province. Encouraged in their search by a Saigon antiquary, the inhabitants of the village during the first months of 1974 came upon the evidence of a former kiln site: kiln supports, saggars, great quantities of sherds, and kiln wasters. The Saigon National Museum authorities learned of the find, but due to lack of money and mobility they have as yet been unable to visit the site. No actual kilns have been reported.[1]

Because of their location, it is thought that the kilns belonged to Champa, a kingdom which, according to Chinese records, was founded in A.D. 192 in the region of Hué. It occupied the central Vietnamese coast from south of Thanh-hóa to the northern borders of the Khmer Mekong Delta region, and it enjoyed the position of port-of-call on the Middle Eastern-China sea trade route from at least the eighth century (see Ferrand, 1913–14). Its people had a reputation of being able seamen and pirates who often pillaged Vietnamese coastal villages to their north. But under the repeated assaults of their northern neighbour, the Cham kings witnessed the receding of their borders, and in the year 1000 were forced to move their capital south to Vijaya (Binh Dinh Province), forsaking their most northerly settlements. The capital then remained there, despite a short Vietnamese occupation in 1446, until the kingdom's final elimination by Vietnam in 1471 when it is reported that 60,000 Chams died and the Royal family, together with 30,000 prisoners, were carried into captivity.[2] Stylistically the ceramics of Go-Sanh do not extend beyond that final collapse of the kingdom.

Because the site has not been properly examined, it is not yet possible to give any estimate of the number of kilns or their construction plan. But since the sherds and wasters recovered are similar to a not uncommon class of wares found abroad, it must have been a site of some importance. So far the wares represented by sherds collected at the site fit into three categories: greenish or bluish-grey, probably copper-glazed wares; celadons; and brown-glazed. There has been no evidence so far of under-glaze decorated wares—all are monochromes and decoration is rare. Only the brown-glazed sometimes have incised or moulded appliqué motifs.

There are two clay types: the first, typifying some of the copper-glazed and celadon sherds, is greyish; the second, seen primarily on the brown-glazed, is orange to reddish-brown in colour and surprisingly light in weight. All the sherds are stoneware.

The most abundant sherds and wasters at the site represent small dishes with a greyish or sometimes reddish-brown or orange body, with carved and bevelled foot rings, and unglazed stacking rings on their interior bottoms. The glaze is watery, cloudy, slightly transparent, and varies considerably in shade from greenish to bluish-grey; it usually stops unevenly on the exterior about two-thirds of the way down from the mouth rim. Waster stacks of the dishes show that they were stacked one upon the other in the same manner as some of the northern Vietnamese wares discussed in Chapter 1. The glazed centre of the dishes, inside the unglazed ring, is often a shade greener or darker than the remainder of the dish—a reflection of the slightly differing kiln atmosphere on that portion of the dish. Dishes like these have been found abroad, both in the Philippines and Indonesia, where they have often been identified as Annamese and assigned to the late thirteenth, fourteenth and fifteenth centuries, and more recently, perhaps on a sunken ship of pottery in the Gulf of Siam along with Sawankhalok and Sukhothai pottery from the Thai kilns.[3] No other shapes in this glaze are represented by the collected sherds in Saigon.

Other types of wares represented by the sherds from the site are larger dishes with a glassy, translucent celadon glaze and spur marks around the interior bottom, and monochrome brown wares that have, like the copper-glazed, often been identified as Vietnamese.[4] The majority of the latter have the reddish, almost pumpkin orange body both on the exposed surface and in cross-section. Unlike the brown of Vietnamese ceramics, the glaze on the Go-Sanh pieces is normally a soft, golden or yellowish-brown, while on Vietnamese examples it is usually a dark, chocolate hue. Furthermore, the glaze on the Vietnamese wares carefully covers the whole exterior including the exterior of the foot ring of the pieces, while that on the Go-Sanh material stops some distance above the base. Because the celadon sherds in Saigon are so few in number, it is difficult to define their characteristics except to say that the celadon is brittle, translucent, glassy and medium green, a type of celadon glaze that is also characteristic of many celadon wares produced at Sawankhalok in Thailand.

The brown-glazed wares so far recovered represent the widest range of shapes, though such sherds are said to be found in smaller quantities at the site than those of the copper-glazed dishes. There are large wine or dragon jars that may have been made originally for the use of the hill tribes of the Vietnamese cordillera who still cherish such vessels, small jars, Vietnamese-style lime pots,[5] cups, pear-shaped bottles, flat-bottomed basins with heavy rounded mouth rims fluted rather like a pie crust, and small ewers (Colour Pl. H and #61–6, Pls. 18–19). Their general characteristics include a runny golden-brown glaze, often marred by air bubbles, that rarely reaches the base of the vessel, rounded mouth rims, and flat or shallowly carved bases that are never glazed. The large wine jars are sometimes decorated with indistinct scrolling motifs that are incised through the glaze rather than beneath it, or appliqué dragons whose necks sometimes form handles at the neck of the jar. On others there are appliqué

lug or epaulette-like handles. All have a thick neck slightly inclined towards a heavy rounded mouth rim.

Besides sherds and wasters, saggars and kiln supports have been uncovered in abundance at Go-Sanh. The saggars are constructed of a grainy, reddish-brown clay, and are cylindrical in shape. One in Saigon measures 25 cm in height and 23·5 cms in diameter; another is half that height. Because the wares of Go-Sanh share sufficient characteristics with the Vietnamese to suggest that they were begun by potters from the north, the finds of saggars are probably indicative that the potters of Tonkin, like many of the craftsmen of China, probably also fired their wares in these containers. None, in contrast, have ever been found at Thai or Khmer kiln sites. The kiln supports recovered from Go-Sanh are disc-shaped, though not solid like those found at the Sukhothai and Sawankhalok sites in Thailand. Instead they are made with a small coil of clay, the ends of which are connected to form a circle; the top surface of the coil is flattened, and from the bottom protrude several appliqué feet; the centre is empty.

The spur marks that would have been left by such supports are especially common on Vietnamese wares dating from the thirteenth and fourteenth centuries, after which they are rare. These are the centuries, too, during which unglazed stacking rings like those on the copper-glazed Go-Sanh dishes make their appearance on Vietnamese bowls and dishes. It is these similarities, along with shape and potting resemblances such as potting marks on the base of dishes that unwind in a counter-clockwise direction, that make it possible to theorize that the glazed ceramic art[6] was introduced to Champa from Vietnam in the late thirteenth or fourteenth centuries. One potiche-like jar, by all appearances from the Go-Sanh kilns, was excavated at Santa Ana in the Philippines from a grave that was estimated to belong to the thirteenth or the beginning of the fourteenth century.[7] Another published example found in the Philippines and probably from Go-Sanh is a wine or dragon jar in the Locsin collection, reportedly found at Puerto Galera, and given an approximate fourteenth to fifteenth century dating (Locsin, 1967, Pl. 110).

The fifteenth century, indeed, probably marked the end of the Cham ceramic industry. Because no sign of underglaze decorated wares has been found at Go-Sanh, it is doubtful whether the kilns' production extended beyond the 1471 conquest. Once Champa was incorporated into the Vietnamese empire, underglaze decorated wares, particularly in blue, then popular in Tonkin and exported abroad, would surely have been introduced at the Cham kilns had they continued operating.

1. Because the writer was unfortunately unable to visit the site, this chapter is based on the collection and information of Ha duc Can, who has visited the site, and on a small collection of sherds and wasters in the Saigon National Museum.

2. Coedès (1968), p. 239. For more history on the Cham kingdom, see Maspero (1928), Coedès (1966 and 1968), and Hall (1968).

3. Brown (1975). Some 1,000 dishes similar to those found at Go-Sanh were found aboard a sunken ship off the coast of southern Thailand, but without a side-by-side comparison certain identification is difficult. There is evidence that similar dishes were also made in southern China. Judging by the probable

dates of Sawankhalok and Sukhothai pottery, both of which were also found on the ship, the vessel probably sank in the late fourteenth century.

4. They are so catalogued by Willetts (1971), and tentatively so by Lammers and Ridho (1974). Another set of wares identified by Willetts in the same catalogue as Annamese, but which have some of the characteristics of the Cham, are the enamel on biscuit. One example illustrated here (#66, Pl. 19) has the typical Go-Sanh-type golden-brown glaze, rounded mouth rim, and lug handles combined with the tomato red enamel on biscuit. Further research may well prove it to be of Cham origin.

5. The lime pots are oval-shaped and small, averaging 9 to 13 cms in height, and have a foot and either a small curled twig-like or zoomorphic mythical *chih* dragon handle. Such shapes have usually been assigned to the thirteenth and fourteenth centuries, see Huet (1941).

6. This statement is qualified with the word 'glazed' because the Chams did decorate their temples with unglazed sculptural ornaments, usually of an orange-coloured lightly fired clay, and these, as yet not conclusively dated, may be earlier than the glazed pottery.

7. The jar, brown-glazed and with a rounded mouth rim and four appliqué lug handles typical of the Go-Sanh brown monochromes, is illustrated in Locsin (1967), Pl. 93 along with the remainder of the contents of Grave #25; the jar occupies the upper right-hand corner of the photograph. The burial included Chinese celadons and monochromes along with an eleventh-century Chinese coin.

[3]

KHMER WARES

RISING abruptly from the vast surrounding plain about 40 kilometres north-east of Angkor and seen through a blue haze from afar is the sandstone hill-plateau of Phnom Kulen. Well-wooded, the plateau has an average height of 600 metres; it is approximately 8 to 10 by 20 kilometres in area. It is there that Jayavarman II in A.D. 802 arranged for the performance of the Brahmin ceremonies initiating the cult of the *deva-râja,* an event that marked the consolidation and independence of the kingdom of Kambuja and ushered in the Angkorian Era (Coedès, 1968, p. 99), and it is there also that the first known and probably the earliest Khmer kilns producing glazed pottery appear to be located.[2]

Although there has been no excavation of the site, the litter of sherds and kiln wasters is a highly promising sign of a former ceramic manufacturing centre. Cracking, slumping and breakages are the perennial mishaps of all ceramic kilns. Since such pieces are commercially valueless, they are usually cast aside after the emptying of the kiln; thus are accumulated the heaps of ceramic rubble that invariably accompany the finds of old kilns. This debris on Phnom Kulen is thickly scattered along a 4-kilometre stretch of dyke, 2 kilometres south-west of the plateau village of Anlong Thom, which forms a small lake that was perhaps constructed as a source of water for the potters. Etienne Aymonier, who visited the site in 1883, described the place, called Sampou Thleai (sometimes, Thnal Mrech) by the local people, as devoid of trees but covered with high bushes. Along the dyke he saw sherds of pale and yellowish-green bowls, covers, heavy tiles, and architectural ornaments. Parmentier, a later visitor, noted the presence of bottles and other simple vessels with and without covers.

According to the legends gathered early this century by Victor Goloubew from the local inhabitants who avoided the area,[3] the founders of the Kulen kilns were the industrious occupants of a Chinese junk that was cast against the slopes of the plateau in a violent storm—a mishap that is supposed to account for the name of the place, Sampou Thleai, literally 'smashed junk'. These Chinese, it is said, were also the first cultivators of a special fruit that bears the same name as the plateau: 'kulen'. The appellation is often translated as lichee, a highly prized fruit native to

the south-eastern coast of China, but modern botanists, Bernard Groslier has told the writer, say that although akin to the lichee, the kulen is unique to Phnom Kulen. Consequently it is unlikely to have been imported from China, and even more improbable that there were ever such violent storms on the Tonlé Sap, the nearest body of water, that a junk could have been tossed as far inland as Phnom Kulen. Thus the literal truth of the romantic legends suffers, though the question of Chinese influence remains.

If the original potters were Chinese, their influence was fleeting, for apart from a few early Kulen shapes which do have a vague resemblance to T'ang Chinese ceramics, the highly architectonic Khmer wares are wholly distinctive. Chinese influence can perhaps be traced to some extent in the shape of the earliest Kulen covered boxes which are circular and flattened in shape with fluting on the cover, and in such pieces as the jardinière on Colour Plate I, 2. There may be Chinese prototypes, too, behind a series of bottles (e.g. Colour Pl. I, 1) that reflect a strong horizontal alignment seen in T'ang Chinese wares, but such shapes may just as easily have been derived from the Indian *amrita kalaśa,* or ambrosia flask, an attribute of some of the Indian deities. The Khmer civilization was, in general, strongly Indian- and Hindu-orientated.

Indeed, it is generally more rewarding to search for Indian influences on Khmer pottery shapes, both glazed and unglazed, than for Chinese. The most common of the surviving Kulen bottles (#68, Pl. 20 and Fig. 10a) can be traced almost directly to the Indian *purna ghata,* a vessel associated with fertility and abundance, that is widely depicted on Indian bas-reliefs from the first millenium B.C. until at least the Gupta period (sixth century).[4] Its Middle Eastern antecedent generally spouts streams of water, while the Indian version contains lotus blossoms.

The sculptors of the eighth to ninth century temple of Borobudur in Java adopted at least two varieties of the vessel for the bas-reliefs there: one is round-bottomed and set, filled with lotus blossoms, at the foot of the Buddha (Combaz, II, 1937, Pl. 120); the other, carved on a section of bas-relief from the temple in the Bangkok National Museum, is illustrated in Figure 9 (compare with Colour Pl. K, 1 and Fig. 12). Two additional renderings of the shape appear on two Khmer lintels in the Phnom Penh National Museum. Both belong to the late twelfth or early thirteenth centuries. One, depicting the Assault of Mara against the Buddha, has a footed *purna ghata* with a small spout; the other, which shows the Buddha calling the Earth as witness, has a similar vessel but with a goose neck-and-head spout rising from the shoulder. Identical ceramic examples that can also be dated to the late twelfth and early thirteenth centuries have been found in lower North-East Thailand.

The conch, which had its bronze counterparts at Angkor, is also an Indian-derived ceremonial object. On Indian sculptures it is often an attribute of Vishnu, and in its realistic ceramic form among the Khmer wares (#71, Pl. 21) can actually be blown to produce a strong low-toned bellow.

The Indians, however, had no knowledge of glaze technology and this must have come, at least indirectly, from China. Evidence of the intrusion of Chinese potters, George Groslier argues (1921, p. 9), is the fact that the modern Khmer language contains no single words, only roundabout phrases, to describe glazed ceramic processes and materials; and further,

Fig. 9 *Purna Ghata* Vessel, Bas-Relief from Borobudur

that glazed ceramic production is a lost art among the Khmer today. Glazed pottery in modern Cambodia has been made only by Vietnamese or Chinese people. The Khmers themselves produce only unglazed earthenware rice pots and other utilitarian wares that they fashion without the aid of a potter's wheel or even a turning table, though a pottery wheel is said to have been found at Phnom Kulen (Boisselier, 1966, p. 362). In addition contemporary Khmer wares are fired in clay pits rather than kilns.[5] However, from the available evidence, glazed pottery making seems to have ceased some 500 years ago; it is not inconceivable therefore that the accompanying technical language would have disappeared even though it may once have been known to ethnic Khmers.

A more compelling argument in support of outside participation is that it is difficult to advance the hypothesis that potters in the as yet not fully consolidated kingdom of Kambuja could have progressed in a mere hundred years from the unglazed earthenware that Groslier has encountered in the excavation of sites dating up to the eighth century to the comparatively fine green-glazed wares of the ninth without some borrowed knowledge of glaze technology. Other possible sources of the glazing craft than China itself were Vietnam, where glazed ceramic processes were known since the first century A.D., or perhaps Burma, where it is recorded in Chinese history that the early ninth century capital of the kingdom of P'iao, whose ruins lie six miles east of Prome, was surrounded by a wall made of green-glazed brick (Coedès, 1968, p. 104).

Apart from Phnom Kulen, no further discoveries of probable kiln sites have been reported within the borders of present-day Cambodia. Instead, attention has shifted to lower North-East Thailand, once an integral part of the Khmer empire, and for many years the source, noted as early as the 1920s by W.A. Graham (1922, pp. 5–6), of a great number of ancient Khmer wares on the Bangkok market. It is because it seems that there are more Khmer wares in Thailand than in Cambodia itself that Boisselier (1966, p. 368) has remarked that the brown-glazed Khmer ceramics may owe more to the art of Lopburi than to Angkor.

Excavations, in fact, have finally uncovered actual Khmer kilns near Ban Kruat, Biriram Province, quite near the present Cambodian border and very close to a former Angkorian highway leading to the Korat Plateau (see Finot, 1925). The site first seems to have been discovered about 1969–70 during forest clearing operations when a particularly large number of Khmer ceramics along with wasters began appearing in Bangkok,[6] and excavation by the Fine Arts Department commenced in late March 1975. At the present time no report on the excavation has been written, but according to information from the Department the kilns, two of which have so far been uncovered, are constructed of fired laterite rather than brick. One that was fairly intact had four chambers, 3 to 4 metres in diameter, that contained much charcoal ash. The other, which was completely destroyed, contained some 500 green-glazed bowls—an indication that the kilns may have been abandoned suddenly. Other sherds collected from the site represent practically the whole range of Khmer ceramics found in the North-East. Another possible site which has yet to be properly examined is near the village of Ban Sawai, 15 kilometres south-west of Surin.[7]

For several reasons the earliest probable date for the Ban Kruat kilns is

the mid-eleventh century. Brown-glazed wares, which are well-represented by the sherds at the site, begin to appear in excavations at Angkor only about the mid-eleventh century, and none of these are known to have been produced at Kulen. Moreover, it is about this time that the green-glazed wares at Angkor seem to show pronounced changes in shape. Enough of the wares at Ban Kruat, however, are so similar to those from Kulen that it is most likely that the kilns were built by potters from the earlier site. They were sent, undoubtedly, as part of the systematic expansion of rule over the North-East initiated by Angkor at the end of the tenth century. Although the Khmer first moved onto the Korat Plateau in the seventh century, their rule during the eighth to late tenth centuries was tenuous at best. Once a strong economic-political base had been established at Angkor, however, the Khmer again turned their eyes to the north. Taxable agricultural communities began to be firmly established as far north as the Mun River basin. Today these communities can be located by the presence of ancient temple ruins and small artificial lakes; and because of the lakes most of these old sites are still occupied today. Practically all the temples of the area were constructed in the eleventh century, though a few belong to the late tenth. For Khmer temples, ceramic architectural tiles and ornaments were needed, and this may have been the primary reason for the construction of the kilns in the region.

What effect the establishment of kilns on the Korat Plateau had on the kilns at Kulen is uncertain. Undoubtedly architectural ornaments were still required at Angkor and the Kulen kilns probably continued to produce these at least. The source of the brown-glazed pottery found at Angkor, however, is unknown. Since no brown-glazed discards or wasters have been discovered at Kulen or elsewhere in Cambodia, it seems likely that they came from North-East Thailand. The ceramic wares of Ban Kruat and those generally found in Thailand are considerably more varied than those found at Angkor. Part of the reason may be that the people there used pottery extensively in place of the metal containers used at Angkor. For instance, ceramic objects, rarely found at the temples of Angkor, are found in considerable numbers at the temples of the North-East.[8]

DATING

Although their existence has been known at least since the visit of Aymonier to Phnom Kulen in 1883, Khmer ceramics have remained one of the least documented of Oriental wares. The number of works that mention them at all is small, and most surveys of Far Eastern ceramics omit them altogether. Only George Groslier (1921, pp. 129–33) and A. Silice (with G. Groslier, 1921–3, pp. 31–63) have made any attempt at classification. A rudimentary classification, summarized by Boisselier (1966, pp. 361–72), includes brown-glazed Sawankhalok wares from the kingdom of Sukhothai. Mistaken identification of Khmer ceramics, indeed, has plagued all studies of them. When Beyer (1947 and 1960) and Van Orsoy de Flines (1949) speak of Khmer ceramics, their identifications are incorrect. There are no Khmer ceramics in the Jakarta museum, and only two examples, to the writer's knowledge, have ever been reportedly excavated in the Philippines.[9] What Beyer and others, for stylistic reasons, have

erroneously described as Khmer in the Philippines are the admittedly Khmer-influenced unglazed wares of Sukhothai and Sawankhalok origin (e.g. Colour Pl. R, 5). No similar examples are included in the Jakarta museum collection, where what de Flines describes as Khmer is a hodge-podge of pieces of as yet unidentified origin.

But while some efforts, however meagre, have been made towards identifying and classifying Khmer ceramics, none, apart from a vague 'Angkorian period' attribution, have been attempted as far as dating is concerned. Until there were proper excavations, such attempts were impossible, and because they are so unlike Chinese wares, no stylistic parallels could be constructed as with Vietnamese and Thai wares. The deficiency began to be remedied by Bernard Groslier, who in 1953 began the first excavations in search of the material culture of the ancient Khmer. Excavations at the Royal Palace (Groslier, 1957) and elsewhere in the Angkor area were conducted by him until 1969, after which work was discontinued owing to the outbreak of war.

The Groslier excavations, ten in number, were never specifically directed towards the dating of ceramics, though on the basis of sherd finds at dated levels, especially at the Royal Palace, and the unearthing of a burial ground at Sra Srang, he has been able to piece together at least a preliminary outline of Khmer types and chronology, a short version of which has already been published by Willetts (1971, p. 8). It can be summarized as follows.[10]

1. Kulen c. 879–?	pale green-glazed wares with whitish-buff paste
2. *Lie de vin* c. 900–1050	unglazed reddish-violet bodied wares
3. Baphuon c. 1050–1068	two-glaze wares (brown plus green); olive-glazed; green-glazed, and early brown-glazed
4. Jayavarman VI c. 1068–1110	two-glaze wares, green-glazed wares, brown-glazed, and olive-glazed
5. Angkor Wat c. 1110–1177	light caramel-brown and blackish glazed wares with incised and modelled decoration, often with the unglazed parts covered with brown slip; some two-glaze, green-glazed, and olive-glazed wares; abundance of small-size vessels
6. Bayon c. 1177–1350	heavily potted, large-size wares with thick, mostly blackish glaze

Although no excavations of sites later than the abandonment of Angkor in 1431 have been conducted, Groslier doubts that any glazed

wares except, perhaps, architectural ornaments were produced in the centuries following the move south. In fact he believes that glazed ceramic production had greatly diminished well before the mid-fifteenth century, for Angkor never fully recovered from the Thai invasions of 1350–1.[11] A specifically fourteenth-century group of Khmer wares has yet to be defined, and no likely fifteenth-century examples have been discovered in any of the country's Buddhist *wats* where such items have a tendency to collect, nor have any filtered into the antique shops of Phnom Penh or Bangkok. If one were to make a serious search for possible post-Angkorian wares, the sites of later capitals such as Lovek, which was devastated by the Thais in 1594, Oudong, or the site of Phnom Penh would necessarily have to be studied.

Circumstantial evidence in North-East Thailand also points to the demise of local ceramic production even before the fourteenth century. The great majority of examples found there correspond with sherd material that can be seen scattered in the dirt around nearly all the temples on the Plateau, most of which were built between A.D. 1000 and 1150 and dedicated to Hindu deities.[12] It is believed that all of these fell into disuse by the end of the thirteenth century following a decline in the power of Angkor and the widespread introduction of Hinayana Buddhism. In addition, the only Chinese wares with which the Khmer pottery of North-East Thailand is ever associated are white-glazed wares, almost exclusively in the shape of covered boxes. Many of these are similar to those unearthed at the late eleventh to early twelfth-century burial site of Sra Srang that will be discussed shortly. Chinese celadon or blue and white are never found alongside Khmer ceramics in the North-East.

Although the find of a kiln still filled with pottery at Ban Kruat implies a catastrophic end, the regrettable decline of indigenous glazed pottery may have been hastened less by political troubles than by the appearance on the market, at least at Angkor, of great numbers of inexpensive high-fired Chinese export wares. In his excavations of four strata at the Royal Palace, Groslier discovered an increasing percentage of Chinese wares in the later levels. By the fourteenth century 80 per cent of the ceramics excavated were of Chinese origin. (Thai ceramics begin to appear after 1350.) Further evidence of this Khmer appetite for things Chinese is contained in the late thirteenth-century account of Chou Ta-kuan, a Chinese emissary who visited Angkor in 1296:

This country [Cambodia] produces neither gold nor silver, so the things the people like most from China are gold and silver, and then silks. After these products come the pewter of Chen-chou, lacquer plates from Wen-chou, and the blue-green porcelains [celadons] of Ch'uan-chou. (Pelliot, 1951, p. 27.)

The technical superiority of the imported Chinese wares is indeed undeniable. The Chinese potters, with their better clays, glaze materials, and high temperature kilns were far ahead of the Khmer. That the Khmer never bothered to upgrade their potting industry and participate in the lively ceramic trade of the Sung, Yüan, and early Ming times (eleventh to fifteenth centuries) or even to satisfy the needs of their own people is puzzling. Even as late as the fourteenth century the Thai of Sukhothai were able to muster the required technology and gain a healthy stake in the trade. But perhaps in Angkorian times, as at present, potting was

essentially a dry season activity of the Khmer farmers (Biagini and Mourer, 1971, p. 199). Moreover, there is no evidence that the Khmer themselves possessed a commercial fleet, and it is unlikely that the Chinese would have lent their ships for the transport of Khmer pottery when they had their own wares to sell.

The body of the Khmer wares, although it may be finely levigated, is sandstone-based, of low quality, and normally coarse and grainy. Sometimes, especially among the large storage jars and the unglazed earthenwares, it seems to include crushed laterite or shell. There is no discernible visual difference between the exposed body of the Kulen wares and that of the green-glazed Ban Kruat; it is usually grey on the thickly potted pieces and whitish-buff or sand-coloured on the thinly potted. A cross-section of newly broken fragments of the thinly potted pieces, however, also shows a grey interior, which indicates that the pale colour may be due to soil leaching. Many of the Khmer ceramics display evidence of having been turned on a wheel, though only a turning table may have been used. All are coil-made, usually with the coils begun from the perimeter of a clay base disc. On the footed urns, where the coils were usually set on the top of the base disc, the coils have not been smoothed on the interior and can be clearly seen on broken pots. Indeed, coil ridges are pronounced on the interior of most vessels. Evidence of considerable ash in the Ban Kruat kilns, along with chemical analysis of the glaze, indicates that the pottery was fired in an oxidizing atmosphere at probably no more than about 1000 to 1100°C.

Because they were not used as articles of trade, Khmer wares today are rarely found outside the present or former Khmer dominions. Besides Cambodia itself and North-East Thailand, where the wares are most abundant, examples of the twelfth century have been discovered at Sukhothai, the former Khmer outpost in northern Thailand, among them several fine wine jars (see Fig. 14). In the shops of Ayudhya, a former mid-fourteenth to mid-eighteenth century capital of Thailand, there are usually on sale a number of miscellaneous Khmer pieces, primarily of the Bayon period, which the shopkeepers say have been retrieved from the river surrounding the island city along with great numbers of Chinese export wares. Elsewhere a number of late eleventh and twelfth-century wares have been found on the east coast of peninsular Thailand, a region which Chinese histories say Jayavarman VII subjugated in the twelfth century (Coedès, 1966, p. 90). A group of over a dozen large jars and footed urns is included in the museum of Wat Mahatat at Nakorn Sri Thammarat (Ligor), a locality visited by Marco Polo at the end of the thirteenth century when it was quiet and independent (Yule, II, 1929, p. 276). The vessels, accidentally unearthed by villagers or caught in nets along the shores by fishermen, were received as gifts by the *wat,* whose sanctity the populace believes will neutralize any bad spirits contained in the objects. There are reports of similar finds all along the coast from Chaiya as far south as Songkhla.[13]

THE KULEN WARES, *c.* 879–?

There are problems with this proposed outline of Khmer wares that will only be solved once the kiln sites are thoroughly investigated. First

of all, most of the categories are based on architectural periods into which the ceramic types do not always conveniently fit, rather than on a systematic review of the evolution of the wares of a single kiln site—the normal approach to the classification of ceramics. But so few wasters or sherds from the Kulen site are available for study that a full definition of the wares made there is not possible.[14] Furthermore some wares known to have been made there are identical to those found at Ban Kruat; unlike Ban Kruat, however, only green-glazed wares are known to have been produced at Phnom Kulen.

Most known wasters from Kulen correspond to types of wares found in the Groslier excavations of sites prior to 1050; green-glazed covered urns, wasters of which are said to be on the surface of the Kulen sherd heaps, do not, however, appear in excavations until after 1050, by which time they seem to have been made at Ban Kruat as well. In general the covered urns found at Angkor differ from those found in North-East Thailand by having a cover that is proportionally larger in relation to the body of the urn, by having somewhat conical or bulbous walls as opposed to the more cylindrical ones of Thailand, and by having a more distinct (though solid) and usually slightly splayed foot. Yet because the glaze, body, and potting are so similar, it is not possible to make a definite identification of the kiln source of any specific urn except to guess that those found at Angkor probably came from Kulen while most of those in Thailand probably came from Ban Kruat. (See #72 and #73, Pl. 21.)

Bowls, wasters of which have been reported at Kulen and which appear at tenth and early eleventh-century sites at Angkor (#67, Pl. 20 and Fig. 10c), appear in identical form at Ban Kruat and are found in association with late eleventh and twelfth-century material at nearby temples. At both sites these bowls have round scars on the lower walls of the interior and on the lower body of the exterior that wasters from Ban Kruat have shown to be the result of firing the bowls, separated by clay balls, in stacks. All these bowls, like many of the other Khmer ceramic vessels, are coil-made, with the coils of clay that formed the walls begun from around the exterior of a disc-shaped base piece that can be clearly seen on the underside of the bowls. They have conical walls and a protruding lower portion that is characteristic of many of the small vessels of the second half of the eleventh and twelfth centuries.

The earliest excavations of Kulen wares were at the temples of Roluos, south of Angkor, which date from A.D. 879; the wares may have been produced earlier, but no excavations covering the first three-quarters of the ninth century have yet taken place. The shapes are relatively simple, often with a strong horizontal aspect reminiscent of contemporaneous T'ang Chinese pottery (see, for instance, Willetts (1965), pp. 229–88), and potted with a finely levigated sandstone-based clay that is pale yellowish-cream to medium grey in colour. The glaze appears to be a result of cupric oxide having been fired in an oxidizing kiln at about 1000–1100°C,[15] it is translucent and varies between a pale to yellowish green. The base of the wares is flat or slightly concave, and most often glazed. Besides architectural finials and tiles,[16] the predominant shapes are short-necked bottles, bowls, flattened oval-shaped covered boxes with fluting on the covers that are similarly found among the sherds of Ban Kruat, and, after 1050, covered urns (#67–9, Pl. 20 and Colour Pl. I, 1).

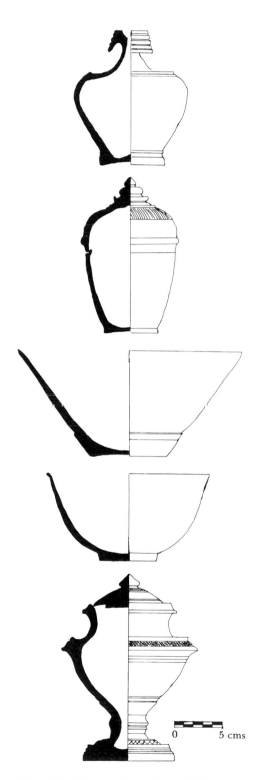

Fig. 10 Khmer Green-Glazed Wares

One characteristic of a great number of Kulen pieces, as well as many from Ban Kruat, is a fabrication mark on the base. Composed of between one and four incised strokes, it sometimes takes the form of carelessly drawn parallel lines, an uneven triangle, crossed lines, or any number of other variations. The purpose of the marks, or why they rarely appear on any other than the green-glazed wares, is unknown, but perhaps individual potters marked their pots in this manner so they could be identified after a communal firing.

At a cursory glance the Kulen vessels, like the Kulen architectural ornaments which were reserved for royal or religious edifices, seem to have been fashioned for some non-secular purpose. The bottles, for instance, could have been used to hold the perfumed water or incense that was habitually placed at the feet of religious images. Groslier, however, denies that they were part of the regalia of the Hindu temples of Angkor. The most precious objects, he says, were made of costly metals; only objects of silver or gold are mentioned in the inscriptions as being sacred, and most of the ceremonial containers pictured in the bas-reliefs of Angkor Wat, the Bayon, and Banteay Chmarr are known metal forms. But perhaps the ceramic vessels of Kulen were the offering containers of the poor for their private shrines and local deities. The common people, of course, would not have the same privileges as the Brahmin priests.

LIE DE VIN WARES, *c.* 900–1050

The thickly potted *lie de vin,* a group of hard-fired stonewares so-christened by Groslier because of their resemblance in colour to the residue left in old wine bottles, a colour varying between violet and red, begin in the early years of the tenth century and evolve into the later dark-glazed wares towards the middle of the eleventh. Although unglazed, the pots often have a slight kiln gloss that, along with the usual reddish discolorations that characterize the wares, is probably the result of being fired near an open flame. Wood ash falling on baking clay forms a natural gloss; wood ash, indeed, is the primary component of many glazes.

Comprising primarily utilitarian medium-sized storage jars and basins, the *lie de vin* are sturdy, flat-bottomed, coil-made and, until the late tenth century, largely undecorated (Colour Pl. J, 1; #70, Pl. 21). Their angular shapes, along with the flaring mouths of the jars (see Fig. 11) and the beginnings of carved and punctured decoration in the early eleventh century, presage the later dark-glazed wares. Decoration, when it occurs, consists of carved bands on the shoulders of the vessels, ornate mouth rims that are carved into rounded tiers, and bands of jabbed points that were punched into the body probably by means of a bamboo point. A small number of other unglazed stonewares with black-speckled grey paste that can be assigned to the late tenth and first half of the eleventh centuries sometimes have bands of an incised cross-hatch, the lines of which were begun from the same type of point jabbed into the body and pulled across the clay; small nicks can be clearly seen where the point entered. Large numbers of unglazed low-fired earthenware utilitarian pots were also made throughout the Angkorian period, and in the early eleventh century these are sometimes carved or incised in a similar manner to the *lie de vin* and unglazed grey-bodied wares of the same period.

Ht. 40 cms

Fig. 11 Khmer *Lie de Vin* Jar, Eleventh Century

THE BAPHUON WARES, *c.* 1050–1068

During the Baphuon period, and perhaps a decade or so earlier, experiments with dark glazes were begun, which chemical analysis has shown to be the result of high iron concentration in the glaze material (see above, footnote #15). Amongst the earliest of these wares are large-size basins and water or storage jars, many of which may date from the fourth decade of the eleventh century, with a *lie de vin* or grey stoneware body and a mottled olive-green glaze that appears to have been summarily brushed on both the exterior and interior of the vessels with a brush of coarse coconut-husk fibre. By the beginning of the Baphuon period brownish and blackish tones were achieved, but for several decades afterwards they often retain a faint olive undertone. Never homogeneous in colour, the flowing brownish and blackish glazes of this period are often mottled with rust-coloured patches that are opaque and slightly more shiny than the surrounding glaze, an effect perhaps due to iron concentrations in an insufficiently ground glaze material. Olive-coloured glaze continues to be seen occasionally throughout the eleventh century and in the ensuing periods.

A special innovation of the period is a two-glaze ware that may have been inspired by the Vietnamese inlay brown wares (see Chapter 1) that were being produced about the same time. On these either a dark-olive or brownish glaze is used in conjunction with green (Colour Pl. J, 3–4). On some the green-glazed portion is also characterized by two different colours of paste. Seen in cross-section there is an interior grey layer that is flanked on either side with well-defined equally thick white-coloured layers that may be the result of the addition of successive coats of slip. Later two-glaze wares never display this peculiarity, and on most of these (#81, Pl. 23) as well, the copper-green is combined with a blackish glaze. The latter were probably produced in Thailand since they are rarely found at Angkor; the former seem to be found in approximately equal quantities in Thailand and at Angkor. On most examples the dark glaze is on the lower portion and the green above, one exception being the elephant lime pot illustrated in Colour Pl. J, 3.

Green-glazed wares continued to be produced during the Baphuon period though the only shape continued from the early eleventh century is the bowl with stacking scars. New shapes that appear are perfume boxes that probably held flower petals melted in bees' wax (Colour Pl. K, 3), zoomorphic lime pots with stopper lids that provide evidence for a widespread betel-leaf chewing habit (Colour Pl. I, 4), and covered urns that are somewhat similar to modern cinerary containers. All these shapes, too, characterize the brownish and blackish glazed wares of the same period, although the dark-glazed wares begin to be slightly more plentiful and include additional shapes such as basins, storage jars, footed urns, and more varied zoomorphic vessels. The green glaze is rarely seen on any vessels above 20 cms in height, except among the two-glaze wares. On some of the Baphuon green-glazed wares such as the jardinière of Colour Pl. I, 2 the glaze is thin, translucent and pale green, but more commonly it is yellowish-green, greenish-yellow, or thick, opaque and cream-coloured (e.g. #71 and 75, Pls. 21–22).

A further characteristic of the Baphuon wares is the experiments made with incising under the glaze. The earliest examples are probably similar to the lime pot of Colour Plate I, 3, which has jabbed lines resembling the punched and carved decoration of the early eleventh-century wares. On others, like the gourd-shaped bottle, #75, Plate 22, incisions are used to delineate anthropomorphic or zoomorphic features. The scratch-like quality of this early under-the-glaze incising can perhaps best be seen on the jardinière of Colour Plate I, 2; it stands in stark contrast to the later assured, delicately executed geometric designs of the twelfth-century wares, and was perhaps due to allowing the pot to dry too long before the decoration was incised. The later wares were probably incised before the surface of the pot hardened. Although the illustrations here happen to be copper-glazed, the same sort of hesitant incising can often be seen on the dark-glazed wares of the same period. In fact, incising on green-glazed wares is rare, and practically confined to the second half of the eleventh century.

JAYAVARMAN VI, *c.* 1068–1110

Ceramics belonging to the last three decades of the eleventh and the first decade of the twelfth centuries have been particularly well-defined by Groslier as a result of the discovery and excavation in 1964 of a burial ground along a dyke of the pool of Sra Srang at Angkor. Single burials at the site (see Groslier, 1966, Pl. 143) consisted of brick enclosures inside which was a cinerary vessel surrounded by other pottery vessels sometimes

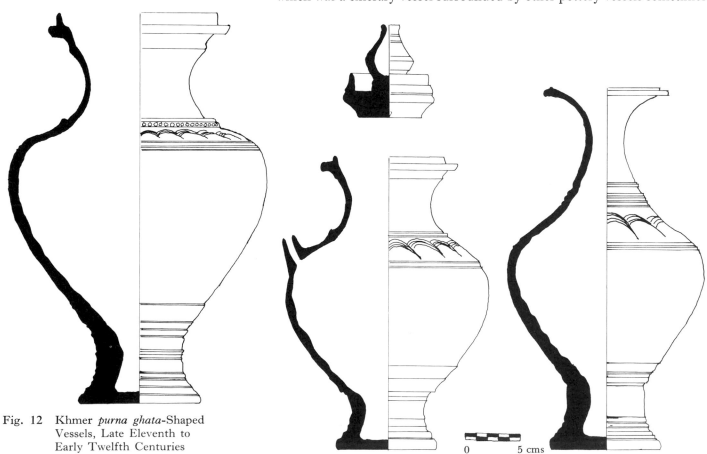

Fig. 12 Khmer *purna ghata*-Shaped Vessels, Late Eleventh to Early Twelfth Centuries

0 5 cms

containing the former possessions of the deceased. In one case a gold-measuring scale complete with weights and other gold-working tools were found inside a jar. Other burials included bronze carriage or umbrella fittings, the signs of a personage of rank. No specific type of vessel was used as the ashes container, though it usually seemed to have been deliberately damaged in some manner; some were cut cleanly off at the neck and others had a hole pierced at the base. Groslier suspects that the damage was inflicted as a sort of ritual 'killing' of the vessel. Ceramics excavated at Sra Srang illustrated here are on Colour Plates I, 2; J, 3; and K, 2–3.

Characteristics acquired about the mid-eleventh century are continued into the beginning of the twelfth, along with a gradual improvement of the dark glaze and the adoption of a few new shapes. The dark-glazed wares may have a thick flowing glaze (Colour Pl. K, 1 and 4) that loses the rust-coloured patches of the Baphuon wares but which, instead, may be marred by minute bubble bursts, perhaps caused by improperly levigated iron that crystallized during the firing, that give the surface of the glaze a speckled or 'powder' appearance (Colour Pl. K, 2). Another peculiarity of the glaze of this period is that when it has been chipped away it often leaves a reddish stain on the body of the pot; this stain is most pronounced on wares of about the turn of the century, then it disappears altogether in the early Angkor Wat period. Also distinctive to the period are small, bulbous, sometimes almost hemispherical jars with a disproportionately small constricted short neck and equally small mouth with flange. Among the green, or copper-glazed, wares is introduced a type of bowl with slightly curving walls and everted rim that does not carry stacking scars; these seem to be distinctive to the wares found in North-East Thailand (Fig. 10d). Footed urns are especially numerous in this period.

ANGKOR WAT PERIOD WARES, c. 1110–1177

The best of the twelfth century wares, the most beautifully classic and sombre of all the Khmer ceramics, with their fine integration of soft lustrous glaze colour, delicate incised decoration and uniquely Khmer shapes, mark the height of the Khmer ceramic tradition, and it is fitting that they were produced during the era of the construction of the most beautiful of all Khmer temples, the Angkor Wat.

The Angkor Wat period dark glaze ranges from light, sometimes almost golden, to dark brown in colour; the texture is cream-like and it is less prone to the chipping that characterizes most wares of other periods. The better integration of glaze and body is largely due to a greater number of small-sized shapes that could be potted fairly thinly and therefore baked more thoroughly; it is doubtful whether, with fired-laterite rather than brick kilns, the firing temperature could be raised much higher than in previous years. Large storage and wine jars still continued to be subject to chipping. The small objects, some of which began appearing in the second half of the eleventh century, include many zoomorphic lime pots, (Colour Pl. K, 2), small covered boxes, angular perfume boxes, small bottles, and a small number of miniatures which are never seen at Angkor. Slightly larger are the wide squat jars with small restricted necks that were probably used as lamps (Colour Pl. L, 4), bottles, and squat jars with

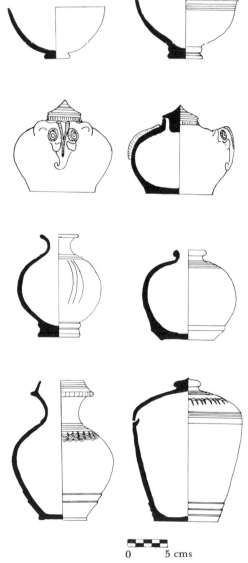

Fig. 13 Late Jayavarman VI and Angkor Wat Period Wares, Dark-Glazed

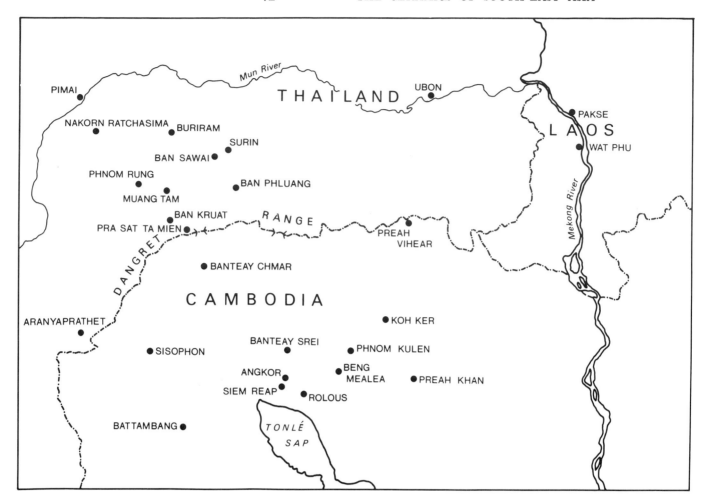

3. Northern Cambodia and North-East Thailand

zoomorphic handles and tiny spouts that were probably honey pots (Colour Pl. L, 1). Many of these pieces, beginning in the late Jayavarman VI period, are characterized by a brown slip which is applied to the lower body and sometimes to the base (Colour Pl. L, 2). Most of the small pieces with dark glaze have a small button-like foot that is never seen among the green-glazed wares; these include a great number of small, mostly lotus-shaped, bowls. Wine jars are another notable addition to the dark-glazed wares (Fig. 14).[17]

Many of the small dark-glazed wares also have semi-circular concentric marks on the foot that are the imprints of their separation from a turning table by pulling a cord beneath them. The base of the honey pots and lamps still show disc-shaped base pieces surrounded by the bottom-most coils that form the beginning of the body. On most of the footed urns, in contrast, the coils are begun from the top surface of a base piece.

It is during the Angkor Wat period that lightly incised, formalized geometric decoration is seen at its best. Unlike the scratched and jabbed incising of the second half of the eleventh century, it is strong, assured, and finely executed. The comb design, vertical striations and narrow bands cut into tiny rectangles by vertical incisions are ubiquitous. Only

rarely do these appear on the green-glazed wares which display little incising. Green-glazed wares, indeed, from the mid-eleventh century appear in increasingly diminishing numbers, with fewer commonly seen shapes. Two-glaze wares practically disappear except for a small number of footed urns with the upper portion in green.

BAYON PERIOD WARES, *c.* 1177–1350

By the last quarter of the twelfth century the delicate wares of the Angkor Wat period begin to give way to the weighty masculine shapes and thick blackish-brown and blackish glazes of the Bayon wares (Colour Pl. M; #82–5, Pl. 23–4). Incised decoration becomes progressively less important and more roughly and deeply cut as the glaze becomes thicker and darker, and the number of existent examples and shapes dwindles. Most common are heavily constructed water and wine jars (#85, Pl. 24), sometimes with thick rounded ridges at the lower body, but there are also squat jars with little decoration; mortar bowls (#84, Pl. 24), some footed urns, some of them with goose-head spouts; and large chunky elephant lime pots (Colour Pl. M, 4).

No specific group of these wares can be assigned with certainty to the fourteenth century, during which the glazed ceramic craft seems to have disappeared from the Khmer empire. But the ceramic tradition there did not vanish altogether without exerting some influence on the character of Thai ceramics which will be discussed in the following chapter.

1. 'Victorious is Iça, who is not moved by the desire to expand or retract, but desires only to remain constant, ceaselessly spinning like the (potter's) wheel.' (Writer's translation.) The allusion, clear in the original Sanskrit, is, according to Bernard Groslier, to the expanding and contracting clay taking the shape of a vessel in contrast to the unchanging size of the moving potter's wheel. Taken from Coedès, II (1942), p. 12.

2. Descriptions of the site have been taken from Goloubew (1924); Aymonier, II (1901), p. 412; Parmentier (1935), pp. 67–9; and from verbal descriptions of Bernard Groslier.

3. The inhabitants of the plateau, according to Goloubew, believed that the place had too many spirits. One reason for this, a former English resident of Battambang who once attempted to visit the site has told the writer, is that the place is infested with cobra snakes.

4. For a history of the shape see Combaz, I (1937), pp. 174–7; II, Pls. 119–22.

5. For a review of modern Khmer pottery making, see Silice and Stoeckel (1921–3), and Biagini and Mourer (1971).

6. The first published report of the site was by Vallibhotama (1974), pp. 30–3.

7. See Brown, Childress, and Gluckman (1974). Deposits of sherds are scattered in numerous places near the village, and although there are very few that could be identified with certainty as fragments of kiln wasters, nearly every deposit is accompanied by chunks of fired laterite that may be remnants of kilns.

8. See Brown and Childress (1976), in press. During the reconstruction of Prasat Ban Phluang in Surin Province, some 4,000 sherds representing nearly 400 vessels were encountered within a 1 to 4-metre radius of the temple. Bernard Groslier has told the authors that he never encountered such amounts at the temples of Angkor.

0 10 cms

Fig. 14 Khmer Wine Jars, Twelfth Century

9. Both are honey pots (see Colour Pl. L, 1). One in the Roberto Villaneuva Collection is said to be from Verde Island, Mindoro; the other, in the Dr. Lydia Alfonso Collection, Cebu, is said to be from the nearby island of Bohol.

10. This outline as well as all information in this chapter provided by Bernard Groslier, except as otherwise cited, is based on the writer's conversations with him. His aid, needless to say, has been invaluable.

11. It is recorded in Thai chronicles that the Thai attacked Angkor twice in the fourteenth century, first in 1352, and then in 1394, but these sources have been considered dubious (Briggs, 1948, p. 3). Groslier, however, has informed the writer that he is convinced, by virtue of the ash deposits from the destructions of the city in the Royal ponds, that there was such an attack in 1350–1.

12. The writer has seen these sherds lying on the grounds of such temples as Phnom Rung, Phnom Wan, Prasat Ban Phluang, Prasat Ban Kruat and Prasat Nikom.

13. See, for example, two footed urns illustrated in line drawings by Stargardt (1973, Figs. 11 and 12), though they are given hollow bases, a feature never seen among the footed urns found in Cambodia or elsewhere in Thailand.

14. For a few wasters, which include small bottles and covered urns, from the site, see Silice and Groslier (1921–3), Pl. X, 9–13.

15. Chemical analysis of the Khmer glazes (see Brown, Childress, and Gluckman, 1974, Appendix II) reveals the presence of both cupric oxide and iron (ferrous and ferric oxides). The latter, in a reducing atmosphere, is the colouring agent for celadon. A consistently higher concentration of iron in the brown and black glazes suggests that this is the colouring agent for those wares. But iron (see Hetherington, 1948) will produce these dark colours only in an oxidizing kiln, and since they appear in combination with the green glaze on the two-glaze wares, the green monochromes must, too, have been fired in an oxidizing atmosphere. The only mineral that will produce green in an oxidizing atmosphere is copper (cupric oxide); thus the Khmer green-glazed wares cannot be celadons and must be copper-glazed.

16. Khmer ceramic architectural fixtures are discussed in a recently published work by Dumarçay (1973).

17. The purpose of this vessel, Groslier has told the writer, can be discerned from a bas-relief on the western half of the southern side of the late twelfth-century temple of Banteay Chhmar in north-western Cambodia (see Map 2). The jar is depicted with a group of Khmers drinking from it through reed straws who in the next scene are dancing about, obviously inebriated. The above mentioned squat jar that has been called a honey pot, according to Groslier, is similar to a modern vessel used for the storage of honey and is immediately recognizable to most Khmers.

[4]

THE SUKHOTHAI
AND SAWANKHALOK KILNS

ORIGINS AND DATING

AT about the time when the manufacture of glazed ceramics disappeared from the retracting Khmer empire, other ceramic kilns appeared in North-Central Thailand—at the newly established kingdom of Sukhothai with its twin cities of Sukhothai and Sri Sachanalai. The first of the independent Thai kingdoms, Sukhothai was founded some time between 1220 and 1250, and it experienced a brilliant though brief expansionist period under its third and most famous king, Rama Khamhaeng, who ruled during the last quarter of the thirteenth century. Thereafter, although it enjoyed an artistic Golden Age under a number of devoutly Buddhist rulers, the kingdom was much reduced, and in 1378 it submitted peacefully to the more powerful Thai kingdom of Ayudhya to the south which had been founded in 1351. Sukhothai seems to have retained some measure of autonomy, however, and it existed for a time as a strong provincial centre governed locally by its own princes. But beginning in the mid-fifteenth century it suffered as a battlefield between the warring forces of Ayudhya and Chiengmai, and its cities were probably effectively depopulated during some particularly devastating raids by Chiengmai about 1512.[1]

It seems that one of the advantages of living in Sukhothai, especially in contrast to the Khmer empire where heavy taxes were extracted from the population, was its lenient economic policy which, with its emphasis on free trade, certainly laid the foundation for the growth of an extensive ceramic export industry. A similar policy was adopted by Ayudhya as well, and in its heyday it was a renowned international trading centre and the port through which most of the ceramics of Sukhothai must have been sent abroad. At sites in the Philippines and Indonesia Thai wares often comprise 20 per cent and sometimes even 40 per cent of the ceramic finds.[2] The policy is described on a stele of Rama Khamhaeng dated 1292:

> During the lifetime of King Rama Khamhaeng the city of Sukhothai has prospered. There are fish in its waters and rice in its rice fields. The Lord of the country does not tax his subjects, who throng the roads leading cattle to market and ride horses on their way to sell them. ... Whoever wishes to trade in elephants or horses does so; whoever wishes to trade in gold or silver does so. ... (Waithayakon, p. 1.)

The Thais traditionally credit the initiation of their ceramic industry to a group of 500 Chinese potters, a gift of the emperor of China to 'Phra Ruang', a general title for all the kings of Sukhothai, who personally

visited the Middle Kingdom and who was also given a Chinese wife. The king in question is customarily reputed to be the famous Rama Khamhaeng. But the often fanciful Thai legends, of which this story is a part, were not collected into written histories until the eighteenth and nineteenth centuries, and the more closely contemporary Chinese court chronicles contain no record of the visit of a Sukhothai king. Nevertheless, there were a number of diplomatic contacts between Sukhothai and the newly installed Mongol court in the last decade of the thirteenth century, and the Chinese chronicles do acknowledge an audience with an heir to the Sukhothai throne in 1299. Perhaps it was he who returned with the potters, though the chronicles mention that he requested horses (Flood, 1969). It is also possible that refugee potters accompanied Ch'en I-chung, an ex-prime minister of the ousted Sung Dynasty, who sought refuge in 1283 at Sukhothai where he later died (Flood, p. 243). The actual presence of Chinese potters at Sukhothai, however, is still a subject of debate.

There are two old kiln centres at the kingdom of Sukhothai. Forty-nine kilns have been surveyed at the centre outside the walls of the city of Sukhothai, and their wares are known as 'Sukhothai'. The other, located about 60 kilometres north at Sri Sachanalai, consists of three groups of kilns along the banks of the Menam Yom: twenty at Pa Yang, one kilometre north of the city walls; five at Tukatha, 2 kilometres north; and 120 at Ban Ko Noi, 5 kilometres north.[3] Although most of the architectural ornaments and many of the figurines seem to have been made at the Pa Yang group, the sherd debris at all three sites is substantially similar and the wares are known collectively as 'Sawankhalok' after the current name of the district. In the Thai museums, which do not always make the Sukhothai-Sawankhalok distinction, both types may be called 'Sangkalok' or described as 'Sukhothai Period' and given the dates fourteenth to fifteenth centuries.

The exact dating of the wares has never been conclusively determined, and at the moment, it rests on deduction, induction, inference, and stylistic reference. But one can safely say they were contemporary with the kingdom of Sukhothai since products of both centres were incorporated into the architecture of both Sukhothai and Sri Sachanalai; and, judging by the disarray of the Sawankhalok kilns—the strewn sherds, wasters, firing supports and collapsed roofs—noted even by the earliest European visitors,[4] plus the discovery of at least two kilns still filled with fired pottery,[5] the end must have been cataclysmic. A sudden abandonment of the kiln centre may have occurred any time during the strife of the second half of the fifteenth century, but excavation evidence abroad, for example the finds of Sawankhalok together with Chinese wares of as late as the first half of the sixteenth century, suggests the kilns could have operated until the final Chiengmai raid of 1512, when Hall (1968, p. 183) reports that the Chiengmai forces returned home with many prisoners and much booty.

Excavations at Angkor have shown that the Sawankhalok ceramics found there do not date before an attack on the city in 1350, but they may have begun arriving any time after that date until the abandonment of the city as a capital about 1431.[6] Sukhothai pottery, which has not yet been identified at Angkor, is generally thought to have preceded Sawankhalok. Besides the technical inferiority of the Sukhothai wares as compar-

Fig. 15 Sukhothai Wares from the Koh Khram Sunken Ship

0 5 cms

ed with the Sawankhalok, Beyer claims to have found them at earlier sites than the Sawankhalok in the Philippines.[7] Beyer's chronology tends to be supported by the fact that although large numbers of Sawankhalok wares have been excavated at sites such as Calatagan (Fox, 1959) and Kampong Pareko (Ito and Kamakura, 1941), they have never, in excavations on which published data exists, been found in association with the Sukhothai.[8] But while archaeological data and stylistic evidence tend to corroborate the idea that the Sukhothai kilns were established earlier, it does not necessarily follow that they closed when those of Sawankhalok opened.

Recent archaeological evidence from Thailand in fact demonstrates that the kilns were contemporary for a while at least. Both Sukhothai and Sawankhalok pottery were found as cargo on the same sunken ship off the coast of Koh Khram Island in the Gulf of Siam near Sattahip; among a total of some 3,000 whole pieces (salvaged by the Thai Fine Arts Department), which also included some Vietnamese, probable Cham, and probable southern Chinese wares, approximately 55 per cent were Sawankhalok and 6 per cent Sukhothai.[9] The resulting percentage of Sukhothai compared to Sawankhalok aboard the ship—10.9 per cent—is interesting because it is higher than the estimated 5 to 8 per cent found in the South-East Asian archipelagos,[10] but much lower than would be expected if the kilns of the two centres operated on an equal production basis. If one Sukhothai kiln produced the same number of wares for export as a single Sawankhalok kiln, the expected percentage of wares would be one Sukhothai to three Sawankhalok, or 33.3 per cent, since there were three times as many kilns at Sawankhalok. There is too little data, of course, to draw conclusions from this variance, yet the lower than expected percentage of Sukhothai to Sawankhalok wares found abroad could indicate that the Sukhothai kilns did not operate throughout the full tenure of those of Sawankhalok.

Significantly, there is no mention of pottery or foreign trade on the Sukhothai stele of 1292, which does contain a lengthy description of the kingdom and the accomplishments of King Rama Khamhaeng, an absence, along with the fact that the ruined temples of Sukhothai known to have had ceramic architectural fixtures were not built until the fourteenth and fifteenth centuries, that suggests the Sukhothai kilns were probably not built before 1300. Whether they actually began operating at the beginning of the fourteenth century is uncertain, although Beyer has given the wares a thirteenth- to fourteenth-century dating on the purported basis of stratified sites in the Philippines (Robb, 1930). However the kilns must have operated after 1350 by virtue of the wares having been found on the Koh Khram sunken ship discussed above in association with Sawankhalok, which on the basis of excavation at Angkor cannot be dated before the mid-fourteenth century. The resemblance of certain of their decorative motifs to those used in Vietnam in the fourteenth century, and their lack of later Vietnamese or Chinese decorative elements or style, together with their failure to borrow any of the more sophisticated glazes or decorative techniques of the Sawankhalok wares, strongly implies that the Sukhothai wares were confined to the fourteenth century and that the kilns began to close not very long after those at Sawankhalok were built.

Sawankhalok wares, which Beyer dated primarily to the late fourteenth

0 5 cms

0 5 cms

Fig. 16 Sawankhalok Celadon Wares from the Koh Khram Sunken Ship

and fifteenth centuries,[11] have been excavated in large numbers from published sites such as Calatagan and Kampong Pareko where they were uncovered in association with Chinese and Vietnamese blue and white wares generally attributed to the fifteenth and sixteenth centuries. But because they were found on the sunken ship discussed above with Sukhothai wares, which can be argued on stylistic grounds to belong to the fourteenth century, they probably began to be produced towards the end of the fourteenth century. Among the Sawankhalok wares salvaged from the Koh Khram sunken ship there were only celadons and a lesser number of black-glazed wares. The celadons comprised plates, dishes, bowls, jarlets, potiches, and ring-handled bottles; the black-glazed, mostly storage jars, and some small bottles and jars. The finds may indicate that not only are these among the early Sawankhalok wares but also that they may be earlier than such other Sawankhalok wares as underglaze black. The array of collected wares, however, may be equally due to a merchant's deliberate selection several hundred years ago or to an accident of salvaging. The Fine Arts Department was not able to retrieve the entire cargo of the ship.

Unfortunately, neither excavations in Thailand nor abroad have yet revealed any chronological order among the Sawankhalok wares. An examination of the grave-by-grave ceramic association at Calatagan in the Philippines would probably provide clues, but this has not yet been published, and at the kiln site where only restoration work has been done, the area is now so disturbed by illicit digging that excavation for stratified

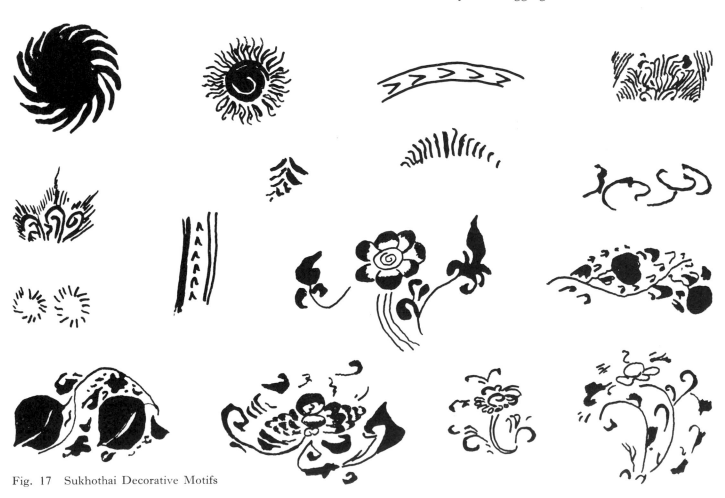

Fig. 17 Sukhothai Decorative Motifs

layering or the isolation of wares produced at a single kiln would probably be unrewarding. The possibility that those Sawankhalok wares which show pronounced affinities with Sukhothai wares are amongst the earliest has been suggested by Willetts (1971) who calls them 'transitional'. But if the contents of the above-mentioned sunken ship truly reflect the realities of production, then the absence of underglaze black wares, which include the 'transitional' wares, intimates that the earliest Sawankhalok products were primarily celadons and that the potters of Sri Sachanalai were perhaps only later joined by Sukhothai potters who introduced the underglaze black wares there. It is hoped that further excavation of ceramic-laden ships in the Gulf of Siam may one day solve this problem of chronology, for some thirty to forty more such sunken vessels have already been reported there.

THE SUKHOTHAI WARES

The best method for identifying the products of old kiln centres is a careful examination of the sherds, discards, and wasters at the kiln site itself, and this, fortunately, is possible in Thailand. Based on a study of the sherds at the kiln centre, the following are considered to be the wares of Sukhothai:

1. Underglaze black	wares decorated in black on a white slip under a transparent, sometimes slightly greenish, glaze
2. Underglaze brown	wares decorated in brown on a white slip under a transparent glaze, sometimes with the decoration scratched through the brown to reveal the white slip below
3. Monochrome white	wares with a white slip and clear glaze
4. Unglazed wares	thin or thick-walled wares with a greyish, reddish, or brownish body

To judge from the kiln site, the primary products of Sukhothai were plates and bowls decorated in underglaze black with an encircled fish on the interior bottom; the fragments of such wares seem to account for a good 50 per cent of the kiln debris. Other common decorative motifs (Fig. 17 and 18) include the solar whorl (or *cakra*), sun-bursts, fern-like sprays, summary classic scrolls, chevron bands on mouth rims, and floral patterns.

Sukhothai glazed wares, even for the casual observer, are perhaps the most easily recognized ceramics of South-East Asia. Their clay body—so coarse and grainy that it necessitated heavy, solid potting, and a thick layer of slip before the underglaze decoration could be applied—is

Fig. 18 Sukhothai Bowl and Plate
Centre Medallions

unmistakable. It is essentially medium grey in colour, and normally speckled with white, plus occasionally black, impurities. However, on the exposed areas of the wares, such as the base and foot, it sometimes burns to brownish or dark reddish-brown in the firing. The slip coat is white, and often smeared at the lower body and onto the foot and base of the wares, and the glaze is normally marred by many pin holes. Foot rings are thick and squarely carved, and the base rough. Thinly-potted, finely decorated pieces like the covered box on Colour Plate N, 3 are rare. On a number of finer pieces such as this one, parts of the design are created by scratching through a layer of black or brown underglaze to the white slip below, a technique also common on many of the ordinary underglaze brown wares.

The fact that there are a few relatively fine Sukhothai examples perhaps indicates that the sturdy, somewhat careless, potting of the majority of the wares may have as much to do with mass production as with the poor quality clay at the disposal of the potters. Sturdy wares, too, could more easily withstand sea or land transport.

For maximum utilization of kiln space, the plates and bowls were stacked for firing, one upon the other, separated by disc-shaped supports (like those that must have been used for Vietnamese wares) that left spur marks on the interior bottom of the piece below. The stacks themselves were set on tubular supports that sometimes left a circular scar on the base of the bottom-most dish (see Fig. 19 and #90, Pl. 26). The tubular supports at Sukhothai range from 30 to 40 cms in height and are broader than those used at Sawankhalok. They are hollow, closed at one end, and seem to be made of the same clay as the Sukhothai wares themselves.

Both the underglaze brown and monochrome white are minor wares and share the shapes of the underglaze black. Although the underglaze brown may be a misfired variety of underglaze black, it seems to typify only bowls decorated with solar whorl motifs; it is rarely seen on the fish plates or bowls, for instance. Underglaze black shapes include bottles, jars, dishes, bowls, and occasional covered boxes, stem plates, and mortar bowls (Colour Pl. N and #86–92, Pls. 25–6). Architectural ornaments, including naga figures, tiles, and triangular roof finials for local use, were also manufactured (#94, Pl. 27).

There are several groups of unglazed Sukhothai wares. The most numerous is composed of Khmer-like jars with brownish or greyish bodies and incised or appliqué decoration (#95, Pl. 27); it also includes a small number of basins with wide-flaring walls that are curved inward near the mouth and a relatively small, thick button-like disc foot. Another group comprises only mortar bowls that are rough-bodied and greyish or red. A final group, which includes only kendi, is thinly-potted; the body, which may be high-fired earthenware, is greyish-black or red. The kendi have thin, brittle bodies, tall tubular necks, funnel-like spouts that are sometimes curved, and a flat foot (see Fig. 21).

THE SAWANKHALOK WARES

Besides having three times as many kilns, the Sawankhalok potting centre had such a wide repertoire of glazes and shapes compared with Sukhothai that it has often been suggested that a second group of

Fig. 19　Methods of Kiln Stacking at Sukhothai, Sawankhalok, and Sankampaeng

Chinese potters arrived after the first. While many of the shapes, decorative motifs and techniques at Sawankhalok can be traced to an evolution from Sukhothai wares, the introduction of celadon glaze, among other things, cannot. Although Margaret Medley (1972) has suggested that the development of the glaze could have been indigenous (celadon is, in fact, a simple glaze requiring only a small iron content and a reduction atmosphere firing — one in which little oxygen enters the kiln), its combination with the technique of incising under the glaze and the new decorative motifs that often resemble those on Chinese wares, cannot be accidental. The overall production of the kilns, on the other hand, displays too many unique characteristics to be attributable solely to any one group of immigrant potters. The types of wares are the following:

1. Underglaze black	wares decorated in black, sometimes over a white slip, under a clear or slightly greenish glaze that sometimes has bluish patches
2. Celadon	wares, usually incised under the glaze, with a translucent green or, less often, an opaque blue celadon glaze
3. Brown monochrome	wares with a medium to dark brown glaze
4. Brown and pearl	wares with incised decoration inlaid with white on a brown background, or vice-versa; occasionally with brown glaze only
5. White-glazed	wares with a white, usually matt, glaze
6. Black monochrome	black-glazed wares, normally in shapes not seen among the other glaze groups
7. Olive-glazed	wares, comprising plates with flat bases and unglazed exteriors not seen among the other glaze groups, and small jars
8. Unglazed wares	thick-walled mortar bowls, and jars with incised, impressed, or appliqué decoration, and a brownish or greyish body; thinly potted reddish or black-bodied kendi

The body of the Sawankhalok wares, like that of the Sukhothai, is fairly distinctive, though more varied in colour on the external exposed surfaces. On sherds the interior is revealed to be fundamentally greyish and often speckled with minute black impurities; this is also true of interior unglazed surfaces such as those on the covers of covered boxes.

But unglazed surfaces that were exposed to the kiln atmosphere may be a black-speckled grey, homogeneous grey, buff-coloured, brownish, pinkish, reddish-orange, cream, or brick red. The clay available to the Sawankhalok potters, while not so fine as that of northern Vietnam, was of better quality than the clay at Sukhothai, and this has often been postulated as the primary reason for the move to Sri Sachanalai. It was finer-grained, a quality that allowed easier manipulation and facilitated more dextrous potting. For this reason Sawankhalok wares are generally much better potted than the Sukhothai. Foot rings, for instance, are always carefully carved, usually squarely on the celadons and with the interior side bevelled on other wares. As on the Sukhothai, the bases are always unglazed.

Most of the wares were fired on tubular supports (see Fig. 19), slimmer than those of Sukhothai and used more extensively, with one closed end (the wider one) and one open (the more narrow). If the pottery vessel were set on the narrow, open end, it appears that an adhesive was used that left a black circular ring on the base of the wares, and the surface inside the ring, not having been as exposed to the kiln atmosphere as the remainder of the exposed clay, is normally lighter in colour than that surrounding it. But if the vessel were set on the wider, closed end of the support (the supports could have been set in the floor of the kiln with either end up), it could be set with its foot upon the support and no scar was incurred.

The underglaze black and the celadons include the greatest range of shapes and are the most numerous of the existent Sawankhalok wares. And it is among examples of the former that Sukhothai influences are most evident; these, indeed, may have been the work of re-located Sukhothai potters. A small number of disc-shaped kiln supports have been found at Sawankhalok and their scars appear only on underglaze black plates decorated with fish or flower centre medallions reminiscent of Sukhothai examples. Because of the scars these plates have sometimes been mistaken for Sukhothai, but the formalized, almost stilted quality of their underglaze drawing belies them even if one is unable to examine their clay body. The free, lively, summary drawing of the underglaze black Sukhothai wares that was usually done with many quick strokes of the brush is totally absent from Sawankhalok wares. On the latter the drawing is normally compartmentalized into horizontal bands, vertical panels, medallions, cartouches, or squares. A special effort seems to have been made to cover the whole surface of a vessel, and the designs themselves are more intricate or complex than on Sukhothai wares. The glaze is sometimes perfectly transparent, but more often it is cloudy or milky with occasional opaque pale blue patches where it is thick. (See Colour Pl. O and #96–106, Pls. 28–30.)

The underglaze decoration includes geometric and vegetal motifs in approximately equal quantities. Some of them, for example classic scroll bands and lotus panels, resemble those in use on Chinese and Vietnamese wares, and some, such as the fish, sun-bursts, and certain floral designs (Colour Pl. O, 1 and #101–4, Pls. 29–30), must have been derived from Sukhothai wares, but others may have been copied from textiles. The cross-hatch pattern with tiny rosette-type flowers at the lines' junctions and the fish scale, as well as a rudimentary solar whorl design (also used at Sukhothai), are all illustrated by G. Groslier (1921, p. 39, Fig. 11) as

Fig. 20 Sawankhalok Black-Glazed Jars, from the Koh Khram Sunken Ship

textile designs known in Angkorian Cambodia. These designs may have typified some of the textiles that Chou Ta-kuan, writing in 1296, claims were imported into Angkor from Siam (Pelliot, 1951, p. 13).

Sawankhalok underglaze black shapes that can be traced to prototypes among Sukhothai wares include the pear-shaped bottle, though at Sawankhalok it often acquired a cup-like mouth; covered boxes; and certain bowls and plates. In contrast to Sukhothai, however, plates and bowls are relatively rare among Sawankhalok underglaze wares, while covered boxes in a much wider variety of shapes are one of the major products. Other departures from Sukhothai wares are kendi with a flattened body, mammiform-spout, and a tall flanged neck (see Fig. 21), zoomorphic vessels, and a greater variety of bottle and jar shapes. Most of these shapes are also scattered among the other glaze categories, but the underglaze group includes the greatest variety.

An added practice at Sawankhalok was the making of miniatures, which occur also among Vietnamese blue and white and some southern Chinese wares. Seen among the wares of several glaze groups, they include tiny covered boxes, jarlets, and bottles (#100, Pl. 28 and #122–3, Pl. 36). Also new are zoomorphic and anthropomorphic figurines (Colour Pl. Q and #113–16, Pl. 33). The zoomorphic are likenesses of such animals as ducks, chickens, birds, dogs, turtles, elephants and horses. The most common human images are those of a woman holding a child, and on these the head of the woman has often been broken off—perhaps intentionally as a magical means of transferring potential harm from a pregnant woman to the inanimate object (Coedès, 1939). Others portray a woman holding a fan or other object, men cuddling fighting cocks, amorous couples, polo players astride horses, or wrestlers. There are also hollow hunchback figures, which may be water droppers, with an opening usually in the top of a small pot held at the figure's shoulder. Most of the anthropomorphic figures, both male and female, are depicted with a ball-like lump in one of their cheeks that has usually been supposed to represent betel-leaf chewing. The idea is disputed by Kraisri Nimmanahaeminda, an antiquary and long-time resident of Chiengmai, who has told the writer that he believes the lumps to be wads of *miang,* a fermented tea leaf delicacy of northern Thailand even today. Betel leaves, he explains, are chewed in the mouth, while *miang* is held in the cheek.

The celadons, which are normally more sturdily potted than the underglaze black wares, include bottles, jars, plates, dishes, bowls, kendi, and figurines; architectural ornaments are unknown among them, and covered boxes (only one, a miniature, has been seen by the writer) virtually non-existent. In contrast they include a large variety of plates, dishes and bowls, and numerous ring-handled bottles, a shape unknown among the underglaze black wares (Colour Pl. P, 1), though included among several other glaze groups. Oddly, this shape can be traced to an underglaze decorated version among the Sukhothai wares (see #86, Pl. 25), and why it does not appear on the underglaze decorated Sawankhalok wares, therefore, is puzzling.

The celadon glaze ranges in colour from a translucent pale, medium, or dark green to a soft-coloured opaque blue. Typically it is a medium green that is hard, brittle, thick, and glassy-looking with fine crazing. It was also a runny glaze, thus there are often teardrop trickles of glaze on

the exterior of the vessels, and patches of glaze which are thicker on the bottom interiors than on the walls. Only in rare instances is the green celadon glaze opaque with an egg shell-like finish in the manner of many Chinese celadon wares, but this is always the case with the blue. Blue celadon was at times purposely produced in China where the colour is believed to have been the result of introducing a strong reduction atmosphere at a specified time in the firing, but at Sawankhalok these pieces were probably fortuitous. (See Colour Pl. P.)

Most of the Sawankhalok celadons are decorated with incised or carved decoration under the glaze that includes both vegetal and geometric motifs. Finger-width vertical gouges on the exterior of plates, dishes, and bowls and in bands on jarlets and ring-handled bottles are also common. A notable peculiarity of the plates, dishes, and bowls is that the incised decoration almost invariably includes two or more concentric circles at the centre of the interior bottom (often enclosing a flower blossom); they are a feature unique to Sawankhalok celadons. Other decorations include lotus petals, lotus flowers, peony blossoms, bands of an undulating vine, onion-skin medallions (rather like series of concentric parentheses) that sometimes enclose flower blossoms, and occasional cross-hatching (#107–9, Pl. 31).

After the underglaze black and the celadons, the next most common Sawankhalok wares seem to be the brown monochromes. The glaze is normally runny and varies between dark and lustrous, and thin and dull. As on a great number of other Sawankhalok wares where it is often less noticeable, the glaze usually stops some distance above the base of the vessels. Shapes include bulbous and elongated ring-handled bottles, covered jars, potiches, covered boxes, and figurines. Most of these are undecorated except for incised horizontal bands and sometimes vertical gouges (Colour Pl. R, 2 and #110–16, Pls. 32-3). An exceptional piece is the jar of Colour Plate R, 1.

These brown monochrome wares have unfortunately become popularly known as 'Chalieng' wares on the unfounded belief first expounded by Phaya Nakon Phrah Ram (1936), adopted by Le May (1933 and 1939) and Spinks (1971), and first disputed by Willetts (1971) that kilns earlier than the Sawankhalok once existed at Sri Sachanalai, at a time when the city, under Khmer vassalage, was called Chalieng. Phrah Ram based his hypothesis on a series of excavations he claims to have conducted, while serving as a Thai government official at Sawankhalok, at Sri Sachanalai and other sites in northern Thailand where he uncovered 'Chalieng' wares at lower levels than those of Sawankhalok. But his criteria for the identification of the wares is never clear: his illustrated examples include celadon, underglaze black, and brown and pearl wares along with monochrome brown.

The theory, as elucidated by Le May who identified olive-glazed and brown-glazed wares as Chalieng, is that local potters first occupied the Ban Ko Noi site at Sawankhalok, then Chinese potters established kilns at Sukhothai, and later Ban Ko Noi was reoccupied. But if better clay had already been discovered at Sri Sachanalai, a potting industry at Sukhothai would have been unjustified. Furthermore, at the Ban Ko Noi site today brown-glazed sherds are freely interspersed with others, and wasters of brown-glazed wares fused with other types exist. One of these is on exhibition at the Sukhothai museum, and another is in the study

collection of the British Museum. Brown glaze was also used for the purpose of accentuation on wares of other glaze groups (e.g. Colour Pl. O, 4) as well as on the brown and pearl wares. Moreover, brown-glazed shapes are duplicated among several of the other groups.

In addition, Dr. Robert Fox has told the writer that there has been no evidence for an earlier dating of the brown monochromes in the Philippines. The Calatagan site (Fox, 1959), for instance, yielded Sawankhalok brown-glazed wares along with underglaze black, brown and pearl, white-glazed, black-glazed, and celadon Sawankhalok wares. Furthermore, if, as Spinks has theorized (1971, p. 28), Chalieng were early wares developed for local domestic consumption, it is curious that so many have been collected abroad. For all the above reasons, the term 'Chalieng' best deserves to be discarded.

The combination of brown with white glazes to form the brown and pearl group of wares is relatively uncommon among the exported pottery from Sawankhalok, but it was used extensively on the domestic architectural ornaments and demon figures that were incorporated into the local religious edifices (Colour Pl. R, 3–4 and #120–5, Pls. 35-6). At the Sukhothai kilns these fixtures and ornaments were decorated in underglaze black, a mode of decoration not so far seen by the writer among those produced at Sawankhalok. The most common shapes among the exported wares decorated with brown and white glazes are zoomorphic and other bottles, and hunchback-figure water droppers, followed by covered boxes. The decorative motifs, primarily saw-tooth borders and scrolling vine with trifoliate leaves, are incised in outline and inlaid with brown on a pearl background or vice-versa. Occasionally the brown glaze appears alone, with the incised motifs inlaid against an unglazed background, or, as seen on some of the miniature covered boxes, thinly brushed over the entire piece.

Also relatively uncommon, though varied in their shapes, are the white-glazed wares (#117–19, Pl. 34). The glaze is usually matt, and the shapes include potiches with handles (probably the most common shape), bottles, jars, jarlets, bowls, covered bowls, covered boxes, and figurines, as well as some architectural tiles and ornaments. The covered boxes are sometimes accentuated with brown on the top of the cover.

The black-glazed wares comprise only bottles and jars. The glaze is usually thick and lustrous, but may be thin, or speckled in appearance; and sometimes on the very large storage jars it has olive tones. Medium-size storage jars are the most common vessel, and on these, along with most of the other shapes, the glaze stops well above the rough flat base, sometimes in neat semi-hemispherical lappets, and sometimes in trickles (#126–7, Pl. 37 and Fig. 20). Most of the storage jars have a raised ridge on the upper shoulder and all have appliqué lug handles that must have been useful for securing the jars with cords during transport; occasionally there are thinly incised bands at the level of the handles.

The olive-glazed plates are enigmatic. No examples, to the writer's knowledge, have been found abroad, and they are unlike any other of the Sawankhalok wares. Sherds of the wares, found exclusively at a small group of kilns at the northern end of the Ban Ko Noi site at the river bank, represent dishes with flat bottoms and unglazed exteriors (see #130, Pl. 38). The clay is rough, granular, and reddish-brown in colour, and the interiors of the dishes are decorated with straight or wavy lines that appear to

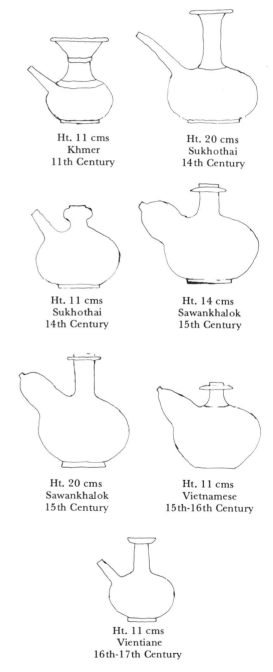

Ht. 11 cms
Khmer
11th Century

Ht. 20 cms
Sukhothai
14th Century

Ht. 11 cms
Sukhothai
14th Century

Ht. 14 cms
Sawankhalok
15th Century

Ht. 20 cms
Sawankhalok
15th Century

Ht. 11 cms
Vietnamese
15th-16th Century

Ht. 11 cms
Vientiane
16th-17th Century

Fig. 21 South-East Asian Kendi

have been drawn with a finger on the wet slip undercoat, and covered with a translucent olive or brownish-olive glaze. When found by the local people at Sawankhalok they are called 'Shan' because of their resemblance to the celadon wares of the Shan potters who migrated to Thailand from Burma in about 1900 (see Brown, March–April 1973) and who also made flat-bottomed dishes with unglazed exteriors. These Shan potters, who set up kilns at Chiengmai and Chiengrai, have said that their knowledge of the craft came originally from Thailand. Other wares with an olive glaze illustrated here are the covered jar (#129, Plate 38) and a jarlet (#128, Pl. 38) that may have been meant to be brown-glazed since similar brown-glazed examples are known. Occasionally, too, the Khmer-like jars of Sawankhalok, which are normally unglazed like those of Sukhothai, have traces of an olive glaze on the shoulder (Colour Pl. R, 5).

There is, as yet, no definite criteria by which to distinguish the unglazed Khmer-like jars of Sukhothai and Sawankhalok, except to say that those with traces of olive glaze, which is not known to have been used at Sukhothai, are Sawankhalok; similar unglazed sherds and wasters have been found at both centres. The same is true of the thickly-potted unglazed mortar bowls. Differences can, however, be discerned between the kendi of the two centres. The thin-walled unglazed kendi of Sawankhalok, unlike those of Sukhothai, have a mammiform spout like the glazed examples, and a short neck with flange (see Fig. 21).

EXTERNAL INFLUENCES

As with pottery the world over, that of South-East Asia has both borrowed and lent decorative motifs, shapes, and techniques, but the extent of this absorption and diffusion requires much further research. As discussed above, Thai legend attributes the initiation of the potting industry in Thailand to a large group of immigrant Chinese, and resemblances of Thai ceramics to those of the Chinese are indisputable. But whether the Thai potting industry was wholly or directly in the hands of Chinese is debatable. It cannot be mere coincidence that the only Asian countries to produce high-fired glazed ceramics were those on or near the borders of China where the craft had been developed centuries earlier, but the transference of the knowledge need only have required a small group or even one craftsman who was willing to teach others. From then on shared characteristics need only come from a study of or familiarity with foreign products, and the wares would then be likely to acquire their own distinctive style.

Sukhothai and Sawankhalok ceramics, for instance, though their glazes and workmanship display a fundamentally Chinese character, are tempered by Khmer and Vietnamese elements as well as by native Thai genius, and once one is familiar with them there is no chance of mistaking them for Chinese. The Khmer contribution, which may even have involved the participation of some of the potters from that empire, is especially evident among the unglazed and the black-glazed wares. In fact, the unglazed wares, when found in the Philippines, have actually been identified as Khmer. When one compares the Khmer footed urns and the Thai jars with their flaring mouth, fine mouth rims, and button-like foot (Colour Pl. R, 5), the mistake is not difficult to understand. There is a

Fig. 22 Sawankhalok Kiln Construction

resemblance between the Khmer unglazed kendi and that of Sukhothai as well (see Fig. 21). Other similarities include a cord-cut foot, and coils begun from the exterior side of a disc-shaped base piece. Some of the smaller examples of both Khmer and Sawankhalok wares have concentric grooves on a flat foot (likened by Willetts to thumb-prints (1971), p. 9) that are the signs of the pieces having been cut from a potting surface by means of a cord pulled under them; and examples of both Khmer and Sawankhalok coiled wares with the coils begun from the exterior side of the base, rather than from on top of it, can be found. On some of these the base has become slightly concave so that the coils form something of a slight foot ring.

The practice of using ceramic architectural ornaments, too, is likely to have been inspired by the nearby Khmer though there is little similarity between specific fixtures. Such things as kendi and lotus-bud handles may also have been borrowed from the Khmer. (See Fig. 21 and compare #73, Pl. 21 and #88, Pl. 25.)

Besides the Khmer influence, there are definite parallels between Thai and Vietnamese products which are most pronounced at Sukhothai. The similarity of fourteenth-century Vietnamese underglaze black wares to those of Sukhothai, a correlation first brought to attention by Willetts (1971), is indeed so striking as to argue for a causal relationship; potters from one of the centres may have moved to the other. Although the Sukhothai are generally believed to be derived from the Tz'u Chou-type wares of China, there exist no such overwhelming stylistic resemblances between specific Sukhothai and Chinese products as between certain underglaze black Sukhothai plates and bowls and those of Vietnam. For example Colour Pl. D, 1 and #92, Pl. 26 can be compared. Both are decorated on the bottom interior with an encircled feathery flower, probably a peony, drawn with quick summary strokes of the brush, and both have a single decorative band on the mouth rim. Bands of cursory classic scroll on the exterior of the wares are also peculiar to both types of wares, as are blossoms with multiple stems and the spur marks of kiln supports.

Until further archaeological data can be gathered, it is questionable which ware exerted influence on the other, but the evidence so far leans towards the Vietnamese. The use of underglaze black decoration in Vietnam is probably earlier; it can be seen on Thanh-hoa wares (Chapter 1) that are presumed to belong to the late thirteenth century, while it is unlikely that the Sukhothai kilns opened before the fourteenth century. Furthermore, Vietnamese wares, some of which are on display at the Sukhothai and Chiengmai museums and in storage at the Bangkok National Museum, have been excavated from several sites in northern Thailand, but no documented Thai wares have thus far been discovered in Vietnam. Vietnamese underglaze blue sherds have been collected from Sri Sachanalai and are among those of Sawankhalok wares kept in storage at the Old Sukhothai museum, and six small underglaze black Vietnamese bowls are among the ceramics excavated from the foundation deposit of Wat Mahatat at Petchabun.[12]

Besides the underglaze black Sukhothai-Vietnamese relationship, one can find certain affinities between Sawankhalok underglaze black and Vietnamese blue and white wares. Excavations in the Philippines and

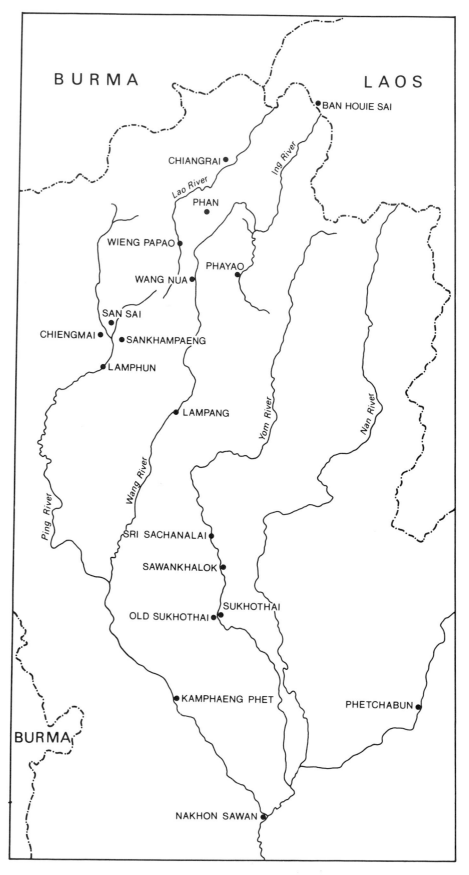

4. Northern Thailand

Indonesia confirm that these wares were largely contemporary. But the similarities here are not decisive enough to suppose more than a familiarity with one another's products. Both wares have a mammiform-spouted kendi (Fig. 21 and #42, 105–6, Pls. 12 and 30) that does not appear among Sukhothai shapes, and both include a wide variety of covered boxes, the Sawankhalok ones occasionally in a predominantly Vietnamese shape, and the Vietnamese sometimes in a common Thai shape (e.g. #37, Pl. 11 and compare #34 and #100, Pls. 10 and 28). Decorative motifs are also shared, and it is not surprising that before the products of Sawankhalok were better defined some Vietnamese jarlets and covered boxes (e.g. #46, Pl. 13) were thought by Beyer in the Philippines to be a type of underglaze blue Sawankhalok (Le May, II, 1933, p. 208 and Robb, 1930, Figs. 30 and 32).

It is a curiosity of Thai ceramics that they do not include blue and white wares, which during the same centuries were being produced on such a large scale in China and Vietnam. A possible explanation is that the making of glazed pottery was introduced to Thailand at a time when the production of blue and white was not yet popular. If this was the reason, then it can be guessed that if potters came from China, they came during the first half of the fourteenth century, and if they came from Vietnam, then they must have arrived before the fifteenth century. Another possible explanation, of course, is that the Chinese and Vietnamese had a monopoly over the cobalt trade.

The limited number of design motifs on Sawankhalok underglaze black wares that can be traced to contemporary Chinese blue and white decorations would seem to support the supposition that if Chinese potters introduced glazed pottery, they came before the widespread use of underglaze blue, for the Thai wares follow their own individual course of evolution. However, the fact that the wares of Sukhothai, which are thought to have begun being produced before those of Sawankhalok, resemble Vietnamese more closely than Chinese wares minimizes the case for immigrant Chinese potters. Another argument against a direct or total Chinese involvement in Thailand is the kiln species. Margaret Medley of the Percival David Foundation of Chinese Art in London, who has done much research on kiln technology, has informed the writer that she knows of no kilns in China of the type built in Thailand. Nor, she says, have tall tubular supports like those of Sukhothai and Sawankhalok been reported, though some Chinese wares, notably Tz'u Chou-types, have the spur marks of disc-shaped supports. There is no evidence for such tubular supports in Vietnam where saggars (see Chapter 2) are more likely to have been in use, but the bases of a small number of Khmer footed urns have distinct circular depressions that may indicate that tubular supports were the innovation of those potters. The Khmer, however, are not known to have had brick kilns. But the Thai brick-constructed kilns do, to a certain extent, resemble in shape the Han-period kilns discovered at Tam-tho in Vietnam by Janse (see Fig. 22). It would be interesting, indeed, if future research revealed that later Vietnamese kilns followed the same general plan as their predecessors.

1. For a more complete history of the period, see Le May (1926), Griswold (1967), and Coedès (1966).

2. Beyer (1947), p. 271; see also the Calatagan (Fox, 1959) and Kampong Pareko (Ito and Kamakura, 1941) excavations. In the Philippines the sites with the higher percentage of Thai wares are those in the southern islands, primarily the Visayans; as one travels northwards the percentage becomes lower.

3. Information provided by Mali Koksanthiya, Director of the Fine Arts Department at Old Sukhothai.

4. For example, Lyle (1901 and 1903), Lunet de Lajonquière (1906 and 1912), and Fournereau (1908).

5. Fournereau (1908), who visited the kilns in 1891, has given the only first-hand account of two kilns filled with fired pottery, although Phrah Ram (1936) mentions that two kilns filled with pottery were uncovered 'about twenty years ago'. But since he does not elaborate, it is unclear whether he is referring to those observed by Fournereau or whether an additional two had been discovered.

6. This information is derived from conversations with Groslier, who has told the writer that the Sawankhalok wares appear only above the ash level dated 1350 at the Royal Palace pools.

7. See Robb's article (1930) based on the notes of Beyer in which Sukhothai examples (Figs. 27–8), though identified as early Sawankhalok, are given a thirteenth to fourteenth century date, while true Sawankhalok examples are dated fourteenth to fifteenth century. In an article written after he had visited Beyer in 1955, Sullivan (1956, p. 77) refers to Beyer's site G. 1200 (without reference) in Cebu where in the lower of two stratified levels Sukhothai wares were associated with chiefly Chinese celadons. There were no Sukhothai wares in the layer above where Sawankhalok and Chinese blue and white wares of the fifteenth century were found; some of the blue and white, he remarks, may have been Annamese.

8. One unpublished but controlled excavation of a single grave in Cebu city by San Carlos University in 1967, however, did yield a white monochrome Sukhothai bowl in association with three Sawankhalok bowls, plus five miscellaneous Chinese monochrome dishes. A reconstruction of the burial is on display in the Anthropological Museum of the University.

9. See Brown (1975). The ship was discovered by fishermen in late August or early September 1974 and the Fine Arts Department conducted a salvaging operation for three months from October to the end of January during which they were able to recover 3,944 pieces; about a thousand of these are fragments.

10. This estimate is based on the examination of 1,000 Thai ceramics in private collections in the Philippines by Sommai Premchit (1971) who found Sukhothai wares in a ratio of one to twelve to Sawankhalok, though Dr. Fox, in a conversation with the writer, estimated only 4 to 5 per cent, and on Willetts (1971, p. 16) who estimated a ratio of one to twenty in regard to the ceramic wares arriving in Singapore from Indonesia.

11. These are the dates attributed to Beyer in Robb's 1930 article, but amongst a set of Beyer's notes dated 1932 that are kept by his son in the Philippines, and which may have been part of the unpublished manuscript reviewed by Le May in 1932, is a notation that Sawankhalok wares begin appearing at fourteenth-century sites, reach their maximum density in the late fifteenth and early sixteenth centuries, decrease by the mid-sixteenth, and are completely absent after 1600. Some of the wares identified as early Sawankhalok, it might be added, may have been Sukhothai (see note 7 above). Although the discovery of kilns at Sukhothai had been reported in a Thai publication (Rama VI) as early as 1909, the first published mention of them in English did not appear until 1930 (Raphael), and examples of the wares correctly identified were not illustrated until 1933 (Le May).

12. Other wares in the group include two green-glazed, flat-bottomed Vietnamese saucers of probable early fourteenth century date; two Sukhothai underglaze bowls decorated with a solar whorl (or *cakra*) on the interior bottom; one unglazed brown-bodied basin with a button-like foot, short, wide foot stem, and flaring walls that curve sharply inward at the mouth, of Sukhothai or Sawankhalok origin; two unglazed naturalistically modelled elephants with grey bodies, of unknown origin; and two white-glazed Chinese jarlets with ring-handles and moulded decoration. The Buddhist edifice was excavated and restored by Mali Koksanthiya of the Fine Arts Department at Old Sukhothai who gave the author the date of 1383 for its construction; the National Museum records, however, give 1443 as the date, a discrepancy the writer has been unable to resolve.

[5]

THE NORTHERN KILNS

WITH the discovery by Phaya Nakon Phrah Ram in 1933 of additional kilns at Kalong, some 80 kilometres north-east of Chiengmai, it became clear that the history of Thai glazed ceramics was not restricted to the Sukhothai and Sawankhalok kilns. In the ensuing years seven more probable sites have been reported, the most recent of these being a group at Wang Nua which was excavated in 1972, and the identification in Chiengmai province of two sites with kiln debris by Kraisri Nimmanahaeminda in 1973. Few of these old centres have been studied in detail, unfortunately, and the character of their wares, their progenitors, and their dates of production are still only vaguely defined or guessed at, a situation partly exacerbated by the fact that the wares did not enter the export trade at the time of their manufacture. Consequently no light has been shed on their history by excavations abroad. None have been reportedly discovered even as close to their sources as Sukhothai, with one exception, this being the two Kalong sherds found in Pahang, Malaysia, which appear to be from a single plate and are now in the collection of the National Museum, Singapore.

While the generally accepted explanation of these further kiln centres has been that they are the work of the dispersed potters of the Sukhothai kingdom, there is no convincing evidence that some of them may not have been contemporary with or even earlier than the Sukhothai and Sawankhalok kilns. The sites, in order of their discovery, include the following:

1. Kalong	primarily wares decorated in underglaze black, a small number of brown-glazed and celadon wares; all thinly potted and with a whitish body
2. Sankampaeng	green-glazed, brown-glazed, two-glaze, and underglaze black decorated wares; the body brown to greyish
3. Phayao	a reported but unverified site; workmanship said to be similar to Kalong and Sankampaeng
4. Phan	pale to yellowish green celadons with a buff to greyish body

5. Vientiane[1]	mostly unglazed stonewares with grey, blackish, or brownish bodies; grey and reddish unglazed earthenwares; a small number of pale green-glazed and underglaze black decorated wares
6. Wang Nua	pale greyish to brown-bodied celadon wares, primarily heavily-potted plates
7. Lampang	brown and black-glazed wares with a greyish-brown body
8. Ban Mae Tao-hai	unknown

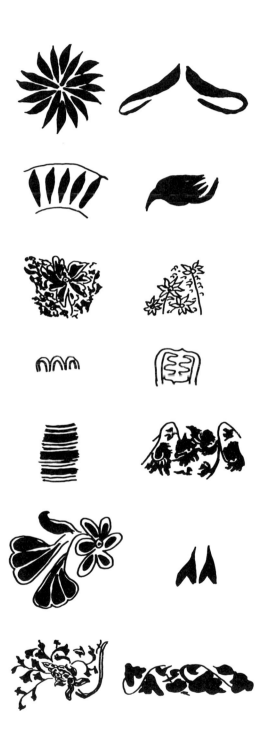

The Kalong kilns, first reported by Phrah Ram (1936), a former official at Sawankhalok, are located on the outskirts of the village of Ban Mae Kachan, 16 kilometres west of Wieng Papao, Chiengrai province. If Phrah Ram's data are correct, the site was one of the largest in the north, comprising over a hundred brick-constructed kilns, up to 5 or 6 metres in length, similar to those of Sukhothai and Sawankhalok. There have been no further published accounts of the kilns, and collected wares and fragments are rare, though the villagers at Ban Mae Kachan say that sherds litter the valleys for kilometres around. Renewed interest in the site, however, by the staff of the recently established museum at Chiengmai has resulted in the mapping of at least a dozen of the reported kilns. These are located near the banks of a stream that runs beside the earthen ramparts of an old town site on a hillock known as Wieng Kalong (from which the centre derives its name), and excavations there are planned as soon as funds permit.

The most distinctive characteristic of the Kalong wares is their fine-grained, whitish body, the clay source of which was probably a reason for the location of the kilns, and it is for this virtue that the Kalong are considered to be among the finest of all Thai ceramics. The wares are extremely thinly potted throughout, the thickness of the base and meticulously carved foot ring being just as thin as the walls of the vessels. Neither disc-shaped nor tubular supports have been reported from the site, and none of the wares so far known bear their scars. As with other Thai ceramics, the bases are unglazed. The majority of the wares are those decorated in broad strokes with underglaze black (see Fig. 23), though many examples of plates have cluttered vegetal decorations consisting of many short strokes; on some examples an undercoat of white slip can be discerned. Only two examples of wares other than those decorated with underglaze black have been seen by this writer: both were bowls in the collection of a villager; one had a thin, translucent bluish celadon glaze, and the other a dark, matt brown glaze. The clear glaze of the underglaze decorated wares may have either a bluish or greenish cast. Shapes known to have been produced at Kalong include pear-shaped bottles, vases, a large number of plates, and bowls with silghtly everted rims (#135–6, Pl. 41).[2]

Fig. 23 Kalong Underglaze Black Decorative Motifs

At the time of their discovery, Phrah Ram espoused the theory that the Kalong kilns pre-dated those at the kingdom of Sukhothai. His belief, however, was criticized by Le May (1939) who assumed an original Chinese influence on Thai ceramics and judged the Kalong wares to be no earlier than the fourteenth or fifteenth centuries both on stylistic grounds and from the evidence of associated finds at the site. Finds of Kalong sherds at excavations of the city walls of Chiengmai,[3] too, indicate that the kilns were operating after the founding of that city in 1350. Since the wares are not known to have been exported in quantity, it seems unlikely, in fact, that a potting centre the size of Kalong could have been possible until there was a large local market, which would have been assured with the founding of Chiengmai.

Certain underglaze decorations, plus the presence of brown-glazed and celadon wares, among other affinities, indicate a relationship between the Kalong and Sawankhalok kilns. Theories explaining this resemblance between the wares put forward by Kraisri Nimmanahaeminda (1960, p. 18) are either that potters from Sri Sachanalai accompanied a governor of Sawankhalok, Phya Yudhishthira, when he sought refuge from the king of Ayudhya at Chiengmai in 1447, or that they were taken as slaves in the subsequent one-year occupation of Sukhothai by Chiengmai in 1461. At any rate, it is doubtful whether the kilns survived the mid-sixteenth century Burmese invasion of northern Thailand when the *Glass Palace Chronicle* (Nimmanahaeminda, p. 18; also Harvey (1967), pp. 165–6) reports that King Bayinnaung of Burma ordered all artists, artisans, and craftsmen of every type to be resettled at Pegu.

A better known and the most accessible of the old northern kiln centres is Sankampaeng, 23 kilometres east of the old city walls of Chiengmai. Most of the kilns there are located near the small village of Pa Ting, whose inhabitants carry baskets of the wares dug from their fields to the roadside at the first sight of an interested visitor, and whose schoolmaster is an eager and knowledgeable guide. Other examples of the wares can be seen in the tourist shops of Chiengmai, and some are on display at the Chiengmai National Museum just outside the city.

The kilns were accidentally discovered in 1952 by Kraisri Nimmanahaeminda (1956 and 1960), a Thai businessman and antiquary, after he noticed many old pot sherds in the fields of the area. He also found an inscribed stone stele buried in the ruins of a nearby wat, the text of which commemorates the establishment of a Buddhist pagoda in 1488 and speaks of a gift of 25 families of slaves. On the basis of this Kraisri surmised, probably correctly, that the slaves were potters and that the kilns of the district date from that time. His supposition has been strengthened by later information on the location of Phu Lao, a place listed in the old Chronicles of Chiengsaen as being a part of that principality and whence, according to the Sankampaeng stele, many of the 'devout Buddhists' came to help build the wat. Kraisri has told the writer that while on a recent visit to Ban Houie Sai, a Laotian town on the Thai border north-east of Chiengmai, he met two former officials of Phu Kha, a district now in Communist hands, who said that Phu Lao was located on the banks of the Mekong River near their former home in northern Houa Khong province. They also said that many old pottery sherds could be found at the village.

Fig. 24 Sankampeang Underglaze Black Plate Centre Medallions

This hint that the potters of Sankampaeng may have come from Laos is especially interesting in the light of the general assumption, expressed earlier by Kraisri (1960) and also by Spinks (1971, pp. 112–25) that all the northern kilns were the handiwork of former Sawankhalok potters. In fact Sankampaeng pottery shows few stylistic similarities with either Sawankhalok or Sukhothai pottery. For instance, none of the distinctively Sawankhalok shapes such as the covered box, the potiche, the stem plate, or any zoomorphic vessels were copied at Sankampaeng, nor do the shapes of the plates and jars show any close resemblance. And although Kraisri has reported the finds of a few saggars, probably for the firing of finer pieces, no tubular or disc supports like those of Sawankhalok have ever been found.

The kilns, eighty-three of which have been surveyed, are scattered about a wide valley near Pa Ting village. They are quite primitive compared to those of the Sukhothai kingdom and are not likely to have been constructed by the same artisans. Barely 3 to 5 metres in length, they are built of hardened earth sometimes mixed with a few broken bricks, though, like other Thai kilns, they are oval-shaped with a firing compartment at the front and a chimney at the rear. According to Kraisri (1960) similar kilns are used even today by the Thai people still inhabiting Yunnan province in China, whence the Thai people originally migrated southwards into Thailand, Laos and Burma.

Sawankhalok or Sukhothai influence, however, is not wholly absent and can be traced in the shape of unglazed Khmer-like baluster jars which, though less elaborately decorated, resemble those of the Sukhothai kingdom. It can also be seen among some of the design patterns of the underglaze black decorated wares, which at Samkampaeng often have an olive tone beneath a slightly greenish glaze. The fish, most often in pairs, the solar whorl motif, and the use of floral and leaf sprays (see Fig. 24) are all reminiscent of Sawankhalok designs, as are the occasional use of classic scroll borders and lotus panels. But the underglaze wares of Sankampaeng comprise only medium-size plates (#132, Pl. 39), and even these are not numerous; such sherds characterize only a limited number of kilns some distance from Pa Ting village. The majority of the kiln sherds and wasters represent green-glazed, black-glazed, brown-glazed, two-glaze, and unglazed wares.

Except for the thickly constructed utility jars (#134, Pl. 40), the wares are usually thinly potted, brittle, and all are low-fired. Only the plates have carved, though short, foot rings. Other shapes have flat bases which are often so sharply cut that the edges are jagged. None of the bases are glazed. The body of the wares, a poor quality clay mixed with sand, varies between buff, light brown, reddish-brown, and greyish-black. The grit adhering to the bottoms of many jars indicates that these were set on the floor of the kiln for firing, while wasters show that the plates and dishes were stacked in piles base-to-base and face-to-face on unglazed rims (see Fig. 19).

The glaze of the green-glazed wares is thin, greyish-green, and customarily laid over a coat of white slip that appears to have been applied while the pot or dish was turning, for on upright vessels there are horizontal brush strokes beneath the glaze, and on the plates and dishes there are circular strokes (Colour Pl. S and #133, Pl. 40). The brown glaze is

usually thick and runny, and appears primarily on small jars; on larger pieces it often has a dark olive cast. The black glaze, which is confined to storage jars, is thin and sometimes combined on a vessel with green, a technique that may somehow have been derived from the Khmer two-glaze wares. One otherwise very typical Sankampaeng small jar illustrated here (Colour Pl. S, 2) has a rare combination of brown and green glazes. Other Sankampaeng shapes include bottles, utility jars, storage jars with flaring mouths, jars like modern fish-sauce jars with a flange rising from the neck (#131, Pl. 39), kendi with tubular necks and funnel-shaped spouts, sometimes with cup-like mouths, basins, bowls, plates and dishes.

Kraisri (1960) believes that the kilns, many of which were overgrown with large teak trees when he found them, must have ceased functioning several hundred years previously. They were probably abandoned, in 1558, after perhaps only seventy years of production, when King Bayinnaung's reported re-location of artisans to Burma took place. That date, indeed, probably marks the termination of all northern kilns (except for those at Vientiane), all of which show signs of a long period of dereliction.

After Kalong and Sankampaeng, a third possible ancient kiln centre 10 kilometres south of Phayao was reported in the late 1950s by Vipat Chutima (Nimmanahaeminda, 1960, p. 13). But although Kraisri published the report and remarked that the workmanship and raw material of the sherds brought to him were similar to those of Sankampaeng and Kalong, and Spinks (1971, p. 113) has suggested that potters may have been brought there by Prince Phya Yudhisthira who fled from Sukhothai in 1447 and was later appointed governor of Phayao by the king of Chiengmai, the actual presence of kilns has become doubtful. There has been no systematic investigation of the site, but villagers in the area say there are only small groups of sherds and no kilns.

The Phan kilns, a further discovery of Kraisri, were identified in 1962 (Spinks, 1971, p. 122). They produced only celadons, the average quality of which exceeds that of most Sawankhalok celadons (see Colour Pl. T). The glaze is evenly applied and lustrous, varying in colour from a pale green to a yellowish or pale lime-green; and though it is translucent and finely crazed, it does not have the glassy quality of most Sawankhalok examples, and it never runs in trickles. The potting is simple but sophisticated, and the body of the wares is fine-grained, homogeneous, and buff to greyish or slightly orange-beige. Decoration is lightly incised under the glaze, normally minimal, and not very common. On the bowls and dishes there may be a decorated centre medallion (Fig. 25), onion-skin medallions on the interior walls, or lotus petals on the exterior. Shapes include small jars, bowls, dishes, elephant figurines with small bowls on their backs, zoomorphic kendi, lamps, and fish net weights. The foot of the smaller pieces is usually splayed and flat-bottomed or slightly concave on the base. On the bowls and dishes a foot ring is carefully carved, sometimes with a bevel on the interior side.

The kilns occupy two sites near Phan township, Chiengrai province.[4] The larger group sits on two adjacent mounds in the middle of rice fields on the western outskirts of the village of Ban Pong Daeng, 6 kilometres north of Phan, and the smaller group is to be found at the village of Chumplu, a kilometre or so south of Phan. At Pong Daeng thirty kilns

Fig. 25 Phan Incised Decorative Motifs

have been surveyed by the Chiengmai National Museum, twelve of which were excavated in July 1973; at Chumplu eight were surveyed and three excavated. Built of brick and similar to those of Sukhothai and Sawankhalok, the kilns are set in clusters, with one group at Pong Daeng looking like spokes on a wheel with their chimneys forming the hub. Though none of the wares so far found bear their scars, tubular supports like those of Sawankhalok lie profusely scattered about the kilns. No disc-shaped supports have been found, nor any sherds with spur marks. Since no evidence for dating the kilns has yet been gathered, they could as easily be assumed to pre-date as post-date the Sawankhalok celadon production.

In December 1969 another group of kilns was excavated 3 kilometres east of Vientiane (Laos) on the road to Thaddeua. Although an ancient potting centre in the area had been suspected for some time (Velder, 1965), partly because the suburb, even today, is known as 'Tao-hai', literally 'jar kilns', and because of large amounts of sherds in the area, the actual existence of kilns was not verified until ground was broken for the construction of the Lao-German technical school that now occupies the site. Seven kilns were encountered at a depth of 2 to 3 metres; they were constructed of hardened earth similar to those at Sankampaeng. There are probably additional kilns buried in the earth nearby, for sherds matching those at the school site litter the ground all along a 3-kilometre stretch of the Mekong River bank.[5]

The pottery shapes include jars with two simple clay buttons on the shoulder, with flaring mouth rims, or with flanges rising from the neck— all strikingly analogous to those made at Sankampaeng (see Fig. 24), and also bowls, cups, lamps, small jars, and reddish-orange or greyish-black bodied kendi, sometimes with ribbed walls (Figs. 26–28). Those kendi with a reddish-orange body appear to be high-fired earthenware, and these are often covered with a thin reddish slip. A large number of ceramic smoking pipes were also found, and these have also occasionally been found at Sankampaeng. Most of the wares excavated are dark greyish-black bodied stonewares and unglazed. The only glazed pieces collected were a few bowls with a thin, translucent greenish glaze over a white slip, sometimes with child-like underglaze black decorations of circular or dot markings. The majority of the wares have a flat base that often has many parallel grooves that are probably marks of cutting the pieces from a wheel or turning table; on a few examples these grooves are semi-circular as on some Khmer and Sawankhalok wares. Handles have been applied by poking perforations through the body of a vessel and inserting the ends of the handles, a feature also seen among Sankampaeng wares.

On the basis of associated Chinese blue and white sherds excavated at the site, the kilns could not date much earlier than 1563 when, following the Burmese invasion of northern Thailand, the Laotian capital was moved from Luang Prabang to Vientiane (Mathieu, 1959, p. 36), nor much later than 1828 when the city was destroyed and the population re-located by the Thais (Mathieu, p. 44). Given the stylistic resemblances and the time period involved, the kilns may well have been operated by potters from Sankampaeng who fled eastward to Laos, whence they may have originally come, in the face of the Burmese encroachment into northern Thailand.

In Thailand itself, a group of recently located kilns in mounds amongst rice fields near Wang Nua, 30 kilometres south of Kalong, were surveyed

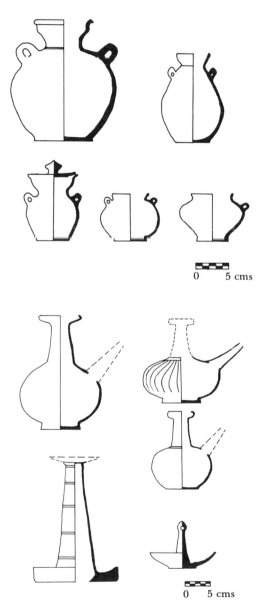

Fig. 26 Vientiane Wares

and partially excavated by the Chiengmai Museum staff in 1972. Twenty-five kilns were identified, and 11 excavated. Dug into hillsides, the kilns, as uncovered, had long dome-shaped shells with an interior firing shelf, a step down to the firing compartment at the front, and a chimney at the rear. Broad, short, cylindrical firing supports, closed at one end and reckoned to be spitoons by the local villagers, were found, and the kilns' wares consisted exclusively of rather crude, sturdily-potted celadons. Nearly all the sherds at the site represent plates with squarely carved, heavy foot rings, unglazed bases, brownish-grey bodies, and often scalloped mouth rims rather like pie crust edges (#137, Pl. 42). Finely-made examples such as that of Plate 42, #138 are a rarity. None of the wares so far seen have any incised decoration, and the glaze ranges in colour from a watery translucent medium-green to an opaque somewhat murky yellowish-green. As compared with other kiln sites in Thailand, the amount of sherd debris at Wang Nua is relatively small, a sign, perhaps, that the kilns' production was short-lived.

Encouraged by the town names of Tao-hai (like that of the Vientiane suburb), Kraisri Nimmanahaeminda in 1973 identified two further prospective old kiln centres. The first is at Tung Tao-hai near Lampang, east of Chiengmai where, he has told the writer, kilns were first discovered by the local people some twenty years ago during the widening of an old canal near Wat Chedi Sao, where a number of the wares have been collected. Sherds from the site kept in the storage rooms of the Chiengmai National Museum represent brown and black-glazed medium-sized jars with dark brown bodies, sometimes with a flange rising from the lower neck like those of Sankampaeng, and animal figurines (#139, Pl. 42). The second site with reported sherds, but which Kraisri had not yet personally examined, is at Ban Mae Tao-hai, village one, Tambon Nong Harn, Ampur San Sai, Chiengmai province, north of the city of Chiengmai, near the ruins of an ancient town called Wieng Pang Kam.

With each new discovery of an ancient kiln site in the area, northern Thai ceramic history becomes more intricate and complicated, but with further investigations its outlines are bound to take shape and will help reveal much about the culture and movements of the northern Thai people. One of the most interesting questions to be answered is whether ceramic influences filtered down from China along with the movements of the Thai people or whether the northern Thai kilns are the result of a chain reaction beginning with the importing of a number of Chinese or other foreign potters to Sukhothai. Another intriguing question is what happened to the potting craft during the hiatus between the mid-sixteenth century Burmese invasion of northern Thailand when all artisans are said to have been sent to Burma and the beginning of the twentieth century when several groups of Thai Shans migrated from Burma to Chiengmai and Chiengrai where they established kilns that produced the precursors of modern Thai celadon.[6] Undoubtedly there are old kiln centres to be discovered in Burma.

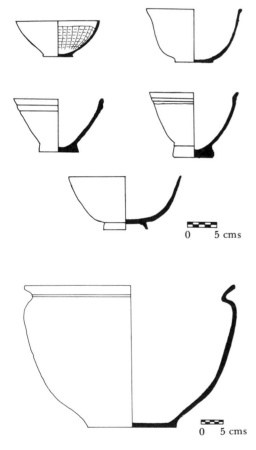

0 5 cms

0 5 cms

Fig. 27 Vientiane Wares

1. The Vientiane kilns are included in this chapter along with the northern Thai kilns both for convenience and because the history, culture, and language of northern Thailand and Laos are very much interrelated.

2. Other illustrations of the ware can be found in Kraisri Nimmanahaeminda (1960).

3. Information from a conversation with Kraisri Nimmanahaeminda.

4. For a further description of the site see Gluckman (1974).

5. The information given here has been gathered from a drawing of the kilns and their location distributed at an exposition of the wares at the Lao-German school in June 1970, from an examination of the finds, and from conversations with Mr. Outé Khamvongse of the École des Beaux Arts, Vientiane, who, with the Germans Nedja Suleiman Pasic and Paul Rupp, excavated the site in January 1970. For another description of the finds see Hang (1970). Most of the finds are preserved at the Laotian Handicraft Centre and at the École des Beaux Arts; others are on display in a showcase at the Lao-German school itself.

6. For accounts of the development of modern Thai celadon, see Nimmana-haeminda (1960), pp. 13–14; and Brown, 'Thai Celadons' (1973).

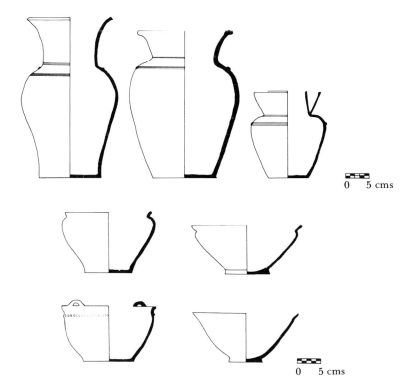

0 5 cms

0 5 cms

Fig. 28 Vientiane Wares

CONCLUDING REMARKS

CERAMICS as a tool for unravelling the past are invaluable. Once their place and time of manufacture can be established, they can indicate the sites and dates of habitation and trading centres, and they can provide clues to the extent and direction of old trading patterns and cross-cultural influences. As artifacts and works of art they can reveal much about the times and culture of the people who created them: one has only to study a Vietnamese blue and white pot of the mid-fifteenth century, for instance, to know that Vietnamese culture was strongly Chinese-influenced, and to suspect a more India-oriented society through the shape of a Khmer twelfth-century footed urn. The use of these objects by foreign cultures, too, has been the source of numerous anthropological studies. It was anthropologists, indeed, who first drew attention to the existence of old imported ceramics in places such as the Philippines and Borneo. In South-East Asia, where other manifestations of art and culture have often disappeared in the moist, hot atmosphere or beneath the fast growing tropical flora, and where history is often shrouded in legend, ceramics become especially important as a form of document.

For these reasons the ceramics of South-East Asia demand more study and research. This work is no more than an introductory survey. Further archaeological data is required, as well as the documentation of collections, and stylistic analyses and comparisons of the wares. The matter of cross-currents of ceramic influence within South-East Asia itself has only been touched upon here; this alone should be the basis of a further investigation of the objects. When the ceramic wares of these countries have been studied separately, their origins have been sought among Chinese ceramics. Yet there is substantial basis for the argument that at least Vietnamese and Thai ceramics directly influenced one another: shapes and decorations peculiar to them cannot be found amongst Chinese wares. It is possible that Vietnamese potters immigrated to Sukhothai, and likely that once a few kilns at Sawankhalok were begun they drew diverse potters from such places as Vietnam, Champa, and the Khmer dominions. A direct Chinese influence in the area probably came only with small groups of potters who moved there at specific times in history. In Cambodia, for example, stylistic evidence indicates that this happened only once—in the ninth century. In between and following these intrusions, which may one day be identified precisely, the ceramic art in South-East Asia evolved in its own individual patterns. The indigenous inventiveness of South-East Asian ceramics cannot be denied. While absorbing what China could give them, the local potters drew on the native environment for shapes and decorations. Once the dating of the material can be more firmly fixed, moreover, one may find that nearly as many ceramic influences flowed into China as from it. Only in its initial inspiration can the ceramics of South-East Asia be considered to be merely an extension of the Chinese ceramic art.

BIBLIOGRAPHY

ADDIS, JOHN M., 'The Dating of Chinese Porcelain Found in the Philippines: A Historical Retrospect' *Philippine Studies,* XVI, 2 (April 1968), pp. 371–80.

AYMONIER, ETIENNE, *Le Cambodge,* Vol. II. Paris: Ernest Leroux, 1901.

BEYER, H. OTLEY, *Southeast Asia Ceramic Wares,* Quezon City: University of the Philippines, 1960 (Unpublished manuscript).

———— 'Outline Review of Philippine Archaeology by Islands and Provinces', *The Philippine Journal of Science,* LXXVII, 2 & 3 (July–August 1947), pp. 205–374.

BEZACIER, LOUIS, *Le Viet-Nam,* Paris: Éditions A. & J. Picard, 1972.

BIAGINI, JEAN AND MOURER, ROLAND, 'La Poterie au Cambodge', *Objets et Mondes,* XI, 2 (Summer 1971), pp. 197–220.

BOISSELIER, JEAN, *Le Cambodge,* Paris: Éditions A. & J. Picard, 1966.

BRIGGS, L.P., 'Siamese Attacks on Angkor before 1430', *Far Eastern Quarterly,* VIII (1948), pp. 3–33.

BRINKLEY, FRANK, *Japan and China,* Vol. IX, London: T.C. & E.C. Jack, 1903–4.

BROWN, ROXANNA M., 'Thai Celadons', *Arts of Asia,* III, 2 (March–April 1973), pp. 39–44.

———— 'Khmer Ceramics', *Arts of Asia,* III, 3 (May–June 1973), pp. 30–5.

———— 'Ceramic Excavations in the Philippines', *TSACS,* I (1973).

———— 'The History of Ceramic Finds in Sulawesi', *TSACS,* II (1974).

———— *The Legacy of Phra Ruang,* London: Bluetts & Co., 1974.

———— 'Preliminary Report on the Koh Khram Sunken Ship', *Oriental Art,* (Winter 1975).

BROWN, ROXANNA M. AND CHILDRESS, VANCE, 'Khmer Pottery at Ban Phluang', *Oriental Art,* in press.

BROWN, ROXANNA M., CHILDRESS, VANCE, and GLUCKMAN, MICHAEL, 'Khmer Kiln Site—Surin Province', *JSS,* LXII, 2 (July 1974), pp. 239–52.

BU'U CAN et al., *Hong Du'c Ban Do,* Saigon: Institute of Historical Research, 1962.

CADIÈRE, M.L., 'Tableau Chronologique des Dynasties Annamites', *BEFEO,* V (1905), pp. 77–145.

CHANG T'IEN-TSE, *Sino-Portuguese Trade From 1514 to 1644,* Leyden, 1969.

(The) *Charles B. Hoyt Collection,* Boston: Museum of Fine Arts, 1952.

CHÊNG TÊ-K'UN, 'The Study of Ceramic Wares in Southeast Asia', *The Journal of the Institute of Chinese Studies,* V, 2 (December 1972), pp. 1–40.

CHÊNG TÊ-K'UN, *Prehistoric China,* Vol. I, Cambridge: W. Heffer & Sons, 1959.

COEDÈS, GEORGE, 'Les Statues Décapitées de Savank'alok', *Bulletin et Travaux de L'Institut Indochinois pour L'Étude de L'Homme,* II (1939), 2.

———— *Inscriptions du Cambodge,* Vol. II, Hanoi: Imprimerie D'Extrême-Orient, 1942.

———— *The Making of Southeast Asia,* London: Routledge & Kegan Paul, 1966.

———— *The Indianized States of Southeast Asia,* Honolulu: East-West Center Press, 1968.

COMBAZ, GISBERT, *Inde et L'Orient Classique,* Paris: Librairie Orientaliste Paul Geuthner, 1937.

D'ARGENCÉ, LEFEBVRE, *Les Céramiques à Base Chocolatée,* Paris: École Française D'Extrême-Orient, 1958.

DEVERIA, G., *Histoire des Relations de la Chine avec L'Annam-Vietnam du XVIe au XIXe Siecle,* Paris: Librairie de la Société Asiatique de L'Ecole Langues Orientales Vivantes, 1880.

DUMARÇAY, JACQUES, *Charpentes et Tuiles Khmères,* Paris: École Française D'Extrême-Orient, 1973.

DUMOUTIER, G., 'Lettre au Director de L'École Française D'Extrême-Orient', *BEFEO,* III, 2 (1903), pp. 365–7.

FERRAND, GABRIEL, *Relations de Voyages et Textes Geographiques Arabes, Persans et Turks Relatifs a L'Extrême-Orient du VIIIe au XVIIIe Siècles,* Paris: Ernest Leroux, 1913–14.

FINOT, LOUIS, 'Dharmâcâlas au Cambodge', *BEFEO,* XXV (1925), pp. 417–22.

FLOOD, THADEUS, 'Sukhothai-Mongol Relations: A Note on Relevant Chinese and Thai Sources', *JSS,* LVII, 2 (July 1969), pp. 201–57.

FOURNEREAU, LUCIEN, 'La Cèramique du Thais', *Le Siam Ancien,* Paris: Annales du Musée Guimet, XXXI, 2 (1908), pp. 129–38.

FOX, ROBERT B., 'The Calatagan Excavations', *Philippine Studies,* VII, 3 (August 1959), pp. 325–90.

GARNER, SIR HARRY, *Oriental Blue and White,* London: Faber and Faber, 1954.

———— 'The Use of Imported and Native Cobalt in Chinese Blue and White' *Oriental Art,* II, 2 (Summer 1956), pp. 48–50.

GERINI, G.E., 'Siamese Archaeology', *Journal of the Royal Asiatic Society* (April 1904), pp. 233–42.

———— *Researches on Ptolemy's Geography of Eastern Asia,* London: Royal Asiatic Society, 1909.

GLUCKMAN, MICHAEL, 'A Visit to the Phan Kilns in Northern Thailand', *TSACS,* II (1974).

GOLOUBEW, VICTOR, *Le Phnom Kulen,* Hanoi: Cahiers de la Société de Geographie de Hanoi, 1924.

———— 'La Province de Thanh-hoa et sa Cèramique', *RAA,* VII (1931–2), pp. 112–16.

GRAHAM, W.A., 'Pottery in Siam', *JSS,* XVI, 1 (October 1922), pp. 1–27.

GRAY, BASIL, *Early Chinese Pottery and Porcelain,* London: Faber and Faber, 1953.

GRISWOLD, A.B., *Towards a History of Sukhodaya Art,* Bangkok: Fine Arts Department, 1967.

GROSLIER, BERNARD PHILIPPE, 'Les Fouilles du Palais Royal D'Angkor Thom', *Proceedings of the 23rd International Congress of Orientalists,* London, Royal Asiatic Society, 1957.

———— *Indochina,* Cleveland & New York: The World Publishing Co., 1966.

GROSLIER, GEORGE, *Recherches sur les Cambodgiens,* Paris: Librairie Maritime et Coloniale, 1921.

GUNN, C. CHAN, *The Talking Jars,* Vancouver: Vancouver Society for Asian Art, 1972.

HALL, D.G.E., *A History of South-East Asia,* London: MacMillan, 1968 (third edition).

HANG MINH KIM, 'Viengchan et son Ancien Site', *Bulletin des Amis du Royaume Lao,* no. 3 (October–December 1970), pp. 100–16.

HARVEY, G.E., *History of Burma,* London: Frank Cass & Co., 1967.

HEJZLAR, S., *The Art of Vietnam,* London: Hamlyn, 1973.

HETHERINGTON, A.L., *Chinese Ceramic Glazes,* South Pasadena: P.D. and Ione Perkins, 1948.

HIRTH, F., *China and the Roman Orient,* Leipsic & Munich: Georg Hirth, 1885.

HOBSON, R.L., 'Chinese Porcelain at Constantinople', *TOCS,* no. 11 (1933–4), pp. 9–14.

HONEY, WILLIAM BOWYER, *The Ceramic Art of China and Other Countries of the Far East,* London: Faber and Faber, 1945.

HUET, CLÉMENT, 'Les Pots à Chaux; Les Pipes à Eau', *BMRAH,* no. 4 (July–August 1941), pp. 74–84.

———— 'Les Terres Cuites de Thô-ha; Les Brule-Parfums de Bat-trang', *BMRAH,* no. 1 (January–February 1942), pp. 2–9.

———— 'Les Terres Cuites Architecturales de Dai-la', *BMRAH,* no. 3 (May–June 1942), pp. 50–61.

ITO, CHUTA AND KAMAKURA, YOSITARO, *Nankai Koto Kame,* Tokyo: Houn-sha, 1941 (first edition, 1937). Translated in manuscript (unpublished) by the Translation Unit of the Australian National University as *Pottery and Porcelain in Southern Lands,* 1971.

JACQUEMART, ALBERT, *Histoire de la Porcelaine,* Paris, 1873.

JANSE, OLOV R.T., 'Breaking New Archaeological Ground in Indo-China', *ILN* (13 July 1935), pp. 50–4.

———— 'The Mysterious Culture of Dong-so'n', *ILN* (28 December 1935), pp. 1172–5.

———— 'Rapport Préliminaire D'Une Mission Archéologique en Indochine', *RAA,* IX, 3 (1935), pp. 144–53; IX, 4 (1935), pp. 209–17; X, 1 (1936), pp. 42–52.

———— 'The Solar Tree Myth in Indo-China', *ILN* (7 March 1936).

———— 'Han Dynasty Art as Developed in Indo-China', *ILN* (25 December 1937), pp. 1142–6.

———— 'A Source of Ancient Chinese Pottery Revealed in Indo-China', *ILN* (12 November 1938), pp. 894–7.

———— 'An Archaeological Expedition to Indo-China and the Philippines', *HJAS,* VI (1941), pp. 247–67.

———— 'Notes on Chinese Influences in the Philippines in Pre-Spanish Times', *HJAS,* VIII (1944), pp. 34–62.

———— *Archaeological Research in Indo-China,* 3 vols., Cambridge, Mass: Harvard University Press, I, 1947 and II, 1951; Bruges: St. Catherine Press, III, 1958.

JENYNS, SOAME, *Ming Pottery and Porcelain,* London: Faber and Faber, 1935.

JOSEPH, ADRIAN M., *Ming Porcelains, Their Origins and Development,* London: Bibelot Publishers Ltd., 1971.

———— *Chinese and Annamese Ceramics,* London: Hugh Moss Ltd., 1973.

KOYAMA, FUJIO, 'Liao Pottery Wares', *TOCS* (1962–63), pp. 69–80.

KOYAMA, FUJIO AND FIGGESS, JOHN, *Two Thousand Years of Oriental Ceramics,* London: Thames and Hudson, 1961.

LAMMERS, CHENG AND ABU RIDHO, *Annamese Ceramics in the Museum Pusat, Jakarta,* Jakarta: Museum Pusat, 1974.

LAUFER, BERTHOLD, *Chinese Pottery of the Han Dynasty,* London: E.J. Brill, 1909.

LÊ THÀNH KHÔI, *Le Viêt-Nam: Histoire et Civilization,* Paris: Les Éditions de Minuit, 1955.

LE MAY, REGINALD, 'A Visit to Sawankhalok', *JSS,* XIX, 2 (1925), pp. 63–82.

———— *An Asian Arcady, the Land and Peoples of Northern Siam,* Cambridge: W. Heffer & Sons Ltd., 1926.

———— 'A Review of H. Otley Beyer's 'A Preliminary Catalogue of Pre-Spanish Ceramic Wares Found in the Philippines', *JSS,* XXV, 2 (1932), pp. 230–2.

———— 'The Ceramic Wares of North-Central Siam', *The Burlington Magazine,* LXIII, 367 & 368 (October and November 1933).

———— 'Notes and Queries on Thai Pottery', *JSS,* XXXI, 1 (March 1939), pp. 57–67.

———— 'The Ceramic Wares of Siam', *TOCS,* XX (1944–5), pp. 9–10.

LOCSIN, LEANDRO AND CECILIA, *Oriental Ceramics Discovered in the Philippines,* Rutland, Vermont & Tokyo: Charles E. Tuttle Co., 1967.

LUNET DE LAJONQUIÈRE, E., *Le Siam et Les Siamois,* Paris: Librairie Armand Colin, 1906.

———— 'Essai D'Inventaire Archèologique du Siam', *Bulletin de la Commission Archèologique de L'Indochine,* Paris, 1912.

LYLE, T.H., 'Siam: Celadon Ware', *Man,* no. 41 (1901).

———— 'Notes on the Ancient Pottery Kilns at Sawankhalok, Siam', *Journal of the Royal Anthropological Institute,* XXXIII (1903), pp. 238–45.

MADROLLE, *Guide Madrolle: Indochine du Nord,* Paris: Librairie Hachette, 1925.

MASPERO, G., *Le Royaume de Champa,* Paris, 1928.

MATHIEU, A.R., 'Chronological Table of the History of Laos', *Kingdom of Laos,* Saigon: France-Asia, 1959.

MEDLEY, MARGARET, 'Review of William Willetts' *Ceramic Art of South-east Asia',* Apollo (February 1972), p. 150.

MILLS, J.V.G., *The Overall Survey of the Ocean's Shores,* Cambridge: University Press, 1970.

NIMMANAHAEMINDA, KRAISRI, 'Sankampaeng Glazed Potteries', *JSS,* XLIII, 2 (January 1956), pp. 139–41.

———— *Sankampaeng Glazed Pottery,* Chiengmai: The Konmuang Publ. Co., 1960.

OKUDA, SEIICHI, *Annam Toji Zukan* (or) *Annamese Ceramics,* Tokyo, 1954.

PARMENTIER, H., 'Complément a L'Art Khmer Primitif', *BEFEO*, XXXV (1935), pp. 1–158.

PATKÓ, IMRE AND MIKLOS RÉV, *L'Art du Viêt-Nam*, Paris: Éditions Aimery Somogy, 1967.

PELLIOT, PAUL, *Memories sur les Coutumes du Cambodge de Tcheou Ta-Kouan*, Paris: Librairie D'Amerique et D'Orient, 1951.

PIRES, TOME, *Suma Oriental*, 2 vols., London: Hakluyt Society, 1944.

POPE, JOHN ALEXANDER, *Fourteenth Century Blue-and-White*, Washington, D.C.: Smithsonian Institution, 1952.

———— *Chinese Porcelains From the Ardebil Shrine*, Washington D.C.: Smithsonian Institution, 1956.

PRAH RAM, PHAYA NAKON, 'Thai Pottery', *JSS*, XXIX, 2 (August 1936), pp. 13–36.

PREMCHIT, SOMMAI, *Thai Pottery in Philippine Prehistory*, Quezon City: University of the Philippines (Unpublished Master's thesis), 1971.

RAMA VI, H.M., *Tiaw Muang Phra Ruang* ('A Tour of the Country of Phra Ruang'), Bangkok: Ministry of the Interior, 1954 (first edition, 1909).

RAPHAEL, OSCAR, 'Notes on Siamese Ceramics', *TOCS* (1930–31), pp. 24–7.

ROBB, WALTER, 'New Data on Chinese and Siamese Ceramic Wares of the 14th and 15th Centuries', *Philippine Magazine*, XXVII, 3 & 4 (August & September 1930).

SANDERS, HERBERT, *The World of Japanese Ceramics*, Tokyo and Palo Alto: Kodansha International Ltd., 1967.

SCHAFER, EDWARD H., *The Vermilion Bird*, Berkeley & Los Angeles: University of California Press, 1967.

SILICE, A. AND GROSLIER, G., 'La Cèramique dans L'Ancien Cambodge', *Arts & Archèologie Khmers*, Vol. I, Paris: Société D'Éditions Geographiques, Maritimes et Coloniales, 1921–3, pp. 31–63.

SILICE, A. AND STOEKEL, JEAN, 'Materiaux pour Servir à L'Étude de la Cèramique au Cambodge', *Arts & Archèologie Khmers*, Vol. I, Paris: Société D'Éditions Geographiques, Maritimes et Coloniales, 1921–23, pp. 149–53.

SPINKS, CHARLES NELSON, 'Siam and the Pottery Trade of Asia', *JSS*, XLIV, 2 (August 1956), pp. 61–105.

———— *Siamese Pottery in Indonesia*, Bangkok: The Siam Society, 1959.

———— 'A Ceramic Interlude in Siam', *Artibus Asiae*, XXIII (1960), pp. 95–110.

———— *The Ceramic Wares of Siam*, Bangkok: The Siam Society, 1971 (first edition, 1965).

STARGARDT, JANICE, 'Southern Thai Waterways: Archaeological Evidence on Agriculture, Shipping and Trade in the Srivijayan Period', *Man*, VIII, 1 (March 1973), pp. 5–29.

TAN YEOK SEONG, 'Report on the Discovery of Ancient Porcelain Wares in Celebes', *Journal of the South Seas Society*, XII, 1 (June 1956), pp. 1–4.

TJANDRASAMITA, UKA, *Projek Penggalian Di Sulawesi, 1970* (or) *The South Sulawesi Excavation Project, 1970*, Djakarta: Lembaga Purbakala dan Peningalan Nasional, 1970.

TRÂN VAN TÔT, 'Introduction à L'Art Ancien du Viêt-Nam', *BSEI*, XLIV, 1 (1969), pp. 5–103.

VALLIBHOTAMA, SRISAKRA, 'The Khmer Ceramic Kilns of Ban Kruat and Their Preservation', *Our Future*, II, 7 (January–February 1974), pp. 30–3 (Bangkok.)

VAN ORSOY DE FLINES, E.W., *Gids Voor de Keramische Verzameling*, Djakarta: Museum Pusat, 1949. Translated as *Guide to the Ceramic Collection*, 1969.

VELDER, CHRISTIAN, 'La Poterie du Wat Si Satthanak, Vientiane (Laos)', *Felicitation Volumes of Southeast-Asian Studies*, Vol. II, Bangkok: The Siam Society, 1965.

VLEKKE, BERNARD H.M., *Nusantara : A History of Indonesia*, The Hague: W. Van Hoeve, 1965 (first edition, 1943).

VOLKER, T., *Porcelain and the Dutch East India Company*, Leiden: E.J. Brill, 1954.

VU'O'NG HÔNG SÊN, 'Les Bleus de Hué', *BSEI*, I (1944), pp. 57–70.

WAITHAYAKON, PRINCE WAN, *Stone Inscriptions of Sukhothai*, Bangkok: The Siam Society, 1965.

WATT, J.C.Y., 'South-East Asian Pottery—Thai, in Particular', *Bulletin of the Art Gallery of South Australia*, XXXII, 4 (April 1971).

WHITE, PETER T. AND GARRETT, W.E., 'South Vietnam Fights the Red Tide', *National Geographic Magazine* (October 1961), pp. 445–89.

WILLETTS, WILLIAM, *Foundations of Chinese Art*, London: Thames and Hudson, 1965.

——— *Ceramic Art of Southeast Asia*, Singapore: Southeast Asian Ceramic Society, 1971.

WOLTERS, O.W., *The Fall of Srivijaya in Malay History*, Kuala Lumpur: Oxford University Press, 1970.

YULE, SIR HENRY, *The Book of Ser Marco Polo the Venetian Concerning the Kingdoms and Marvels of the East*, 2 vols., London: John Murray, 1929.

INDEX

COLOUR PLATES

PLATE A
VIETNAMESE WARES

1. House model, unglazed, with a flat base, reddish body, and removable roof. First to third centuries. Length of roof: 27·5 cms. Saigon National Museum.

2. Covered urn, with two single leafed-vine motifs (one shown) and two lotus profiles, a flat unglazed base, and whitish body; covered with a slightly greenish translucent glaze, the interior body also glazed. Ht. 25 cms. Late tenth to twelfth centuries. Saigon National Museum.

3. Covered urn, with a flat unglazed base, whitish body, and a thin copper green glaze. Ht. 21 cms. Late tenth to twelfth centuries. Saigon National Museum.

4. Covered urn, unglazed, with four handles, a carved foot ring, and brownish-grey body. Ht. 22 cms. Late tenth to early twelfth centuries. Saigon National Museum.

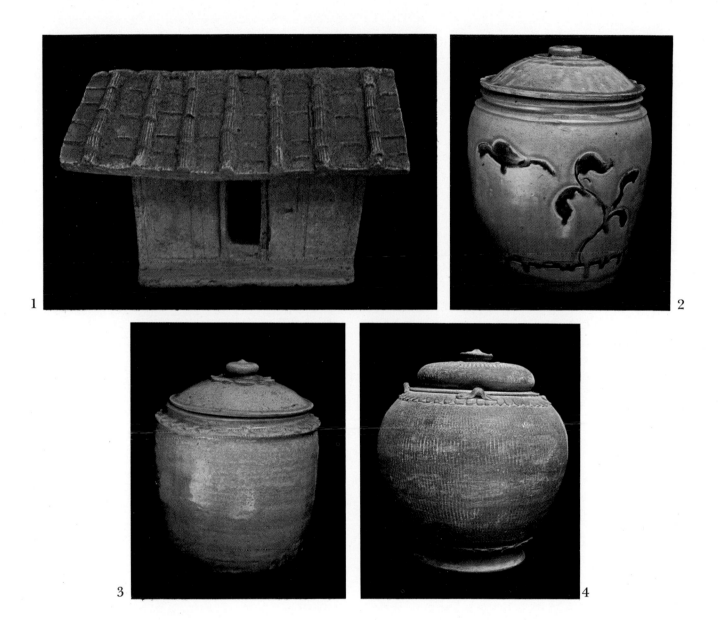

PLATE B
VIETNAMESE WARES

1. Wine pot, with a carved foot ring, whitish body, and crackled white glaze. Ht. 12 cms. Late twelfth to thirteenth centuries. Saigon National Museum.

2. Covered box, with a carved foot ring bevelled on its interior side, whitish body, unglazed interior, and covered with a thin, pale copper green glaze. Diam. 7 cms. Thirteenth century. Saigon National Museum.

3. Jar, with four handles, a flat unglazed base, unglazed interior, and whitish body; covered with a pale, crackled copper green glaze, with reddish slip on the lower body. Ht. 9 cms. Thirteenth century. Saigon National Museum.

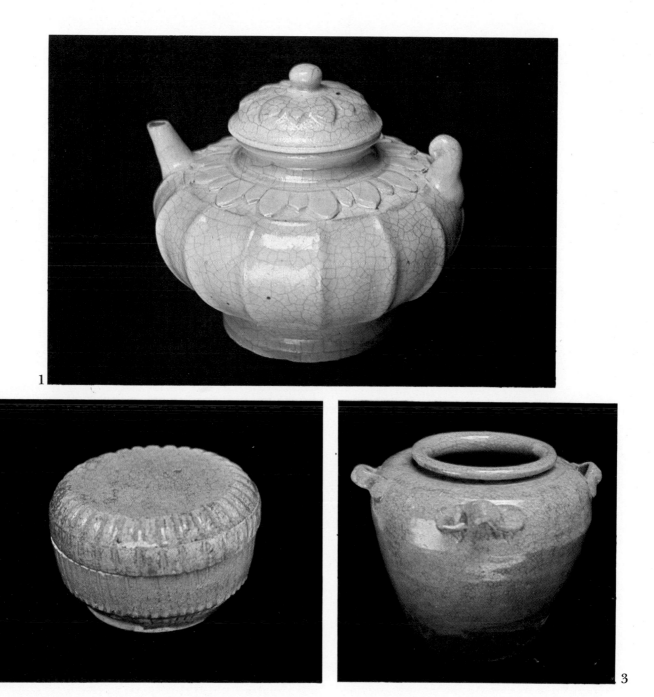

PLATE C
VIETNAMESE WARES

1. Wine pot, with a shallow, carved, unglazed foot, whitish body, and crackled greyish olive-green celadon glaze. Ht. 17·5 cms. Thirteenth century. Saigon National Museum.

2. Bowl, with a carved, unglazed foot, whitish body, incised decoration, and translucent lime-green glaze. Ht. 7·5 cms. Thirteenth century. Saigon National Museum.

3. Bowl, with a carved foot ring, chocolate base, unglazed mouth rim, and blackish-brown glaze. Diam. 18 cms. Thirteenth century. Saigon National Museum.

4. Beaker, with shallow fluting on the exterior, a carved foot ring, chocolate base, five triangular-shaped spur marks on the interior bottom, and pale, runny copper green glaze. Ht. 12·5 cms. Thirteenth century. Saigon National Museum.

PLATE C

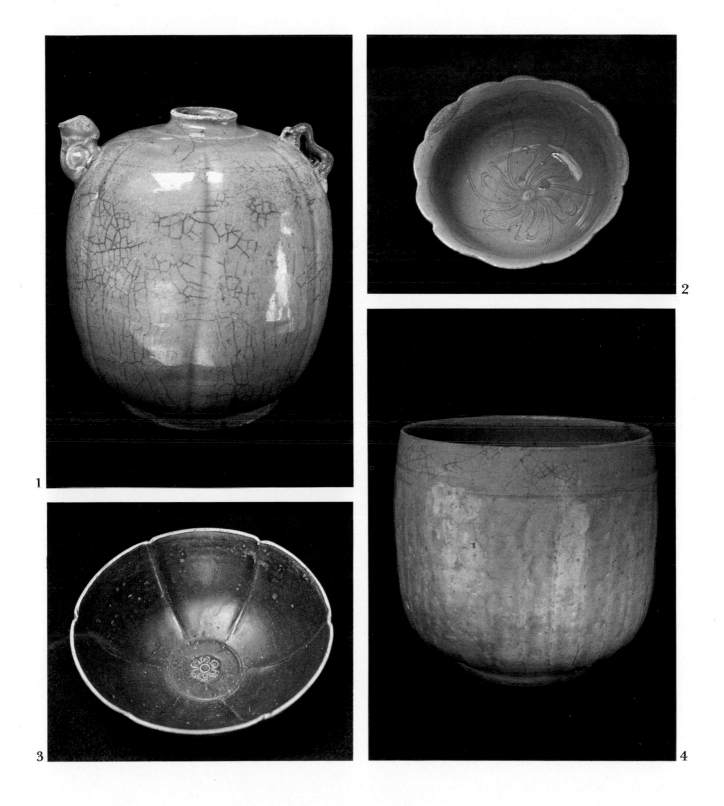

PLATE D
VIETNAMESE WARES

1a,b Plate, with a wide, shallow, carved foot ring, chocolate base, flattened mouth rim with a raised outer edge, six spur marks on the interior bottom, and a translucent, slightly greenish glaze; decorated in underglaze black. Diam. 28·5 cms. Fourteenth century. Collection of Benno Anciano.

2. Covered box, with a flat base, whitish body, and a fruit stem and calyx moulded on the cover; decorated in underglaze blue. Diam. 6·5 cms. Fifteenth to sixteenth centuries. Collection of Mr. and Mrs. Martin P. Gillert.

3. Covered box, the cover moulded and the whole painted in a pale hue of underglaze blue to resemble a phoenix; with a shallow carved foot and whitish body, the interior with a translucent, slightly greenish glaze. Ht. 6·5 cms. Early or mid-fifteenth century. Private collection.

4. Bowl, with a tall carved foot ring, chocolate base, and whitish body; decorated in a runny underglaze blue wash. Diam. 11·7 cms. Fifteenth to sixteenth centuries. Saigon National Museum.

5. Bottle, pear-shaped, with a carved foot; decorated in red and green enamels. Ht. 25 cms. Fifteenth to sixteenth centuries. Collection of Virgil and Suzanne Walston.

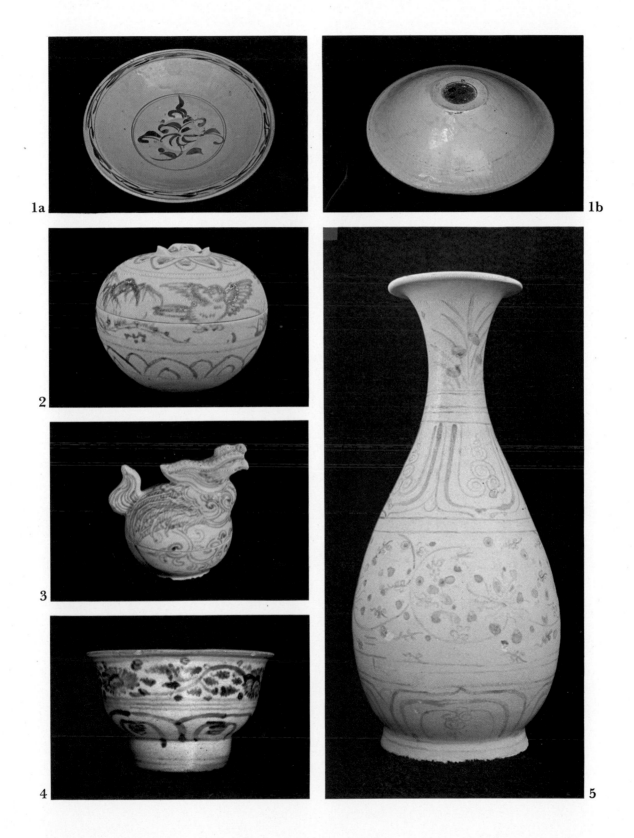

1a

1b

2

3

4

5

PLATE E
INSCRIBED TOPKAPU
SARAYI BOTTLE

Bottle, with a carved chocolate base
and an inscription in Chinese charac-
ters around the shoulder reading
'Painted for pleasure by P'ei, a work-
man of Nam Sach Phu in the 8th year
of 'Ta Ho', a date corresponding to
A.D. 1450. Ht. 54 cms. Reproduced
by permission of the Topkapu Sarayi
Museum, Istanbul.

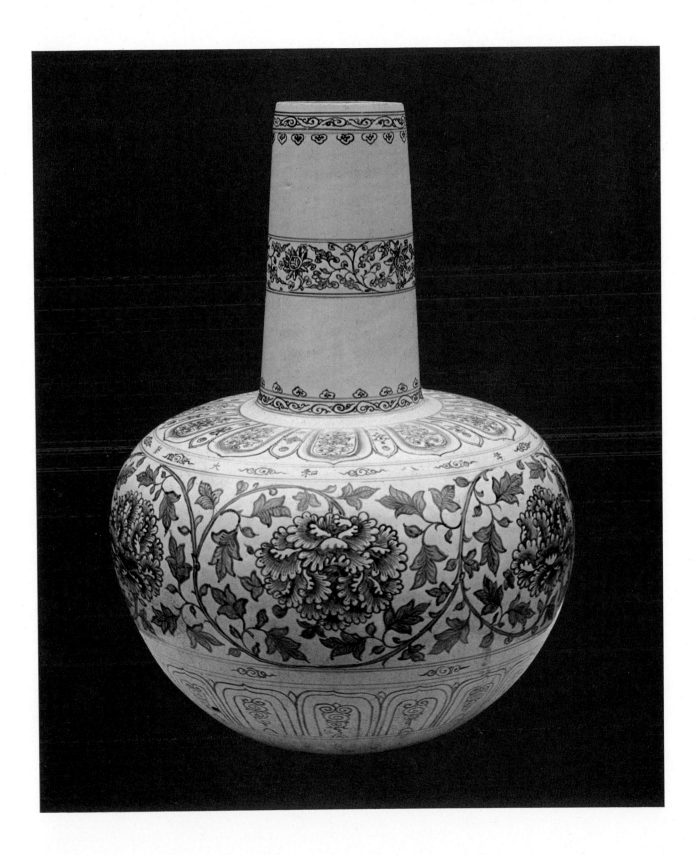

PLATE F
VIETNAMESE WARES

1. Bowl, with a carved foot and glazed base; decorated in greyish-blue underglaze wash with two single peony blossoms and leaves (one shown); the glaze crackled and greyish. Diam. 22 cms. Seventeenth to eighteenth centuries. Saigon National Museum.

2. Vase, with a thick, rounded foot ring, glazed base, and dirty whitish body; decorated in a greyish-blue underglaze wash with a fir tree on one side (shown), and a tall bamboo on the other; the glaze crackled and greyish. Ht. 27 cms. Seventeenth to eighteenth centuries. Saigon National Museum.

3. Dish, with a carved foot ring, glazed base, metal mouth band, dirty whitish body, and three spur marks on the interior bottom; decorated in greyish and dark blue underglaze wash; the glaze crackled and greyish. Diam. 18 cms. Seventeenth to eighteenth centuries. Saigon National Museum.

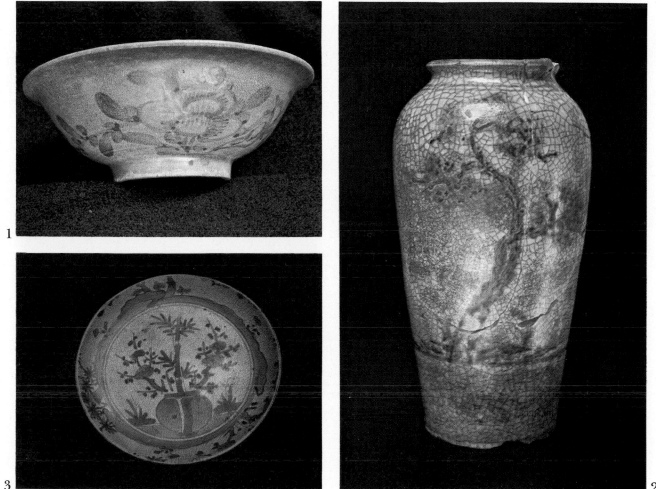

PLATE G
VIETNAMESE WARES

1. Lime pot, with whitish body, a brown-glazed ring at the lower body, white and green glazes. Ht. 11 cms. Dated fourteenth century by Huet (1941, Figs. 7–8). Saigon National Museum.

2. Censer, with a rounded foot ring, buff-orange body, white and green glazes. Ht. 14·3 cms. Fifteenth to sixteenth centuries. For a similar piece in the Musée Historique, Hanoi, see Patkó and Rév, Pl. 39. Saigon National Museum.

3. Censer, hollow, with a floor separating the upper and middle sections, unglazed, carved or moulded appliqué decorations, and a thin, translucent greenish glaze. Ht. 31 cms. Sixteenth to seventeenth centuries. For a similar piece see Dumoutier, Fig. 1. Saigon National Museum.

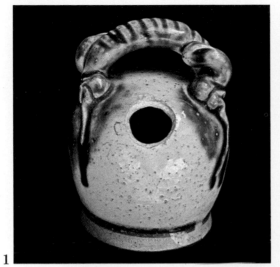

1

2

3

PLATE H
CHAM WARES
c. Late Thirteenth to Mid-fifteenth Centuries

1. Dish, with a pale orange body, runny greyish-green glaze, and an unglazed stacking ring on the interior bottom with the scar of the dish that was set above. Diam. 16·7 cms. Collection of Ha duc Can.

2. Jar, with a reddish-orange body, the decoration incised through a golden-brown glaze. Ht. 42 cms. Collection of Ha duc Can.

3. Jar, with a reddish-orange body, the decoration incised through a runny golden-brown glaze. Ht. 24·5 cms. Collection of Ha duc Can.

4. Basin, with a flat base, buff-orange body, and largely unglazed exterior; the interior and a thin strip of the exterior with a runny greenish-brown glaze. Ht. 23 cms., diam. 41 cms. Collection of Ha duc Can.

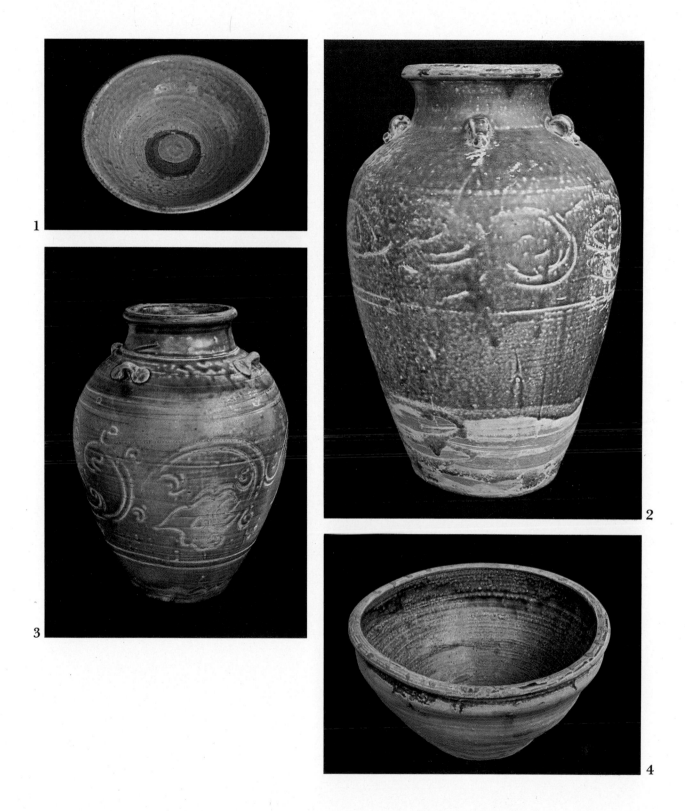

1

2

3

4

PLATE I
KHMER WARES

1. Bottle, with a flat, slightly concave, glazed base with a single incised slash; the glaze runny, translucent, and pale green. Ht. 18·5 cms. From Sambour Prei Kuk, late tenth or early eleventh centuries. Conservation D'Angkor.

2. Jardinière, with four feet, incised and modelled decoration, buff paste, and a thin, watery pale green glaze. Ht. 14·2 cms, diam. 25 cms. From Sra Srang, second half of the eleventh century. Conservation D'Angkor.

3. Lime pot, with the zoomorphic features of an owl, a flat cord-cut foot, pale greyish body, and greenish-cream crackled glaze. From North-East Thailand, mid-eleventh century, Baphuon period. Private Collection.

4. Lime pot, modelled and incised to depict a caparisoned elephant with carriage; with four feet, pale grey body, and thin yellowish-green glaze. Ht. 16·5 cms. Late eleventh century, Jayavarman VI period. Conservation D'Angkor.

PLATE I

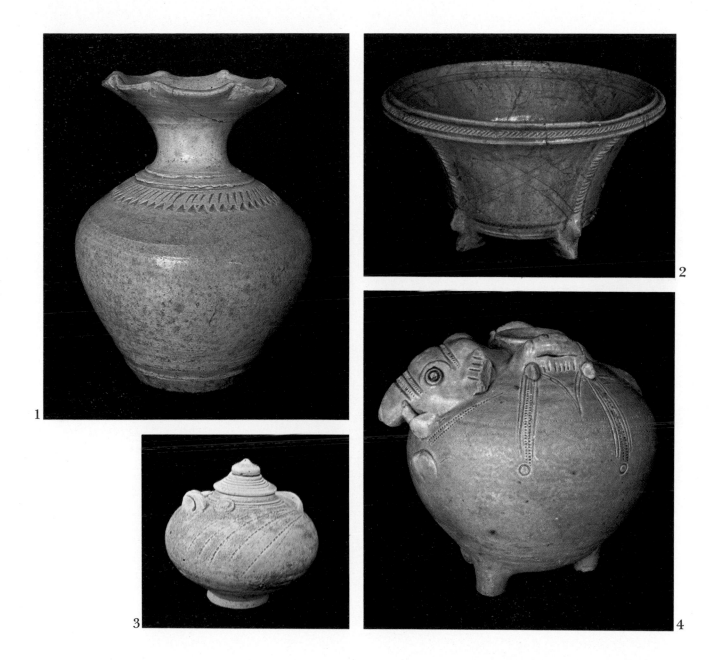

PLATE J
KHMER WARES

1. Jar, heavily potted and unglazed, the body smooth and purplish-brown with reddish discolorations. Ht. 49 cms. *Lie de vin* ware, tenth to early eleventh centuries. Conservation D' Angkor.

2. Ewer, with reddish body, a flat unglazed foot, and olive-brown glaze. Ht. 25 cms. From North-East Thailand, second half of the eleventh century. Private Collection.

3. Lime pot, modelled and incised to represent a bulbous, caparisoned elephant, with four feet, buff-brownish body, light caramel-brown glaze, and a strip of pale green glaze at the lower body. Ht. 11·5 cms. From Sra Srang, second half of the eleventh century. Conservation D'Angkor.

4. Bottle, gourd-shaped, with the upper portion glazed pale yellowish-green and the lower dark brown. Ht. 11 cms. Second half of the eleventh century. Conservation D'Angkor.

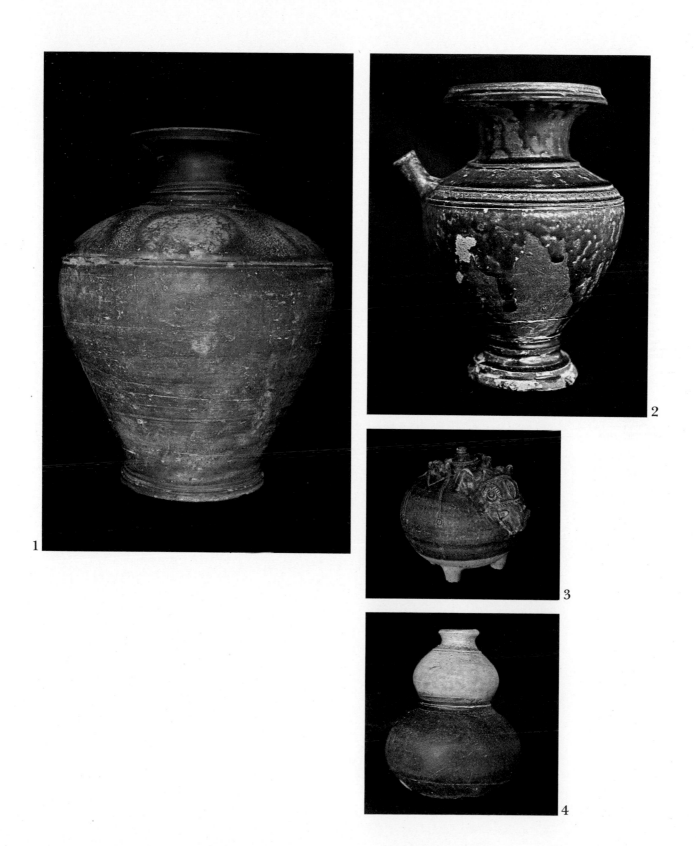

PLATE K
KHMER WARES

1. Footed urn, with a flowing glaze that is light caramel-brown where thin and blackish where thick. Ht. 40 cms. From North-East Thailand, fourth quarter of the eleventh century, Jayavarman VI period. Private Collection.

2. Jar, with incised decoration, buff body, and a light caramel-brown glaze. Ht. 14·5 cms. From Sra Srang, fourth quarter of the eleventh century. Jayavarman VI period. Private Collection.

3. Perfume box, with a flat cord-cut foot, yellowish-buff body, brown glaze, and glazed interior. Ht. 6·5 cms. From Sra Srang, fourth quarter of the eleventh century, Jayavarman VI period. Conservation D'Angkor.

4. Lime pot, modelled and incised to represent a rabbit, with buff body and a flowing light brown to blackish glaze. Ht. 11·5 cms. From North-East Thailand, fourth quarter of the eleventh century, Jayavarman VI period. Private Collection.

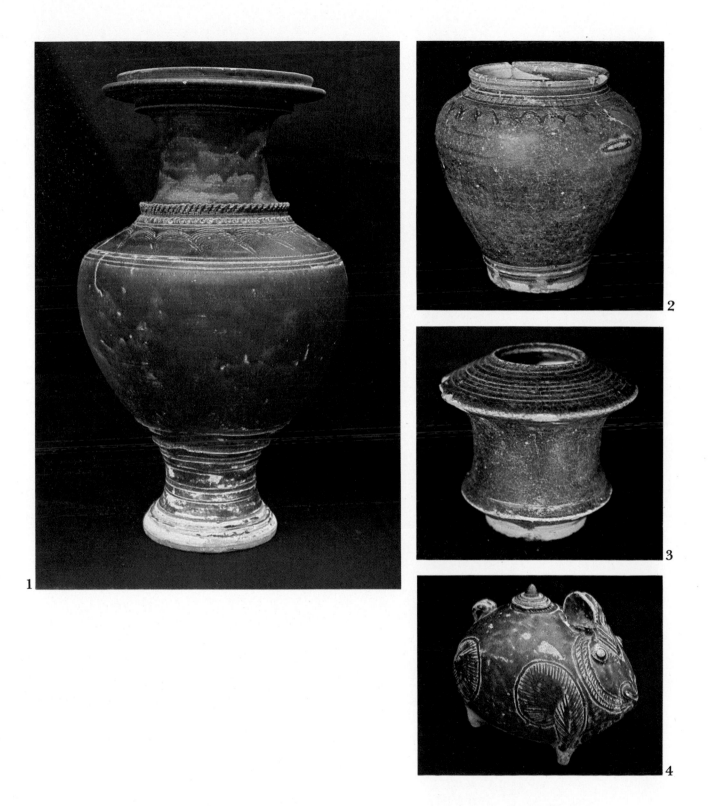

PLATE L
KHMER WARES

1. Honey pot, with a zoomorphic handle and eyes set at the spout, incised decoration, and medium brown glaze. Diam. 19 cms. Twelfth century, Angkor Wat period. Suan Pakhad Palace, Bangkok.

2. Bottle with modelled zoomorphic features, the lower body and foot with a brown slip. Ht. 12·3 cms. From Sra Srang, beginning of the twelfth century. Conservation D'Angkor.

3. Lime pot with zoomorphic features and a light caramel-brown glaze that ends in a black ripple on the lower body. Ht. 5 cms. From North-East Thailand, twelfth century, Angkor Wat period. Private Collection.

4. Jar (or lamp), with a flowing medium to blackish-brown glaze and brown slip on the flat base and lower body. Diam. 16·5 cms. From Sra Srang, beginning of the twelfth century. Conservation D'Angkor.

PLATE L

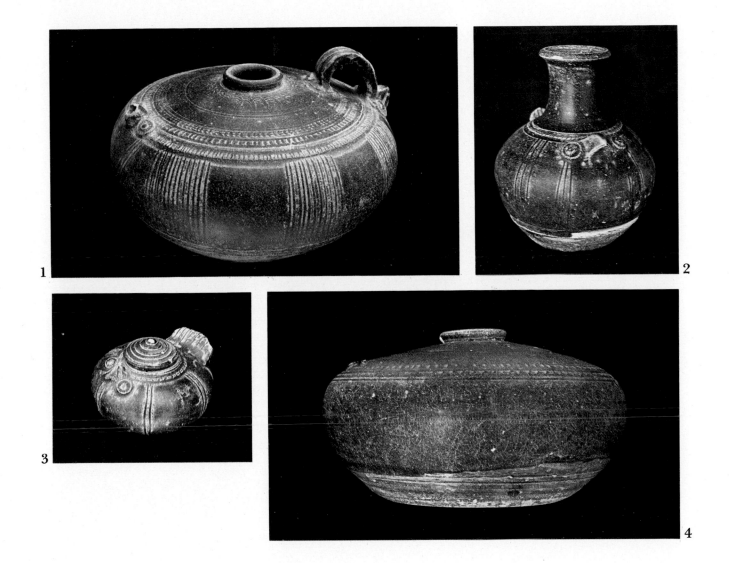

PLATE M
KHMER WARES

1. Footed urn, with a collar of rosette buttons on the upper shoulder, incised decoration, greyish body, and a flowing blackish-brown glaze. Ht. 43 cms. From North-East Thailand, late twelfth century, early Bayon period. Private Collection.

2. Jar with cover, with horse head and button-tail appendages, and brownish-black glaze. Ht. 36 cms. From North-East Thailand, late twelfth to early thirteenth centuries, Bayon period. Private Collection.

3. Bottle, with incised decoration and a slightly eroded, sparse, thick black glaze. Ht. 23·5 cms. Late twelfth to early thirteenth centuries, Bayon period. Conservation D'Angkor.

4. Lime pot, heavily potted and modelled into the shape of an elephant, with a thick, sparse black glaze. Ht. 18 cms. From North-East Thailand, late twelfth to late thirteenth centuries, Bayon period. Bangkok National Museum.

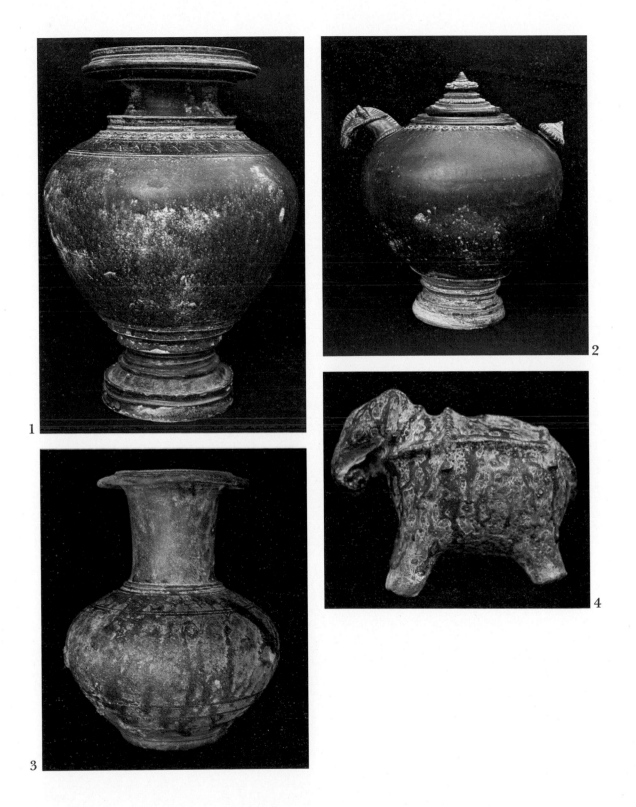

PLATE N
SUKHOTHAI WARES

1a,b Bowl, with a squarely carved foot ring with white slip smears, and a greyish white-speckled body. Diam. 28·2 cms. Suan Pakhad Palace Collection, Bangkok.

2. Bowl, with five spur marks on the interior bottom, a squarely carved foot ring, and brownish body. Diam. 13 cms. Collection of Kasem Sirikantraporn.

3. Covered box, with the decoration scratched through the underglaze black to the white slip below, the interior bottom with an encircled fish, and the interior cover with a brown-painted peony blossom; five spur marks on the interior bottom, a squarely carved foot ring, and white-speckled brownish body. Diam. 20 cms. Collection of Suan Pakhad Palace, Bangkok.

4. Covered jar, with a squarely carved foot ring, brownish body, and slightly greenish glaze. Ht. 17 cms. Collection of Suan Pakhad Palace.

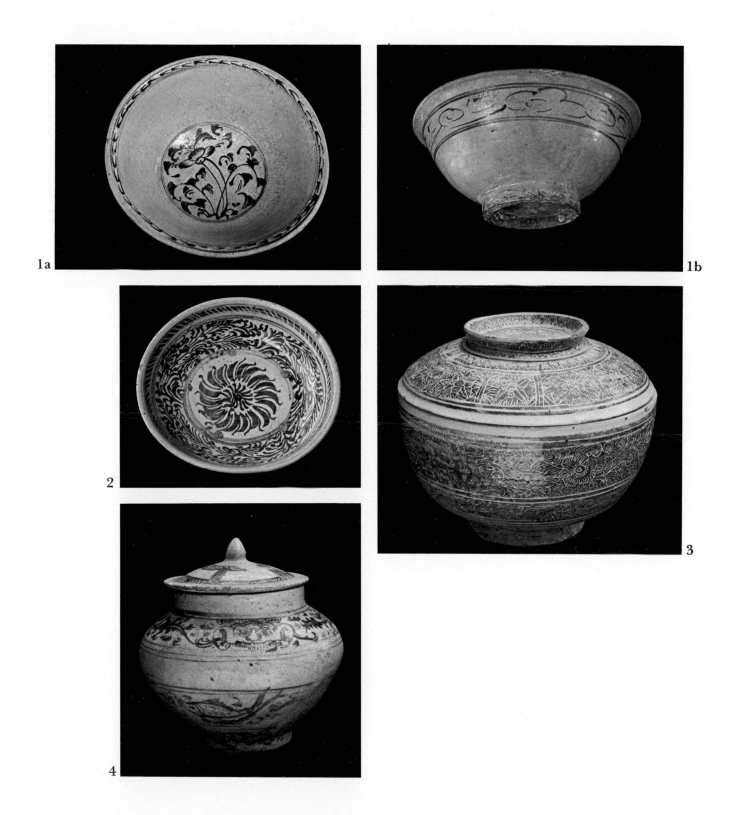

1a

1b

2

3

4

PLATE O
SAWANKHALOK UNDERGLAZE BLACK WARES

1. Covered box, decorated in black under a slightly cloudy glaze, with olive glaze on the centre cover and handle, greyish body, and a glazed interior except for the cover. Ht. 11 cms. From Sulawesi, transitional type, late fourteenth to fifteenth centuries. Collection of Benno Anciano.

2. Covered bowl, decorated in black under a slightly greenish glaze. Ht. 17 cms. Suan Pakhad Palace Collection.

3. Bowl, decorated in underglaze black, with a buff body, and a circular support scar on the base. Diam. 12·8 cms. Suan Pakhad Palace Collection, Bangkok.

4. Covered box, the centre of the cover brown-glazed, with a black-speckled greyish body, and a circular support scar on the base. Diam. 11·6 cms. Suan Pakhad Palace Collection, Bangkok.

5. Kendi, with two carved bands at the lower body, a carved foot ring, black-speckled greyish body, a circular support scar on the base, and a cloudy, slightly greenish, glaze. Ht. 15·5 cms. Collection of Prok Amranand.

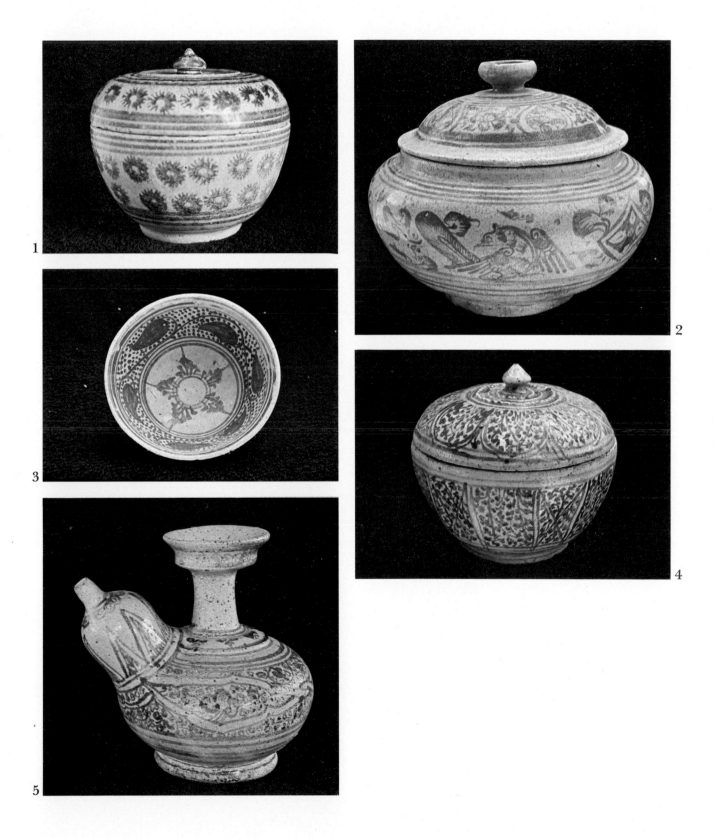

PLATE P
SAWANKHALOK CELADON WARES

1. Bottle, with a squarely carved foot ring, reddish body, and a translucent green celadon glaze. Ht. 18 cms. Collection of Frank and Pamela Hickley.

2. Mortar bowl, with a splayed foot, flat base, unglazed interior, reddish body, and a translucent, watery green celadon glaze. Diam. 15·2 cms. Suan Pakhad Palace Collection, Bangkok.

3a,b Dish, with a speckled brownish-orange body, a circular support scar on the base, and a thick blue celadon glaze. Diam. 20·5 cms. University of Malaya Art Museum (Lammers Collection).

4. Bowl, with a plain exterior, an orange-brown body, except within the circular support scar on the base where it is whitish, and translucent green celadon glaze. Diam. 23 cms. University of Malaya Art Museum (Lammers Collection).

5. Bowl, with buff body, a circular support scar on the base, and a translucent bluish-green celadon glaze. Diam. 21·5 cms. University of Malaya Art Museum (Lammers Collection).

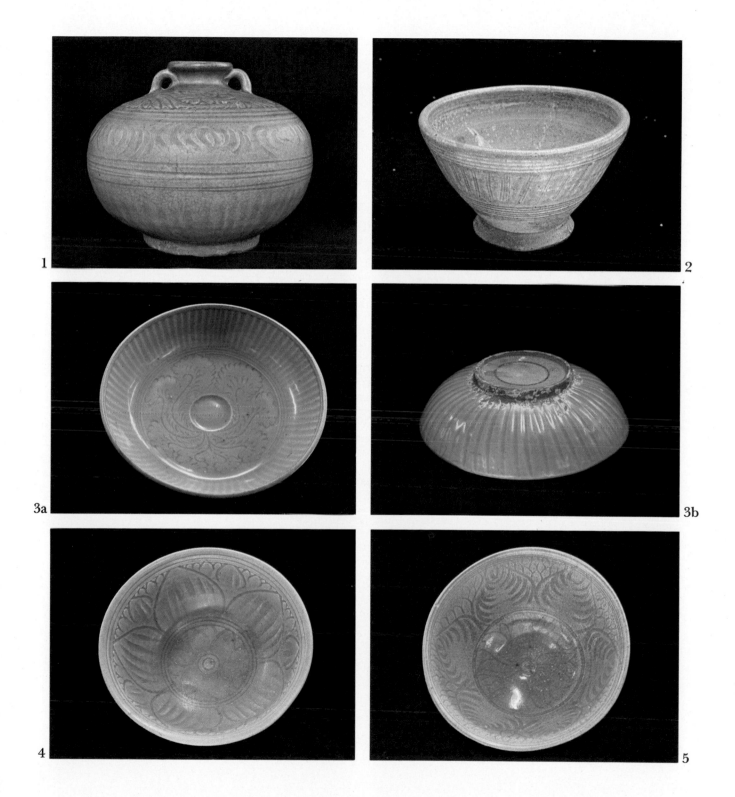

PLATE Q
SAWANKHALOK FIGURINES

1. Figurine of an amorous couple and child, decorated in underglaze black, with reddish body, and a crackled slightly cloudy glaze. Ht. 10 cms. Bangkok National Museum.

2. Figurine of a seated woman and child, a wad of *miang* (fermented tea leaves, see page 53) in the woman's cheek, with a pale reddish-brown body, and greyish-green celadon glaze; repaired at the neck. Ht. 11·7 cms. Collection of Frank and Pamela Hickley.

3. Figurine of a seated woman holding a ball-like object, a wod of *miang* in her cheek, with a pale reddish body, and a dull yellowish-green celadon glaze; repaired at the neck. Ht. 16·5 cms. Bangkok National Museum.

4. Hunchback figurine, hollow, with an opening in a pot held at the figure's shoulder; decorated in black under a clear glaze that has now turned brownish; set on four small feet. Ht. 15·5 cms. Bangkok National Museum.

5. Figurine of an amorous couple, decorated in black under a slightly cloudy glaze; both figures repaired at the neck. Ht. 11·5 cms. Collection of Kasem Sirikantraporn.

6. Figurine of two fighting elephants on a flat base, with greyish body and a flowing brown to blackish glaze. Length 10·3 cms. Collection of Suan Pakhad Palace, Bangkok.

PLATE R
SAWANKHALOK WARES

1. Jar, in the shape of a caparisoned elephant with a carriage and two riders; the short neck and flared mouth of the vessel just behind the forward rider; heavily potted; with a black-streaked runny brown glaze. Ht. 27 cms. Collection of Suan Pakhad Palace, Bangkok.

2. Bottle, with a carved foot ring, reddish body, and a watery brown glaze with opaque tan patches. Ht. 16·5 cms. Bangkok National Museum.

3. Covered box, with the decoration incised in outline and inlaid with white on a brown-glazed background, a carved foot ring, and a black-speckled greyish body. Ht. 10 cms. Collection of Benno Anciano.

4. Head of a *Yaksha* figure, the eyebrows brown-glazed and the remainder white, with a black-speckled greyish body; thickly modelled. Ht. 34 cms. Private Collection.

5. Jar, with a dark grey to reddish-brown body, flat foot, and traces of olive glaze on the upper shoulder. Ht. 30·5 cms. Collection of Suan Pakhad Palace, Bangkok.

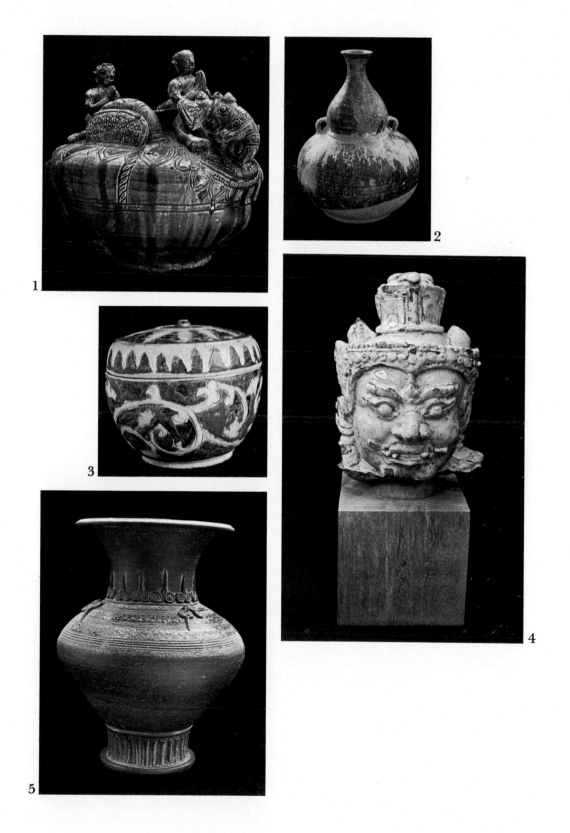

PLATE S
SANKAMPAENG WARES
c. Late Fifteenth to Mid-sixteenth Centuries

1. Jar, with a thin flat base, brownish body, and runny, thin, pale green glaze. Ht. 34 cms. Bangkok National Museum.

2. Jar, with a flat base, greyish-brown body, two brown-glazed handles, and a thin pale green glaze applied over a white slip coat. Ht. 9·6 cms. Collection of Prok Amranand.

3. Jar, with a flat base, greyish-brown body, and a thin greenish glaze applied over white slip. Ht. 11·2 cms. Collection of Frank and Pamela Hickley.

4. Jar with cover, with a thin flat base, brownish body, and thin yellowish-green glaze over a white slip coating. Ht. 12 cms. Collection of Frank and Pamela Hickley.

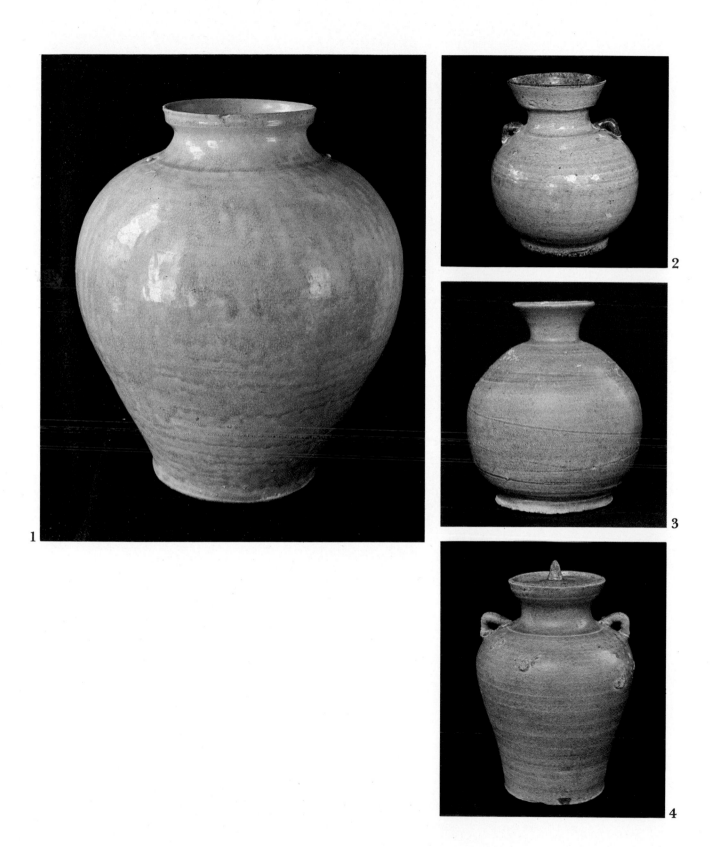

1

2

3

4

PLATE T
PHAN WARES
c. Fifteenth(?) to Mid-sixteenth Centuries

1. Lamp, with a hollow base, buff-coloured body, and lustrous pale lime-coloured celadon glaze. Ht. 19 cms. From the Pong Daeng site. Chiengmai National Museum.

2. Kendi, modelled to represent *Haṁsa,* the sacred mount of Brahma, the spout at the bird's mouth, with a carved splayed foot, unglazed base, buff, slightly orange body, and a lustrous pale lime translucent celadon glaze. Ht. 10 cms. From the Pong Daeng site. Chiengmai National Museum.

3. Jarlet, with a solid slightly concave foot and thick lustrous pale lime-coloured celadon glaze. Ht. 6·5 cms. From the Pong Daeng site. Chiengmai National Museum.

4. Bowl, with lightly incised decoration under the glaze on the interior, a carved foot ring, slightly orange, buff body, and lustrous pale lime-coloured celadon glaze. Diam. 16·5 cms. From the Pong Daeng site. Chiengmai National Museum.

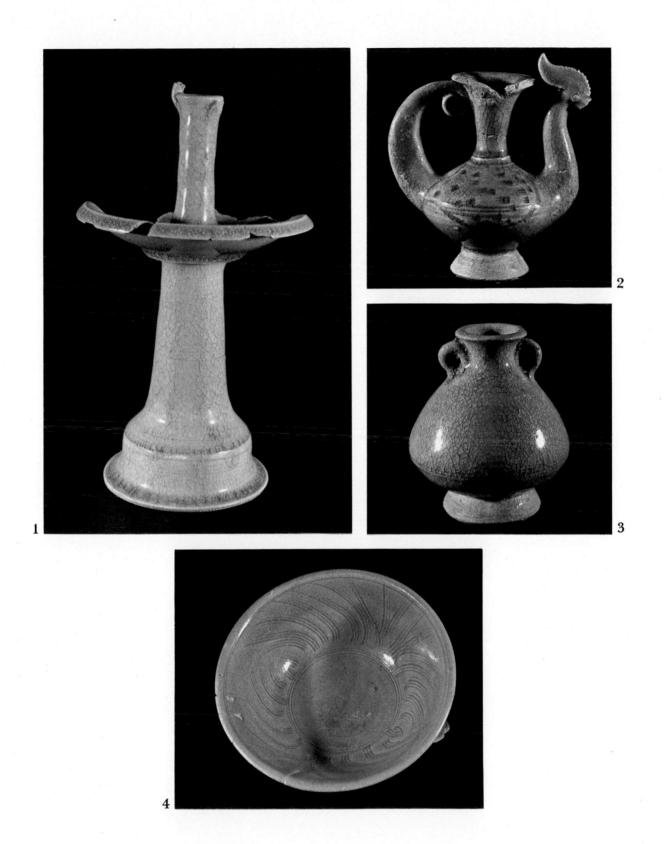

BLACK AND WHITE PLATES

PLATE 1

VIETNAMESE WARES
From Thanh-hoa

1. Jar, with a thin cream-white glaze, a translucent crackled green glaze run from the lower shoulder, an unglazed interior, and a flat unglazed base. Ht. 25 cms. First to third centuries. Musées Royaux D'Art et D'Histoire.

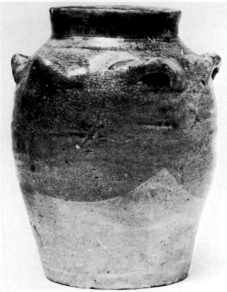

2. Jar, with six handles, yellowish-cream glaze, buff body, and a flat unglazed base. Ht. 19 cms. Dated T'ang (seventh to tenth centuries) by Janse ('Rapport Preliminaire', 1936, Pl. XV, c). Saigon National Museum.

4. Cup, with a crackled greenish glaze, a black glaze run down one side, buff body, and a flat foot. Ht. 4 cms. Dated T'ang (seventh to tenth centuries) by Janse (*Arch. Research,* III, Pl. 76). Saigon National Museum.

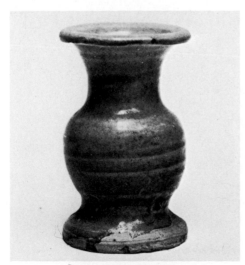

3. Jar, with a dark olive glaze, brown body, and flat base. Ht. 10 cms. From Ninh Phue, Ha-dong Province, c. fourth to tenth centuries. Saigon National Museum.

5. Bowl, with traces of a dark green glaze, a greyish-brown rough body, and flat splayed foot. Ht. 7 cms. c. fourth to tenth centuries. Saigon National Museum.

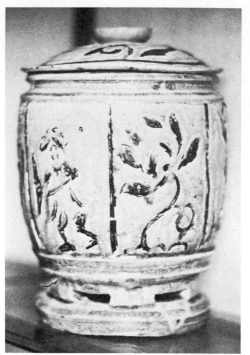

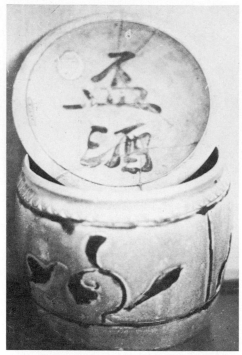

6. Covered urn, with a hollow stand-type foot, decorated in panels with lotus and human figures, covered with a runny, translucent greenish glaze. Ht. 31 cms. Late tenth to early twelfth centuries. Musées Royaux D'Art et D'Histoire.

7. Covered urn, decorated with three panels of vine motifs, with a translucent greenish glaze and the Chinese characters for 'wine vessel' in brown slip on the inside cover. Ht. 20 cms. Late tenth to early twelfth centuries. Musées Royaux D'Art et D'Histoire.

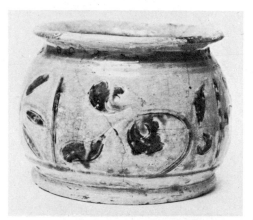

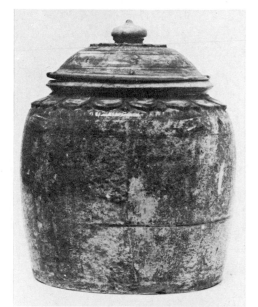

8. Basin, decorated in three panels with vine and six-petal flower motifs, with a translucent, crackled greenish glaze. Ht. 13 cms. Late tenth to early twelfth centuries. Saigon National Museum.

9. Covered urn, with lotus petal collars on the cover and shoulder, four handles, and a greyish-cream glaze. Ht. 24 cms. Late tenth to early twelfth centuries. Saigon National Museum.

PLATE 3

VIETNAMESE WARES
From Thanh-hoa

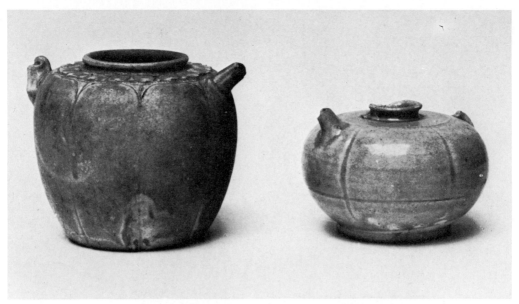

10. Two wine pots, the right with a crackled cream glaze and shallow carved foot, ht. 6 cms.; the left with an opaque greyish-cream glaze and shallow carved foot, ht. 9 cms. Both late twelfth to thirteenth centuries. Saigon National Museum.

11. Covered jar, with a shallow carved foot and pale translucent greenish glaze. Ht. 13 cms. Twelfth to thirteenth centuries. Saigon National Museum.

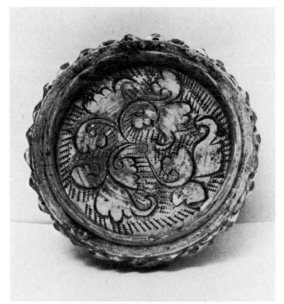

12. Cosmetic tray, with incised decoration on the face, a thick stand-type foot, and traces of a thin, translucent greenish glaze. Diam. 11 cms. Eleventh to early thirteenth centuries, see Janse, *Arch. Research,* III, Pl. 82–3. Saigon National Museum.

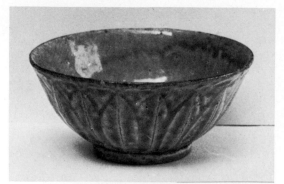

13. Bowl, with lotus petals on the exterior, five spur marks on the interior bottom, and a thin, runny copper-green glaze. Diam. 14·3 cms. Twelfth to thirteenth centuries. Saigon National Museum.

14. Beaker, with lotus petals on the exterior, five spur marks on the interior bottom, a flat base, and a thin, runny copper-green glaze. Diam. 12·8 cms. Thirteenth century. Saigon National Museum.

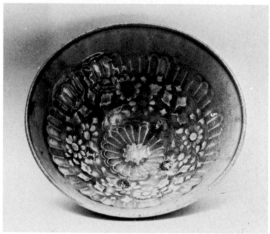

15. Bowl, with embossed fencepost-like and floral designs, five spur marks on the interior bottom, and a cream-white glaze. Diam. 17 cms. Thirteenth century. Saigon National Museum.

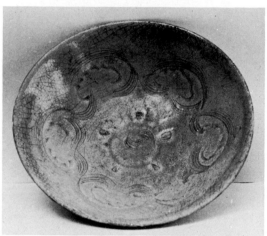

16. Bowl, with incised decoration, five spur marks on the interior bottom, and a cream-white glaze. Diam. 17 cms. Twelfth to thirteenth centuries. Saigon National Museum.

17. Bowl, with a foliate mouth rim, carved foot ring, five spur marks on the interior bottom, and a thick white glaze. Diam. 17 cms. Thirteenth century. Saigon National Museum.

PLATE 5

VIETNAMESE WARES
From Thanh-hoa

18. Bowl, with incised decoration, foliate mouth rim,
(a,b) unglazed ring interior, tall carved foot ring,
chocolate base, and murky olive-green celadon

glaze applied over white slip. Diam. 16·3 cms.
Thirteenth century. Saigon National Museum.

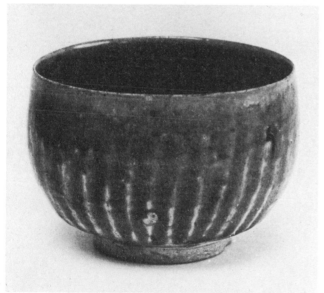

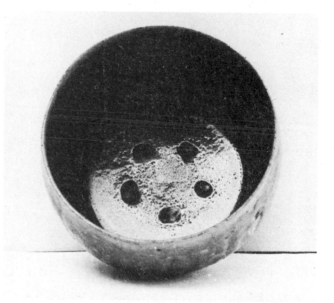

19. Beaker, with ribbed exterior walls, five spur
(a,b) marks on the interior, a carved and bevelled foot
ring, and thick olive-green celadon glaze. Ht.

9 cms. Thirteenth century. Saigon National
Museum.

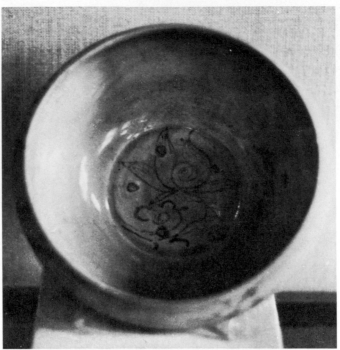

20. Bowl, with a finely drawn underglaze black lotus and five spur marks on the interior bottom, a flat unglazed foot, whitish body, and thick, lustrous cream-white glaze. Ht. 13·5 cms. Thirteenth century. Musées Royaux D'Art et D'Histoire.

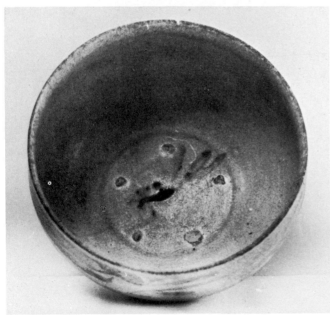

21. Bowl, with three underglaze black broad-stroke (a,b) motifs under a cloudy glaze on the exterior, and one on the interior bottom along with five spur marks; a flat unglazed base, and a whitish body. Diam. 13·5 cms. Saigon National Museum.

PLATE 7

VIETNAMESE WARES
Early Exported Wares

22. Bowl, decorated in underglaze black with an
(a,b) encircled peony blossom among five spur marks
on the interior bottom, and bands of scribbly
classic scroll on the mouth rim and exterior, with

a carved foot ring, chocolate base, and a thin,
translucent, crackled slightly greenish glaze.
Diam. 15·5 cms. From Sulawesi, fourteenth cen-
tury. Collection of Benno Anciano.

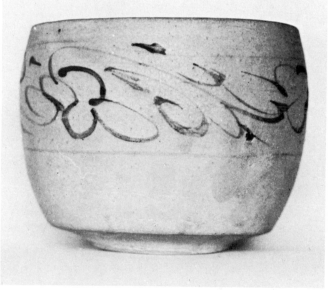

23. Bowl, decorated in underglaze black
with an encircled peony among four
spur marks on the interior bottom,
three rings at the interior mouth, and
a band of cursory classic scroll on the
exterior, with a flat chocolate base.
Ht. 4·1 cms. Fourteenth century.
Saigon National Museum.

24. Beaker, decorated in underglaze black
that has an olive-green cast, with a
wide, shallow carved foot ring,
whitish body, and a chocolate base.
Ht. 9·5 cms. Fourteenth century.
Private Collection.

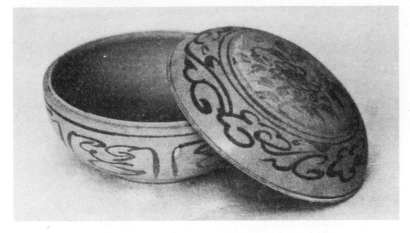

25. Covered box, decorated in underglaze black, with a carved wide, shallow foot ring. Diam. 14·2 cms. Fourteenth century. The Sinclair Collection.

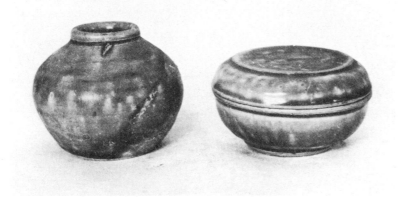

26. A jarlet and covered box, the jarlet with a flat unglazed base, ht. 5·7 cms; the box with a wide, shallow carved foot ring, ht. 4·2 cms. Both with a watery copper-green glaze. Fourteenth century. The Sinclair Collection.

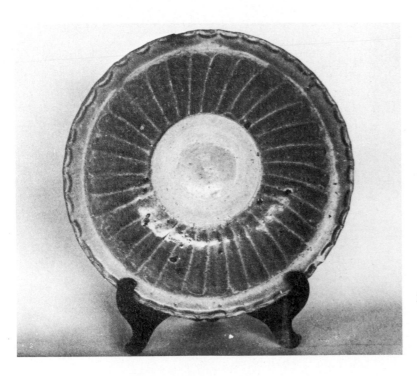

27. Dish, with plain exterior walls, a carved foot ring, chocolate base, and apple green glaze. Diam. 21 cms. Fourteenth century. Private Collection.

PLATE 9 VIETNAMESE WARES
 Early Exported Wares

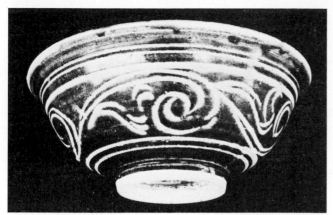

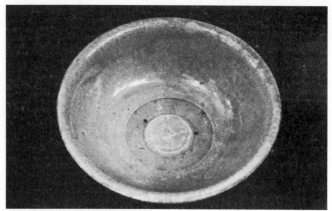

28. Bowl, with the exterior decoration incised through
(a,b) the glaze, cream-glazed interior, carved foot ring,
whitish body, and a chocolate base. Diam. 14
cms. Fourteenth century. E.M.T. Lu Collection.

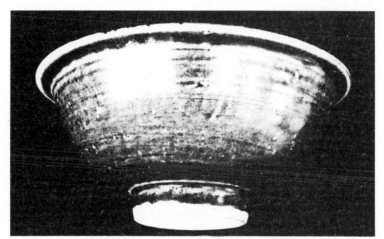

29. Bowl, with a brown-glazed exterior,
an unglazed ring and cream glaze on
the interior, and a carved foot ring.
Diam. 14·7 cms. Fourteenth century.
E.M.T. Lu Collection.

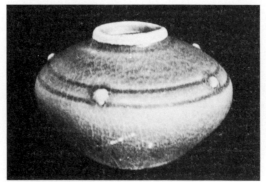

30. Jarlet, with a flat base, greyish-white
body, matt olive-green celadon glaze,
and glazed interior. Ht. 4·5 cms.
From Sulawesi, fourteenth century.
Collection of Benno Anciano.

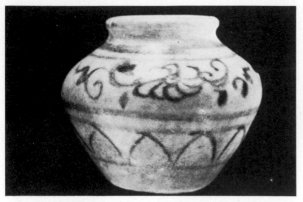

31. Jarlet, miniature, decorated in a medium hue underglaze blue, with a whitish body, flat chocolate base, and glazed interior. Ht. 3·5 cms. Early fifteenth century. Saigon National Museum.

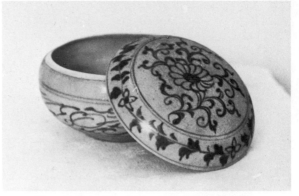

32. Covered box, decorated in underglaze blue, with a whitish body, and shallow carved foot ring. Diam. 13·7 cms. Early fifteenth century. The Sinclair Collection.

33. Covered box, miniature, the cover moulded into six sepals, decorated in a pale hue underglaze blue, with a whitish body and flat foot. Diam. 3·8 cms. Probably early to mid-fifteenth century. Saigon National Museum.

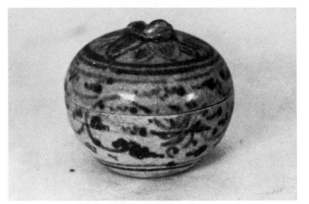

34. Covered box, miniature, decorated in pale underglaze blue, with a whitish body, and flat base. Ht. 4·8 cms. Probably early to mid-fifteenth century. The Sinclair Collection.

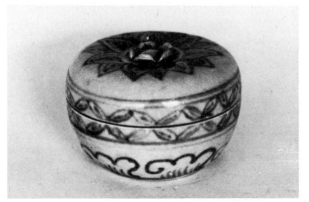

35. Covered box, decorated in a pale hue underglaze blue, with a wide, shallow foot ring, and whitish body. Ht. 4·5 cms. Early to mid-fifteenth century. Private Collection.

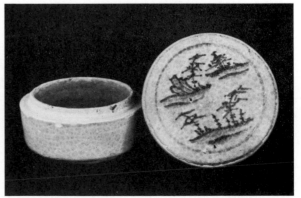

36. Covered box, decorated in a pale hue underglaze blue only on the cover, with a whitish body, and a shallow carved foot ring. Ht. 4·2 cms. Probably fifteenth century. The Sinclair Collection.

PLATE 11

VIETNAMESE WARES
Fifteenth to Sixteenth Centuries

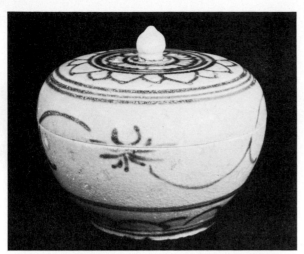

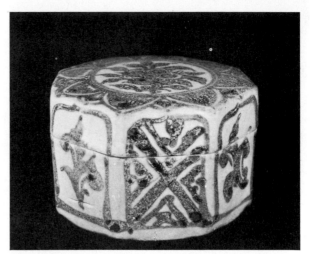

37. Covered box, decorated in a pale hue underglaze blue, with whitish body, and a shallow carved foot ring. Ht. 7·5 cms. Fifteenth to sixteenth centuries. E.M.T. Lu Collection.

38. Covered box, decorated in a runny underglaze blackish-blue wash. Fifteenth to sixteenth centuries. Ht. 5 cms. The Sinclair Collection.

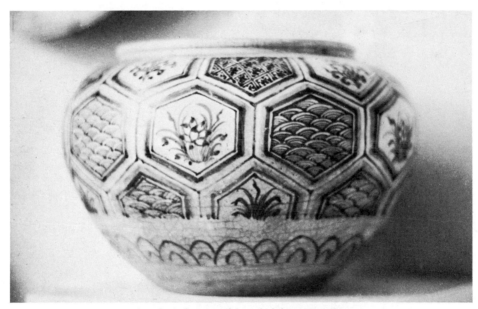

39. Jar, decorated in a bright underglaze blue, thickly potted, with clear glaze on the base and interior. Ht. 16·5 cms. From southern Sulawesi, probably mid-fifteenth century. Museum Pusat, Jakarta.

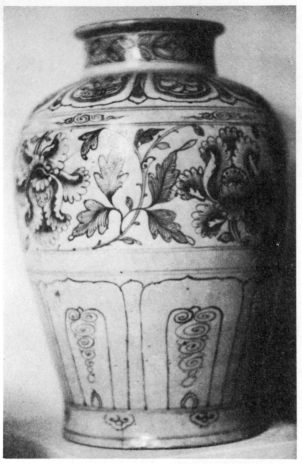

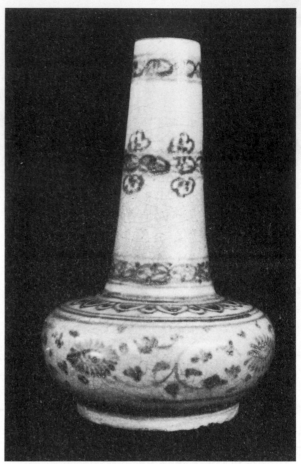

40. Vase, decorated in fine lines with a pale hue underglaze blue, with clear glaze on the base and interior. Ht. 31 cms. Probably mid-fifteenth century. Museum Pusat, Jakarta.

41. Bottle, decorated in a pale, slightly runny underglaze blue, with whitish body and a carved foot ring. Ht. 18 cms. E.M.T. Lu Collection.

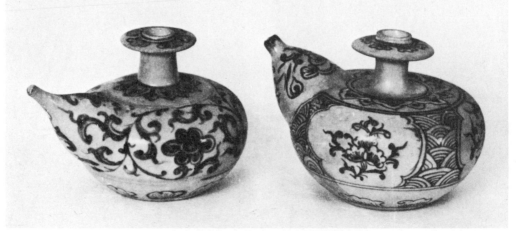

42. Two kendi, the left decorated in a slightly runny, dark underglaze blue, with a flat unglazed base, ht. 10·5 cms; the right decorated in a medium hue underglaze blue, with a flat unglazed foot, ht. 11 cms. Probably fifteenth century. The Sinclair Collection.

PLATE 13

VIETNAMESE WARES
Fifteenth to Sixteenth Centuries

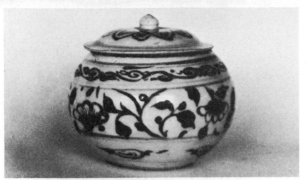

43. Covered bowl, decorated in blackish underglaze blue, with a flat base, greyish body, and chocolate slip on the interior cover. Ht. 8·5 cms. Fifteenth to sixteenth centuries. Private Collection.

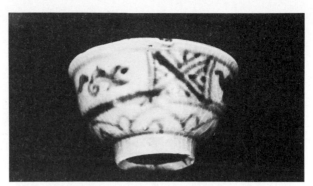

44. Bowl, miniature, decorated in a pale underglaze blue wash, with an unglazed mouth rim, carved foot ring, and chocolate base. Ht. 3 cms. Fifteenth to sixteenth centuries. Saigon National Museum.

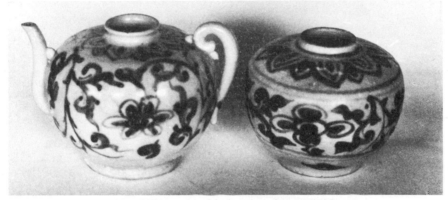

45. Wine pot and jarlet, the wine pot with a whitish body, ht. 8 cms; the jarlet with a greyish body, ht. 7·5 cms; both decorated in a medium hue underglaze blue. Fifteenth to sixteenth centuries. Private Collection.

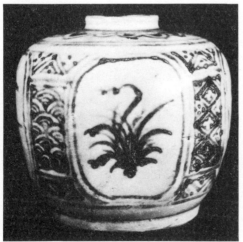

46. Jarlet, decorated in a slightly runny blackish underglaze blue that has silvery flashes where thick. Ht. 10 cms. Fifteenth to sixteenth centuries. E.M.T. Lu Collection.

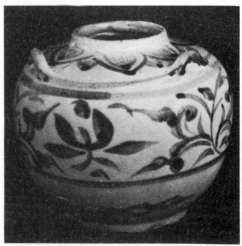

47. Jarlet, with a medium hue, slightly runny underglaze blue. Ht. 7·5 cms. Fifteenth to sixteenth centuries. E.M.T. Lu Collection.

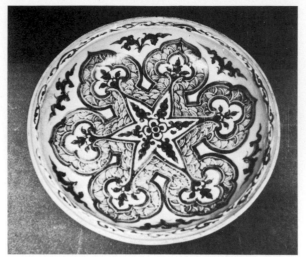

48. Plate, decorated in a blackish under-glaze blue, with a carved foot ring and chocolate base. Diam. 36·2 cms. From Mandar, Sulawesi; fifteenth to sixteenth centuries. Museum Pusat, Jakarta.

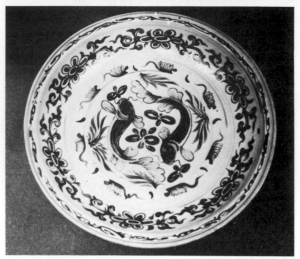

49. Plate, decorated in a blackish under-glaze blue except for the pale hue blue rings encircling the central medallion, with a carved foot ring and chocolate base. Diam. 36·2 cms. Fifteenth to sixteenth centuries. From Sumba. Museum Pusat, Jakarta.

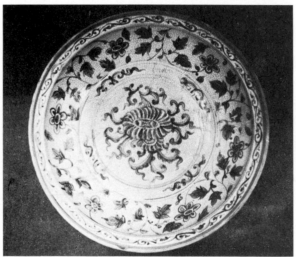

50. Plate, decorated in a blackish, slightly runny, underglaze blue, with a carved foot ring and chocolate base. Diam. 37·4 cms. Fifteenth to sixteenth centuries. Museum Pusat, Jakarta.

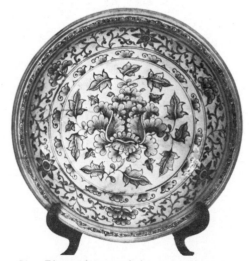

51. Plate, decorated in a medium hue underglaze blue, with a carved foot ring and chocolate base. The similarity between this and the Vietnamese plate at the Ardebil Shrine (Pope, 1956, Pl. 57) is striking. Diam. 35 cms. Mid-fifteenth century. The Sinclair Collection.

PLATE 15

VIETNAMESE WARES
Blue and White with Enamels

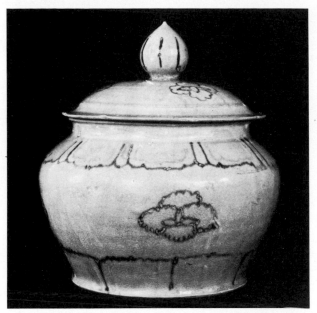

52. Covered jar, decorated sparsely in pale underglaze blue, with traces of red and green overglaze enamels. Ht. 26·7 cms. Fifteenth to sixteenth centuries. E.M.T. Lu Collection.

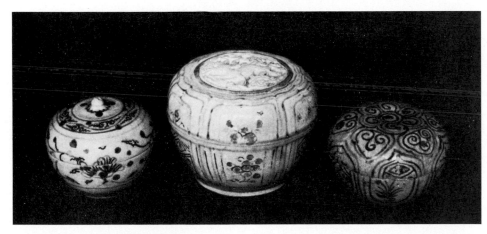

53. Three covered boxes. The left with pale underglaze blue, and red and green overglaze enamels, ht. 6·5 cms., from central Sulawesi. The centre with medium blue, and red and green overglaze enamels, ht. 8 cms., from the Jambi Plateau, Sumatra. The right with pale underglaze blue, and red and green enamels, ht. 6 cms., from southern Sulawesi. All fifteenth to sixteenth centuries. Museum Pusat, Jakarta.

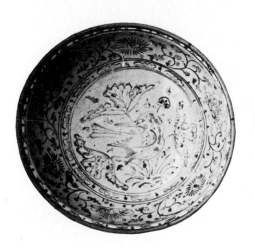

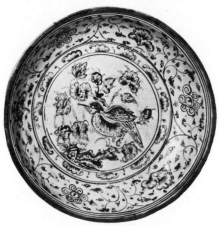

54. Two plates, decorated with a pale hue underglaze blue, and red and green overglaze enamels, the exteriors with lotus panels in enamel only. The left from Palembang, Sumatra, diam. 32.5 cms; the right from northern Lampang, diam. 34·5 cms. Both fifteenth to sixteenth centuries. Museum Pusat, Jakarta.

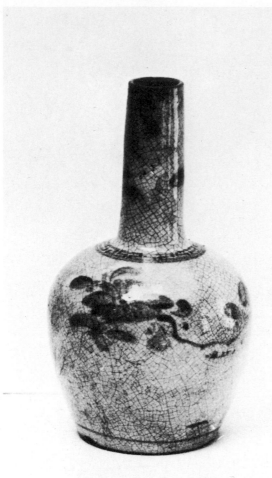

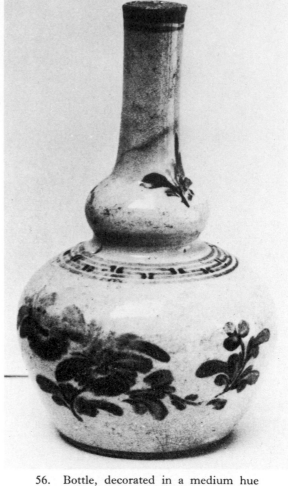

55. Bottle, decorated in a medium hue underglaze blue wash, with a clear, crackled, greying glaze, thick rounded foot ring, and glazed base. Ht. 16·5 cms. Seventeenth century. Saigon National Museum.

56. Bottle, decorated in a medium hue underglaze blue wash, with a creamy glaze, thick rounded foot ring, and glazed base. Ht. 25 cms. Seventeenth to eighteenth centuries. Saigon National Museum.

57. Jarlet, with a medium hue underglaze blue wash,
(a,b) a crackled greying glaze, thick rounded foot ring, dirty whitish body, and unglazed base. Ht. 6·4 cms. Seventeenth century. From Indonesia, The Sinclair Collection.

PLATE 17

VIETNAMESE WARES
Domestic Cult and Bleu de Hue

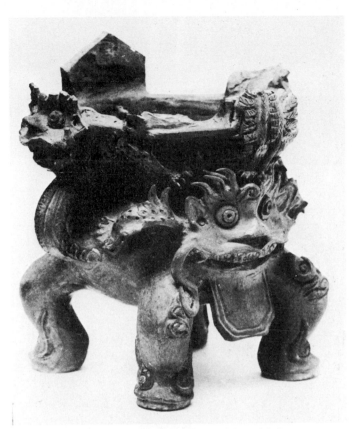

58. Censer, unglazed but with reddish-brown slip. Ht. 22 cms. Sixteenth to seventeenth centuries. Saigon National Museum.

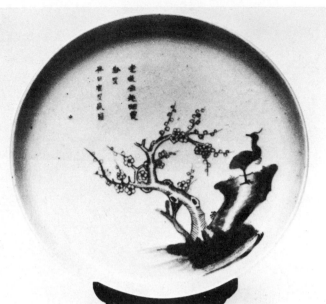

59. Dish, decorated in a clear medium hue underglaze blue, with a slightly bluish glaze, squarely carved foot ring, and glazed base. A poem in Vietnamese *chu nom* characters, attributed to the Vietnamese poet Nguyen Du (1765–1820), on the face translates roughly as 'The favourite of my pleasures is to create in my verses the vaporous clouds; the flowers of May (i.e. the wild prunus) are old friends, and the sacred crane a familiar acquaintance.' (See Vu'o'ng hong Sen, 1944, p. 59). A two-character mark on the base reads 'Bibelot of Jade'. Diam. 17·2 cms. Third quarter of the nineteenth century. Saigon National Museum.

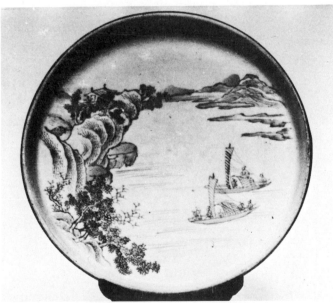

60. Dish, decorated in a clear medium hue underglaze blue, with a squarely carved foot ring, glazed base, and a metal mouthband; the glaze with a bluish cast. Diam. 16·6 cms. Second half of the nineteenth century. Saigon National Museum.

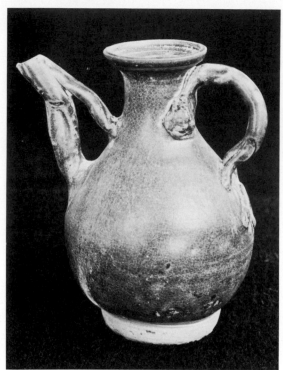

61. Ewer, pear-shaped, with a *chih*-dragon handle, flat, slightly concave foot, brownish-orange body, and thin, crackled light brown glaze. Ht. 11·9 cms. From Qui Nhon, fourteenth to fifteenth centuries. Collection of Ha duc Can.

62. Cup, with a flat foot, greyish-orange body; and a thin, runny, light caramel brown glaze, crazed and with pin holes. Ht. 8 cms. From Qui Nhon, fourteenth to fifteenth centuries. Collection of Ha duc Can.

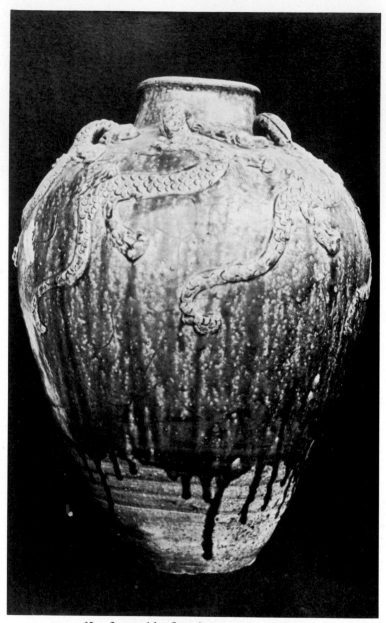

63. Jar, with five long scaly dragons whose necks form handles, incised decoration of waves under the glaze, a reddish body, and a thin runny golden-brown glaze speckled with pin holes. Ht. 42 cms. From the hill tribes, Binh Dinh Province, fourteenth to fifteenth centuries. Collection of Ha duc Can.

PLATE 19

CHAM WARES
The Go-Sanh Kilns

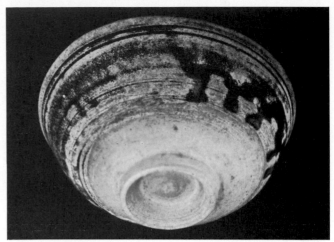

64. Bowl, with a reddish-orange light-weight body,
(a,b) carved and bevelled foot ring, stacking-ring on the
interior bottom, and runny, mottled brown glaze.

Diam. 15·3 cms. From Qui Nhon, fourteenth to
fifteenth centuries. Collection of Ha duc Can.

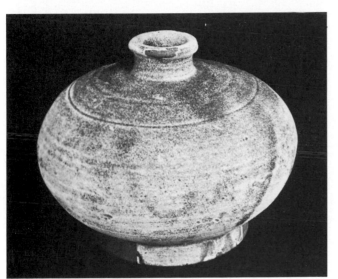

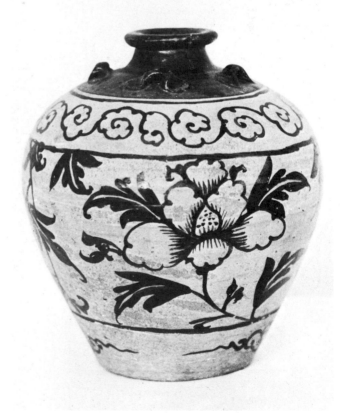

65. Jar, with a carved foot ring, reddish-
orange body, and somewhat degraded
light brown glaze. Ht. 7 cms. From
Qui Nhon, fourteenth to fifteenth
centuries. Collection of Ha duc Can.

66. Jar, with golden-brown glaze on the
upper portion, and tomato-red ena-
mel decoration on the remaining
unglazed body which is marred by
several large blisters caused by
escaping air bubbles, the base rough,
unglazed, and slightly concave. For a
similar piece identified as Annamese
see Van Orsoy de Flines, 1949, Pl. 74.
Ht. 33 cms. The Sinclair Collection.

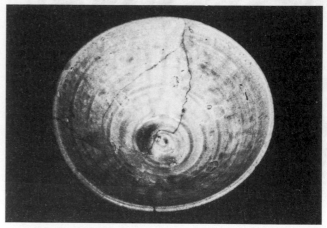

67. Bowl, with six round scars at the lower interior (a,b) and exterior walls, and a thick, translucent pale green glaze that partially covers the flat base.

Diam. 17·8 cms. From Sambour Prei Kuk, tenth century. Conservation D'Angkor.

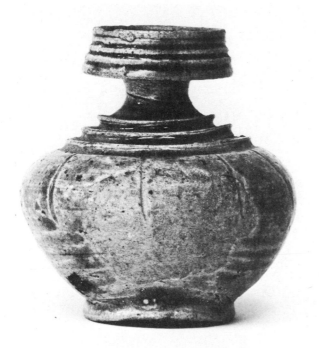

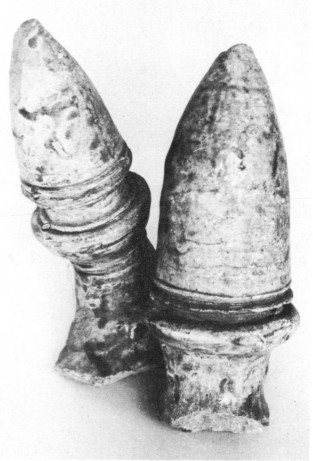

68. Bottle, with a flat base, whitish body, and a thin, runny, greenish glaze. 10th century. Ht. 9·5 cms. Collection of Robert P. Griffing, Jr.

69. Roof finials, with pale to yellowish green glaze. Hts. 24 and 25 cms. Tenth to eleventh centuries. Conservation D'Angkor.

PLATE 21

KHMER WARES

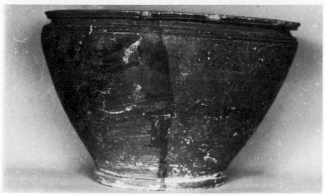

70. Basin, *lie de vin* ware, unglazed, with a dull purplish-brown kiln gloss. Ht. 23 cms, diam. 34·2 cms. Tenth to early eleventh centuries. Conservation D'Angkor.

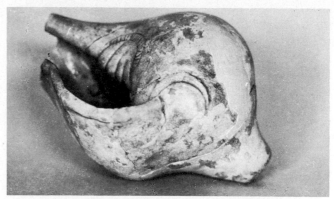

71. Conch, with a whitish buff body and chipped yellowish-green glaze. Length 14·5 cms. Mid-eleventh century. Conservation D'Angkor.

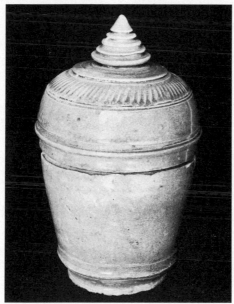

72. Covered urn, thickly potted, with a flat base, and crazed yellowish-green glaze. Ht. 18 cms. Mid-eleventh to mid-thirteenth centuries. Conservation D'Angkor.

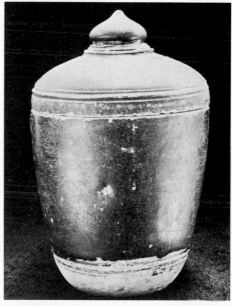

73. Covered urn, with a chocolate-brown glaze, buff paste, and a slightly recessed base. Ht. 16 cms. From North-East Thailand, late eleventh to twelfth centuries. University of Malaya.

74. Bottle, with a partly degraded whitish opaque glaze, and a flat cord-cut foot. Ht. 3·5 cms. From North-East Thailand, mid-eleventh century, Baphuon period. Private Collection.

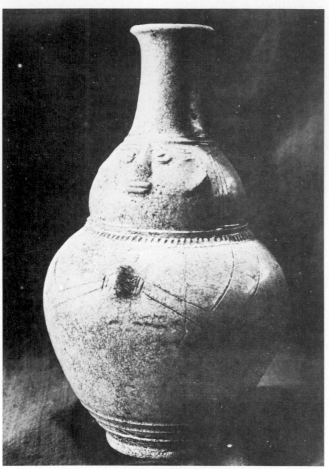

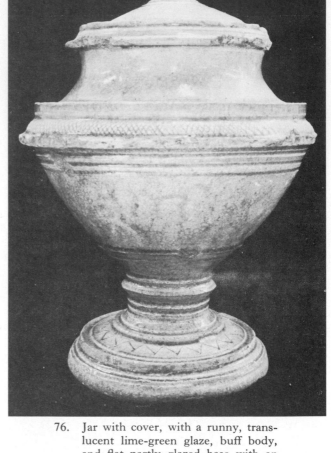

75. Bottle, gourd-shaped, with modelled and incised anthropomorphic features, whitish-green glaze, and a flat base. Ht. 11·5 cms. From North-East Thailand, second half of the eleventh century. Private Collection.

76. Jar with cover, with a runny, translucent lime-green glaze, buff body, and flat partly glazed base with an X-shaped fabrication mark lightly incised. Ht. 18 cms. From North-East Thailand, late eleventh to twelfth centuries. University of Malaya.

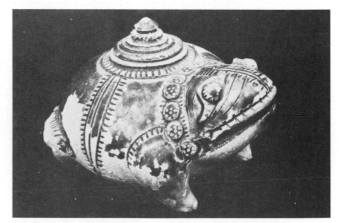

77. Figure of a turtle, with a flowing, partly chipped brown glaze. Length 11 cms. From North-East Thailand, late eleventh to twelfth centuries. Private Collection.

78. Lime pot in the shape of a frog, with a stopper-type lid, and yellowish-brown glaze. Length 7·2 cms. From North-East Thailand, late eleventh to early twelfth century. Private Collection.

PLATE 23 KHMER WARES

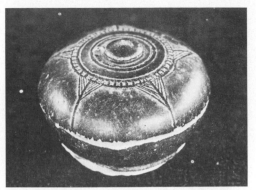

79. Covered box, with greyish-buff body, flat base, and a light caramel-brown glaze. Diam. 7·6 cms. From North-East Thailand, twelfth century, Angkor Wat period. Collection of Prok Amranand.

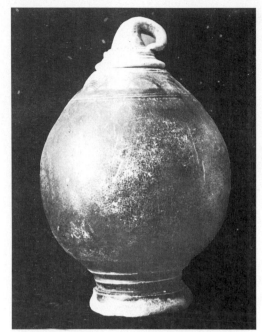

81. Jar and cover, with dark brown glaze on the body, and pale green translucent glaze on the fruit stem cover. Ht. 11 cms. From North-East Thailand, twelfth century, Angkor Wat or early Bayon periods. Private Collection.

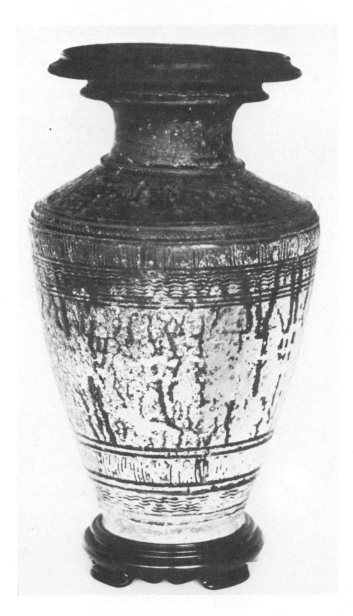

82. Conch, with badly chipped blackish-brown glaze. Length 16·5 cms. From North-East Thailand, twelfth century. Private Collection.

80. Jar, with incised decoration, and a partially chipped lustrous light brown glaze. Ht. 42 cms. From North-East Thailand, twelfth century, Angkor Wat period. Private Collection.

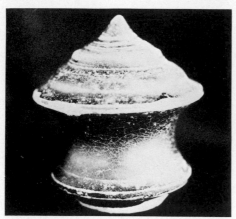

83. Perfume box, with blackish-brown glaze, a stopper-type lid, glazed interior, and flat cord-cut foot. Ht. 6 cms. From North-East Thailand, late twelfth century, early Bayon period. Collection of Michael Gluckman.

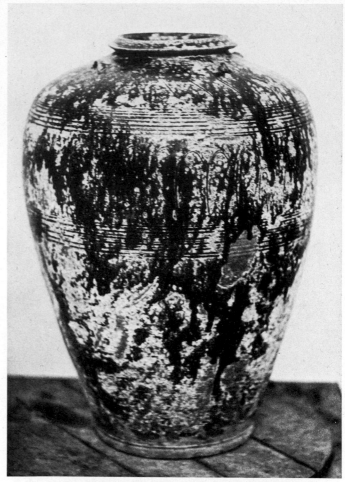

85. Wine jar, with a thick, runny, sparse, partially eroded olive-black glaze, four token handles on the shoulder, and incised decoration on the shoulder and upper body. Ht. 65 cms. Thirteenth to early fourteenth centuries, late Bayon period. Conservation D'Angkor.

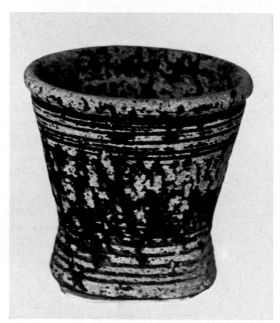

84. Mortar bowl, heavily potted, with a chipped flowing black glaze. Ht. 12 cms. Thirteenth to early fourteenth centuries, late Bayon period. Conservation D'Angkor.

PLATE 25

SUKHOTHAI WARES
Fourteenth Century

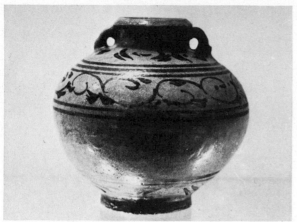

86. Ring-handled bottle, the body red-
 dish-brown. Ht. 18 cms. University
 of Singapore Art Museum Collection.

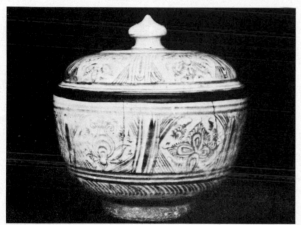

88. Covered box. Formerly in the collec-
 tion of Phaya Nakon Phrah Ram.
 Diam. 19·3 cms. Bangkok National
 Museum.

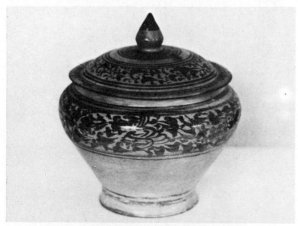

89. Covered jar, with a tubular support
 scar on the base. Ht. 22·5 cms. The
 Sinclair Collection.

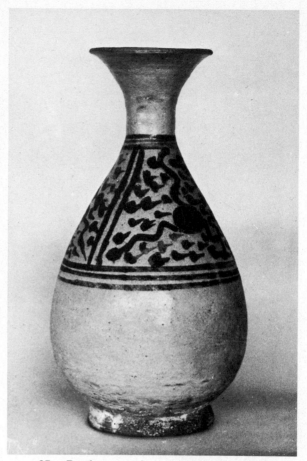

87. Bottle, pear-shaped, with white slip
 smears on the squarely carved foot
 ring. Ht. 22 cms. Private Collection.

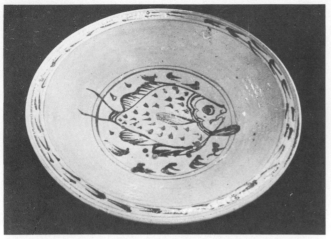

90. Dish, with six spur marks on the interior bottom, (a,b) a tubular support scar on the base, pin holes in the glaze, and white slip smears on the squarely

carved foot ring. Diam. 32 cms. University of Malaya Art Museum (Lammers Collection).

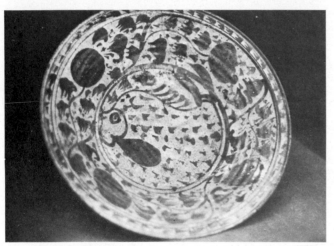

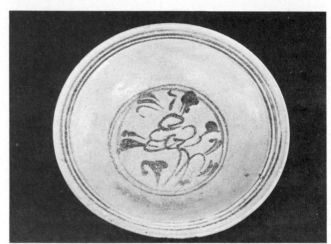

91. Plate, with five spur marks on the interior bottom. From Bali. Museum Pusat, Jakarta.

92. Plate, with a slightly greenish glaze. Diam. 20·2 cms. Collection of Prok Amranand.

PLATE 27

SUKHOTHAI WARES
Fourteenth Century

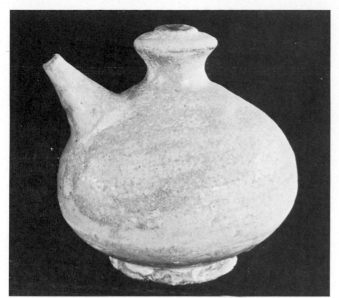

93. Kendi, with a squarely carved foot ring, and a thick white slip under a clear glaze. Ht. 14·5 cms. Collection of Prok Amranand.

94. Architectural finial, with a man, his hands in *anjali* (an attitude of respect), and a lotus. Found at Kampaeng Pek, Thailand, Ht. 52 cms. Kampaeng Pek Museum.

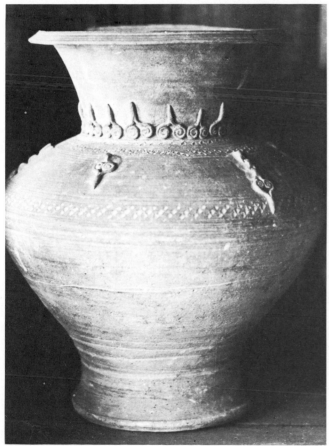

95. Jar, unglazed, with appliqué decoration, and a brownish-buff body. Ht. 26 cms. Shop, Old Sukhothai.

96. Covered box, transitional-type, with two carved ridges at the lower body, a slightly recessed base, and a grey body. Ht. 9 cms. Private collection.

97. Covered box, with the raised centre of the cover accented with brown glaze. Ht. 15 cms. Private Collection.

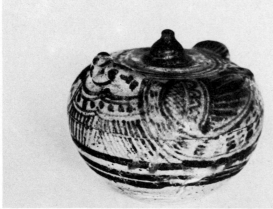

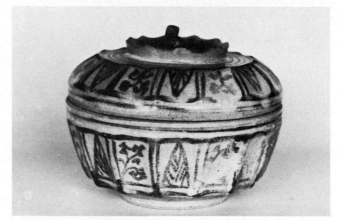

98. Covered box, with modelled and underglaze decoration depicting a pair of ducks, a tubular support scar on the flat base. Ht. 9·8 cms. Private Collection.

99. Covered box, with the centre cover brown-glazed, two carved rings at the lower body, and a cloudy glaze with bluish patches. Ht. 10 cms. Private Collection.

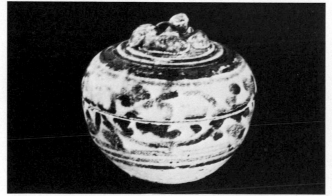

100. Covered box, miniature, decorated in underglaze black, with a brown-glazed interior, two lightly incised grooves at the base, a recessed base, olive-glazed fruit stem centre cover, and a cloudy glaze with blue tinges. Diam. 6·1 cms. Late fourteenth to early sixteenth centuries. Collection of Benno Anciano.

PLATE 29

SAWANKHALOK WARES, C. 1350–1512
Underglazed Black Decorated

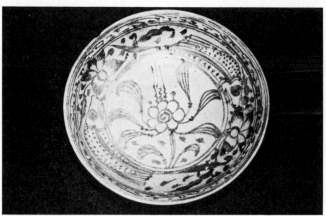

101. Stem plate, with a thick white slip under-coat,
(a,b) a tubular support scar inside the base, five
spur marks on the interior bottom, and pinkish
body. Ht. 13·5 cms, diam. 27 cms. Found on

Cebu Island, transitional type, late fourteenth
to early fifteenth centuries. Collection of Dr.
Lydia Alfonso.

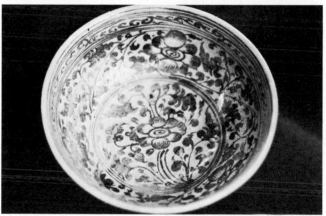

102. Bowl, with white slip, a band of
classic scroll and lotus panels on the
exterior, and a tubular support scar
on the base. Diam. 25·1 cms. From
the Palembang Highlands, Sumatra,
transitional type, late fourteenth to
fifteenth centuries. Museum Pusat,
Jakarta.

103. Bowl, the glaze cloudy and with blue
patches. Diam 20 cms. Transitional
type, late fourteenth to early fif-
teenth centuries. University of
Singapore Art Museum Collection.

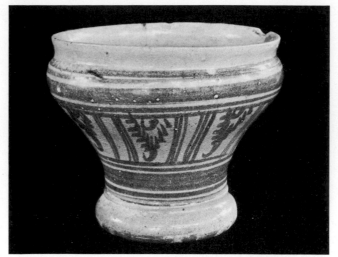

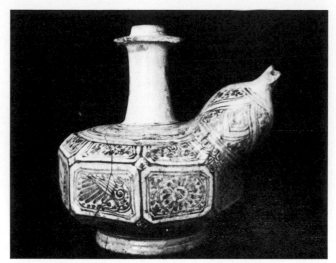

104. Mortar bowl, with a white slip, solid flat base, cloudy glaze, and reddish body. Ht. 12 cms. Transitional type. late fourteenth to early fifteenth centuries. Collection of Prok Amranand.

105. Kendi, the glaze cloudy and with bluish patches. Ht. 15 cms. Bangkok National Museum.

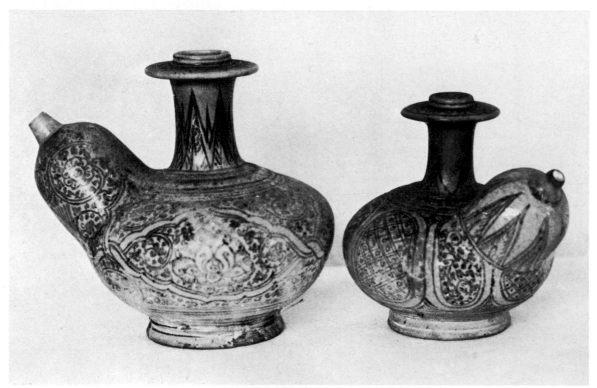

106. Two kendi, both with carved rings at the lower body, cloudy glaze, and a slightly splayed foot. Hts. 20 and 18·1 cms. The Sinclair Collection.

PLATE 31 SAWANKHALOK WARES, C. 1350–1512
 Celadons

107. Stem plate, with a hollow base, and
 an opaque greyish-blue glaze. Ht.
 10 cms. Bangkok National Museum.

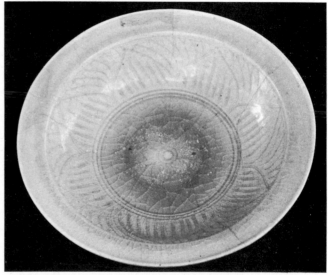

108. Bowl, with a buff body, carved foot
 ring, tubular support scar on the
 base, incised decoration, and a trans-
 lucent bluish-green glaze. Diam.
 21·5 cms. University of Malaya Art
 Museum (Lammers Collection).

109. Bowl, with incised decoration, and
 a translucent green glaze. Diam. 27·5
 cms. Collection of Prok Amranand.

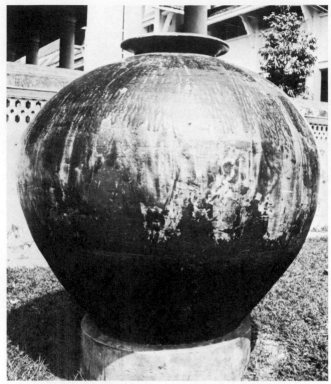

110. Jar, heavily potted, with a flowing glaze, and dark reddish-brown body. Ht. 53 cms. Bangkok National Museum.

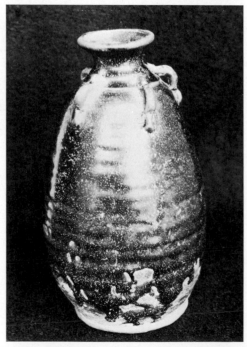

111. Bottle, with four handles, a flowing glaze, and dark reddish-brown body. Ht. 20 cms. Collection of Peter E. Beal.

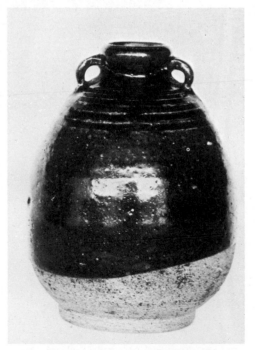

112. Bottle, with two ring-handles, a carved foot, reddish-brown body, and a thick, lustrous, dark brown glaze. Ht. 14·5 cms. Late 14th–early 16th centuries. Private collection.

PLATE 33

SAWANKHALOK WARES, C. 1350–1512
Brown-glazed

113. Figurine, a bird, with a rounded base. Ht. 5 cms. Collection of Kasem Sirikantraporn.

114. Figurine, in the shape of a bridled horse, with a brownish body. Ht. 6·2 cms. Collection of Kasem Sirikantraporn.

115. Figurine, in the shape of an elephant carrying a reliquary bowl, brownish-bodied. Ht. 6·3 cms. Private Collection.

116. Figurine, in the shape of an elephant and rider. Ht. 8·4 cms. Collection of Kasem Sirikantraporn.

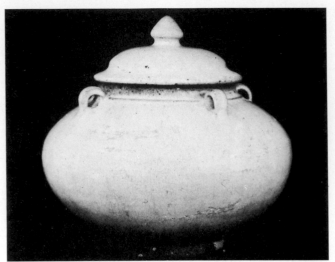

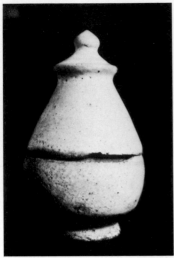

117. Covered potiche, with three ring-
handles and a matt white glaze. Ht.
16·7 cms. E.M.T. Lu Collection.

118. Covered box, cone-shaped, perhaps
a lime container, with a matt white
glaze. Ht. 6·6 cms. Private Collec-
tion.

119. Architectural ornaments, with floral
decoration, and a matt white glaze.
Shop, Sri Sachanalai.

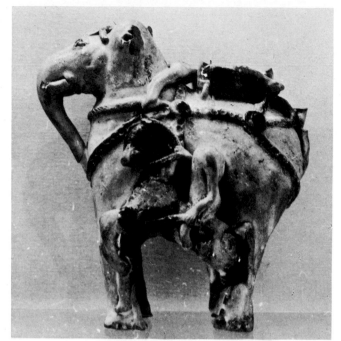

121. Ceramic sculpture, in the shape of a caparisoned elephant, with a galloping horse on each side, the riders of which carry polo bats. Ht. 24 cms. Bangkok National Museum.

120. Architectural ornament in the shape of a scaly, crested naga. Ht. 63 cms. Collection of Fredrick Knight.

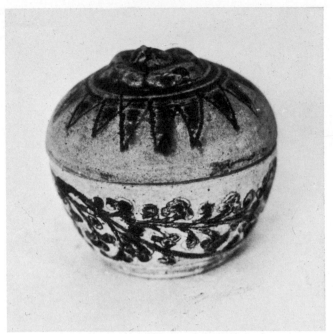

122. Covered box, miniature, with the incised decoration inlaid with brown glaze, unglazed elsewhere. Ht. 5·8 cms. The Sinclair Collection.

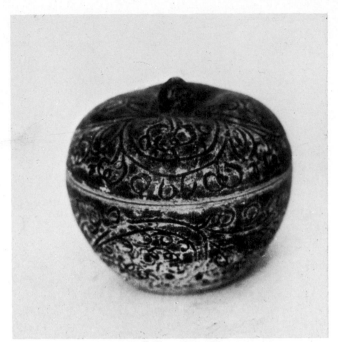

123. Covered box, miniature, with incised decoration, the whole brushed with a thin brown glaze.

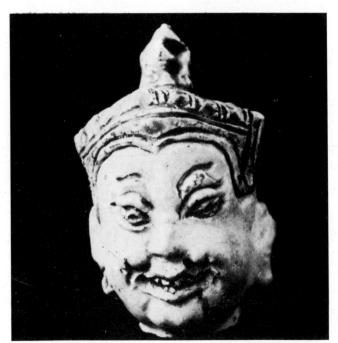

124. Head of a male figure. Ht. 6·8 cms. Collection of Kasem Sirikantraporn.

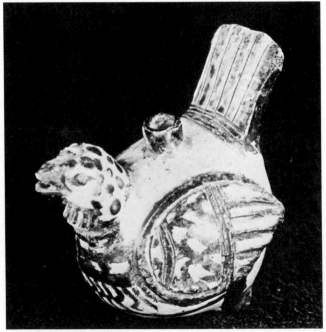

125. Bottle, in the shape of a bird. Ht. 9 cms. Collection of Prok Amranand.

PLATE 37

SAWANKHALOK WARES, C. 1350–1512
Black-glazed

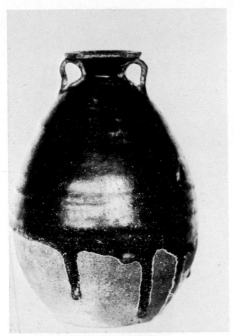

126. Bottle, with a dark reddish-brown
body and a rough flat base. Ht. 18
cms. Private Collection.

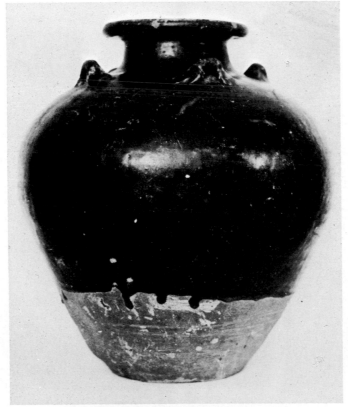

127. Jar, with thick glaze, and a dark
reddish-brown body. Ht. 39 cms.
The Sinclair Collection.

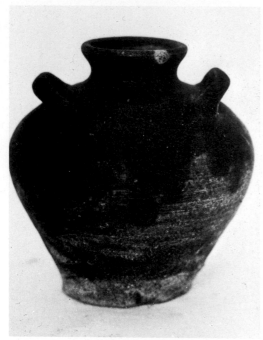

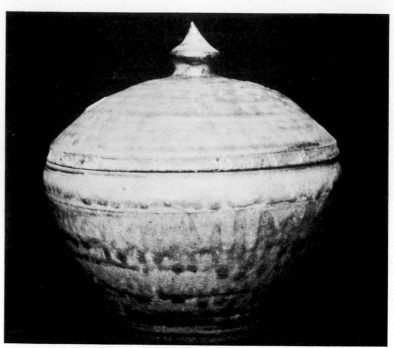

128. Jarlet, with a cord-cut base, greyish-brown body, and a thin brownish olive glaze. Ht. 9·5 cms. The Sinclair Collection.

129. Covered jar, with a thin, runny olive glaze, a rough flat base, and dark reddish-brown body. Diam. 20·5 cms. Formerly in the collection of Phaya Nakon Phrah Ram. Bangkok National Museum.

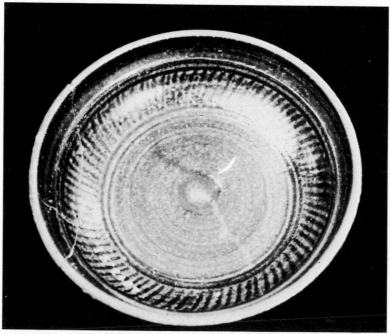

130. Plate, with white slip and brownish-olive glaze on the interior, a flat base, and a coarse reddish-brown body; the whole exterior unglazed. Diam. 20 cms. Bangkok National Museum.

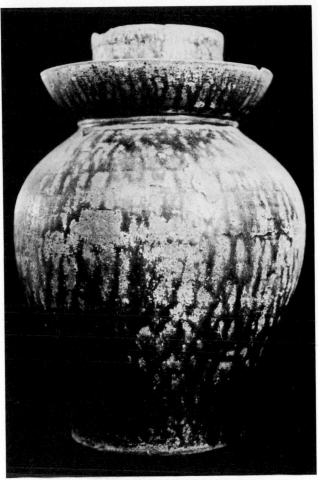

131. Jar, with a large flange rising from the base of the neck, dribbly brown glaze, brownish body, and grit adhering to the flat unglazed base. Ht. 31 cms. Formerly in the collection of Phaya Nakon Phrah Ram. Bangkok National Museum.

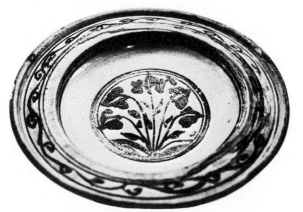

132. Plate, with a greyish-brown body, and a carved slight foot ring. Diam. 20 cms. Chiengmai National Museum (Nimmanahaeminda Collection).

133. Bottle, with a reddish-brown body, rough flat base, and thin greyish-green glaze over an undercoat of white slip. Ht. 17 cms. Private Collection.

134. Utility jar, heavily potted, with a brownish body and dark-olive glaze. Ht. 20 cms. Private Collection.

PLATE 41

KALONG WARES
c. Fifteenth to Mid-sixteenth Centuries

135. Bottle, with underglaze black decorations on a white slip under a cloudy glaze, a whitish body, carved foot ring, and unglazed base. Ht. 12·2 cms. Collection of Prok Amranand.

136. Plate, thinly potted, with a whitish body, carved foot ring, and unglazed base. Diam. 21 cms. Private Collection.

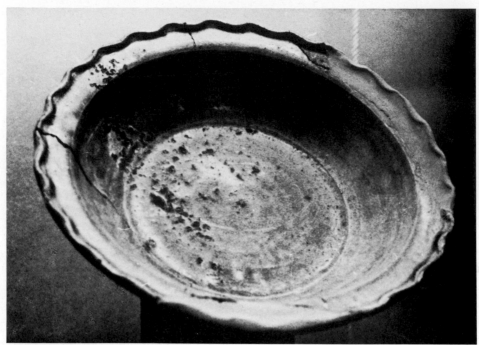

137. Plate, with a greyish-brown body and translucent yellowish-green glaze. Diam. 21 cms. Bangkok National Museum.

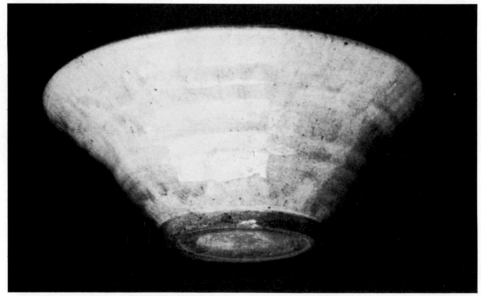

138. Large bowl, with a pale reddish-brown body, carved foot ring, an unglazed base with a tubular support scar, and thin, watery, translucent celadon glaze. Collection of Fredrick Knight.

PLATE 43 LAMPANG WARE

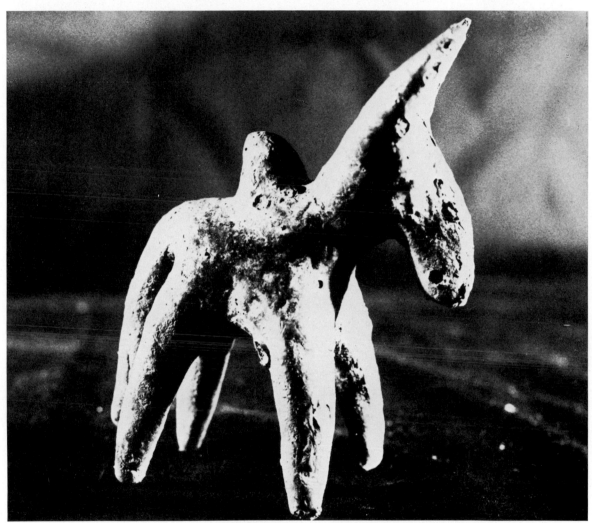

139. Bovine figurine, with a brown body and brown glaze. Ht. 12 cms. Perhaps fifteenth to mid-sixteenth centuries. Chiengmai National Museum.